THE NORMAN

ROCKWELL

TREASURY

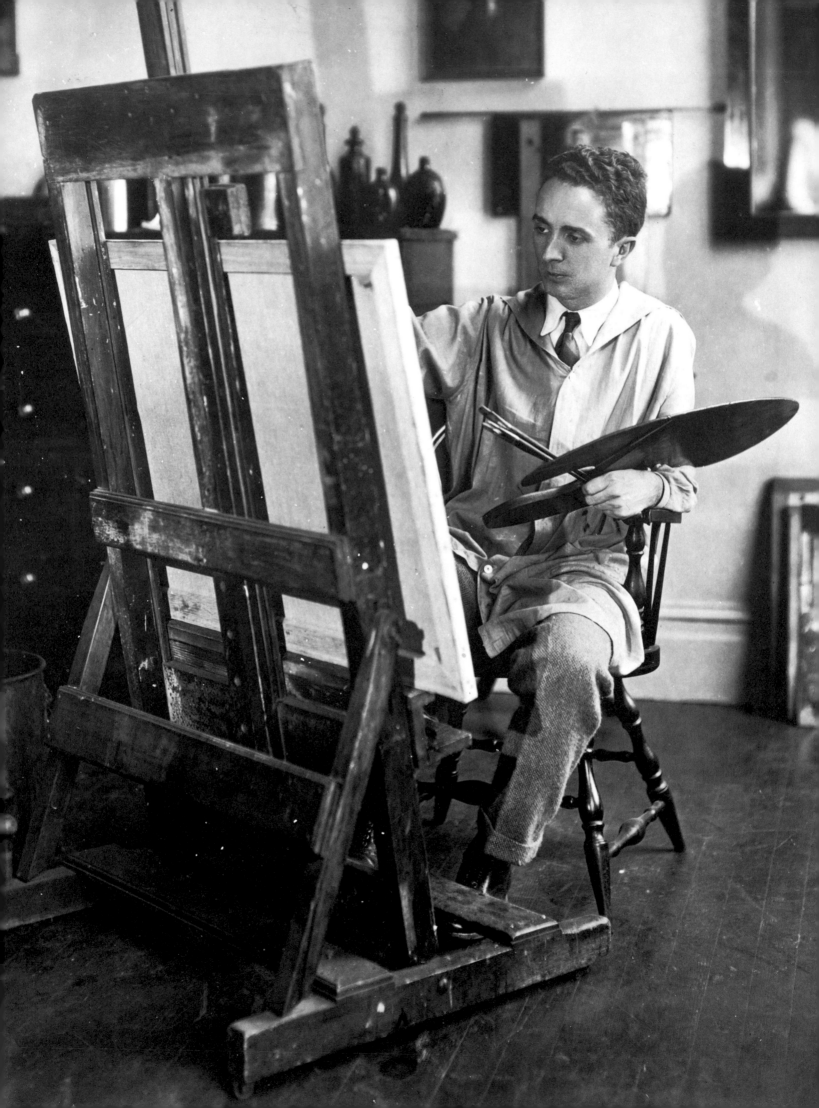

Thomas S. Buechner

THE NORMAN ROCKWELL TREASURY

Galahad Books · New York City

frontispiece:
Rockwell in his studio, 1934

The purpose of this book is pleasure. It contains some of Rockwell's best work, well reproduced and arranged chronologically. The subject matter alone will delight most people, but there are several other possible approaches. The plates can be viewed as a popular history of America in the twentieth century—as revealing in its omissions as in its inclusions (no Prohibition, no Depression, no Korea or Vietnam; plenty of baseball, presidential campaigns, and, recently, civil rights). In another sense, these illustrations provide an intimate family view of how many Americans would like to see themselves—including their *national* sense of humor. The personality of the artist himself should emerge through the turning of these pages—he is at once consistent and changing. What the old *Saturday Evening Post*, in its issue of December 18, 1926, lovingly referred to as his "naive and wholesome manner" permeates everything, but his interests expanded from the swimming hole to politics, the Peace Corps, and even to fantasy. On a more specialized level, students of illustration should be able to assay Rockwell's role within that complex tradition and to recognize influences both given and taken. How he used the space on which he painted, the development of his tonal and color sense, contours, textures, the introduction of various compositional devices can all be seen in this sequence of reproductions. At the risk of being pedantic—particularly in contrast with the illustrations—this book attempts to be useful in all these respects. It also has a point of view, which is that illustration should be considered an aspect of the fine arts.

Thomas S. Buechner

Library of Congress Catalog Card Number:
79-64356
ISBN 0-88365-411-3
© 1979 The Estate of Norman Rockwell and
Harry N. Abrams, Inc., New York

Published by arrangement with Harry N. Abrams, Incorporated, New York

Printed and bound in Japan

CONTENTS

Advertisement for
Massachusetts Mutual
Life Insurance Company

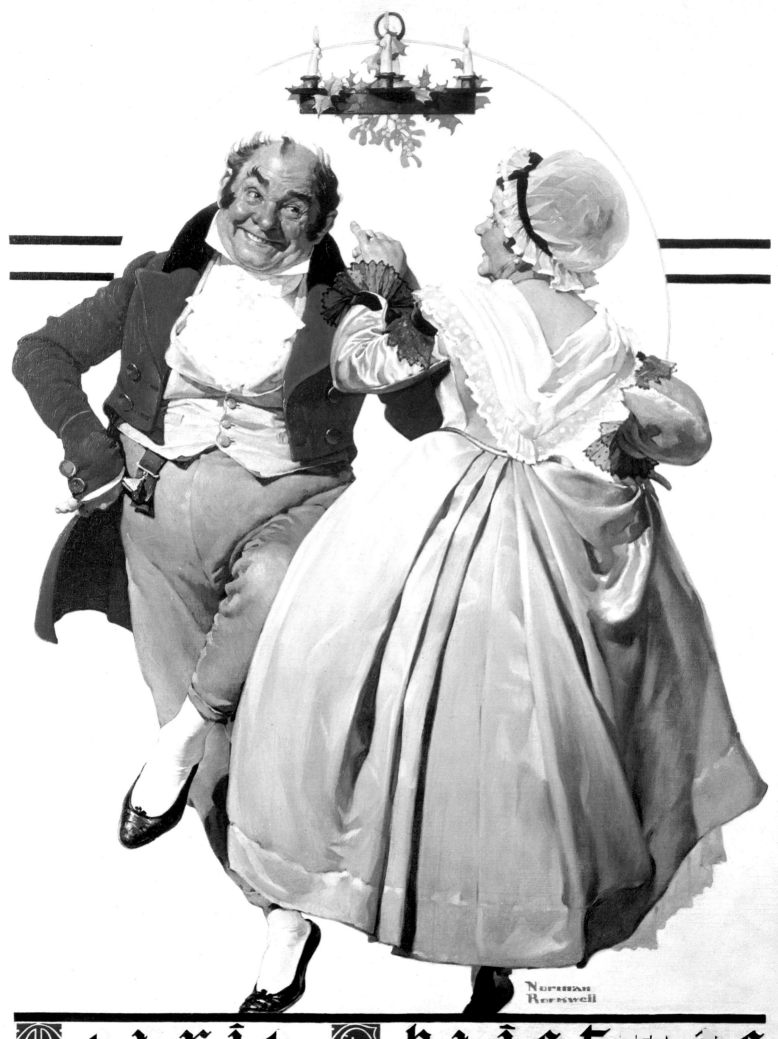

Merrit Christmas

INTRODUCTION

Norman Percevel Rockwell was born on February 3, 1894, in a brownstone on 103rd Street and Amsterdam Avenue in New York City. His father, Jarvis Waring Rockwell, was the manager of the New York office of George Woods, Sons, and Company, a textile firm. According to Rockwell's autobiography, his father's family was "substantial, well to do, character and fortunes founded on three generations of wealth." In addition to reading Dickens aloud after dinner, Waring Rockwell also enjoyed copying illustrations from magazines.

Norman's mother, Nancy Hill Rockwell, was one of twelve children. Her father was an unsuccessful English artist who came to America shortly after the Civil War. "He hoped to open a studio as a portrait and landscape painter...instead he became a painter of animals, potboilers and houses....He painted in great detail — every hair on the dog was carefully drawn; the tiny highlights in the pig's eyes — great, watery human eyes — could be clearly seen." Nancy's pride centered on her mother's family, who traced their English ancestry back to Sir Norman Percevel. Norman, as the first son, received the entire ancestral inheritance — the name (his only brother was named Jarvis). Waring Rockwell was an aloof, gentlemanly father, Nancy a self-indulgent, complaining mother. Norman was never close to either of them. Interestingly, few of his storytelling covers dealt with parental relationships until he himself became a father.

The family was very religious. As a choirboy at St. Luke's and later at the Cathedral of St. John the Divine, Rockwell sang four services on Sunday after attending four rehearsals during the week. He also marched with a wooden gun in the St. Luke's Battalion. Thin, poorly coordinated, and pigeon-toed, he started wearing corrective shoes when he was ten, eyeglasses at twelve. Unable to compete satisfactorily in sports, he used his drawing skill to entertain his contemporaries from an early age. He loved summers in the country and disliked the city, which he found dirty,

Advertisement for Massachusetts Mutual Life Insurance Company

opposite page:
Merrie Christmas. Oil painting for *Post* cover, December 8, 1928. Collection Mr. and Mrs. Murray L. Pfeffer

Illustration for *Boys' Life*, 1915

sordid, and ugly. No theme is more dominant through the first three decades of his work than the idealization of boyhood in the summer in the country. It gradually expanded to include adults and other seasons but very rarely do city streets appear.

In 1903, the Rockwell family moved to Mamaroneck, and by 1906 Norman had decided what he was going to be: "...boys who are athletes are expressing themselves fully. They have an identity, a recognized place among other boys. I didn't have that. All I had was the ability to draw, which as far as I could see didn't count for much. But because it was all I had I began to make it my whole life. I drew all the time. Gradually my narrow shoulders, long neck, and pigeon toes became less important to me. I drew and drew and drew."

By 1908, when he was fourteen, Rockwell commuted to New York on Saturdays and later, with the school principal's permission, on Wednesdays, for his first formal art training—at the Chase School of Fine and Applied Art. He left high school altogether in the middle of his sophomore year and switched to the National Academy School as a full-time student. As might be expected, the curriculum was academic in the grand French tradition. Students began by doing laborious charcoal studies from plaster casts of antique sculptures. When they had learned the fundamentals of proportion, anatomy, and rendering, they graduated to living models—male students in one classroom, female in another. The school was stiff, stilted, and oriented toward winning that classic scholarship, the Prix de Rome. In 1910, Rockwell left and enrolled at the Art Students League. Founded in 1875, it was the most liberal and exciting art school of its day. Winslow Homer had studied there and so had Charles Dana Gibson, but of the long list of famous alumni none would have impressed Rockwell more than Howard Pyle, who had been one of the founders.

During this brief period of training, Rockwell had a series of part-time jobs. One summer he earned pocket money by being a paint box caddy for Ethel Barrymore; during another he bought a mail delivery route in Orienta Point near Mamaroneck. In the winter while a full-time student at the Art Students League he worked as a waiter from 8:00 P.M. to midnight at a Child's restaurant then located near the League on Columbus Circle. This uninspiring occupation soon gave way to an exotic one—supernumerary at the Metropolitan Opera (his autobiography contains a delightful account of his relationship with Enrico Caruso). By 1912, when his family moved back to the city from Mamaroneck,

illustrating jobs were coming in fast enough to make other employment unnecessary. At eighteen he was a full-time professional.

TECHNIQUES

Norman Rockwell developed his pictures in a series of separate, self-contained phases; first, a loose sketch of an idea; second, the gathering of models, costumes, background, and props; third, individual drawings of parts or, from about 1937, photographing everything; fourth, a full-scale drawing in great detail; fifth, color sketches; and sixth, putting all the parts together in the final painting. As with most artists, the procedure varied from picture to picture — he might do a whole series of compositional sketches in color or, at the other extreme, simply project a photograph onto a white canvas, draw around the image and start painting. The one essential constant in his technique was the rigid separation of drawing and painting. He solved as many problems, made as many decisions as he could in black and white and then took on the color and textural possibilities of paint as the second phase. This separation prevented, or at least greatly hampered, the spontaneous totality possible when all the parts were developed simultaneously. On the other hand, having worked out all the details in black and white, he could concentrate fully on color and texture. Great works of art have resulted from both approaches — Michelangelo's Sistine ceiling had to be done in stages; line, form, and color must have evolved simultaneously in Rembrandt's *Night Watch*. Taking the six steps as an organizational device for describing Rockwell's technique rather than as a rigid formula that he might or might not follow, the first was the conceptual sketch. These were often very small — about two by three inches — drawn with a carbon pencil on any convenient scrap of paper. They contain so little information and are so undistinguished in quality that their main purpose was to remind Rockwell of the idea so that he could present it verbally to the client's art director. His own abilities as an actor were more important than the sketch at this stage and many an idea was sold through a facial expression rather than a drawing.

In the second step, Rockwell abandoned his role as actor and became producer, casting director, set and costume designer, prop man, and wardrobe mistress. He did not draw — he gathered. In searching for *exactly* the right type, he employed bank presidents, jockeys, umpires, society

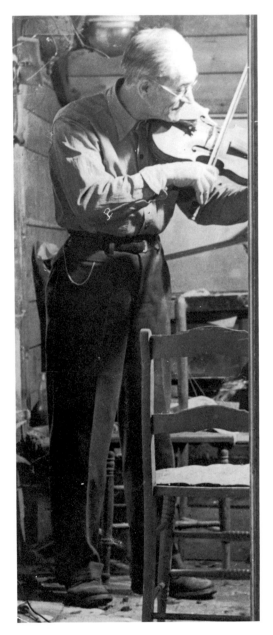

Photograph taken under
Rockwell's direction for
Shuffleton's Barber Shop

opposite page:
Shuffleton's Barber Shop. Oil
painting for *Post* cover, April
29, 1950. Collection Norman
Rockwell

ladies, farmers, sheriffs, and almost every other conceivable
type (always excluding the "sordid and ugly") — sometimes
posing as themselves, sometimes in completely unrelated
roles. Two Arlington, Vermont, ladies posed as Broadway
charwomen, the local mailman as a big city political boss.
Designing the set could be literal, in which case it was
constructed in Rockwell's studio; more often and for greater
authenticity, he traveled to the real thing — whether it was a
local swimming hole or the ball park in St. Louis (where his
models were Stan Musial and Joe Garagiola) or to the U.N.
building (where Henry Cabot Lodge and Andrei Vishinsky
posed for him). If he could not find the real thing in
costumes he rented a good facsimile — Charles Chrisdie and
Company on Eighth Avenue behind the old Metropolitan
Opera building used to supply most — or he designed what
he wanted and had it made. The same thoroughness went
into finding exactly the right props. This second stage not
only epitomizes Rockwell's concern with authenticity but it is
in itself highly creative — as much so for a *Post* cover or book
illustration as for a scene in a film.

The third step changed over the years. With the exception
of very young children and unruly animals, until the
mid-thirties Rockwell worked directly from living models
and not from photographs. Both before and after, he began
this phase by arranging models, costumes, and props and
then assuming the role of director in the theatrical sense.
Rockwellian poses, gestures, and facial expressions are the
result of his acting out the situation for his models. Before
he lifted a pencil, he had created a Rockwell.

This "tableau vivant" used to be made of parts — one boy
would pose, then another, then the dog and each would be
drawn separately. The hardest part would be keeping facial
expressions alive during hours of standing still. Action poses
such as diving or running brought other problems. In a
knock-out scene, Rockwell had to stretch the victim out on a
sloping board to get the effect of the mid-air impact. The
camera changed all this. Using dozens of photographs,
sometimes hundreds, taken by a professional photographer
under Rockwell's direction, a bank of visual information
could be gathered containing just the right moments as well
as the right details.

A drawing the same size as the final painting comprised
step four. The general composition was pretty well defined
by the arrangement of models and props. Now the job was to
produce a detailed, lineal design with some indication of the
dark-light pattern. This was a most important phase from an
aesthetic point of view because in addition to getting

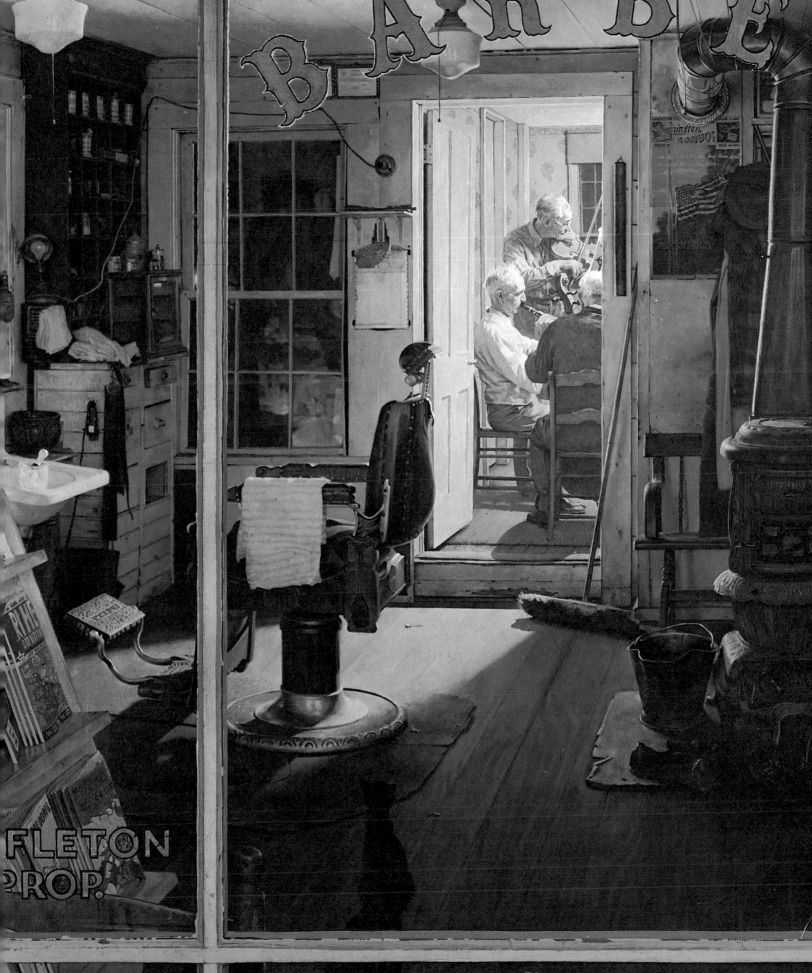

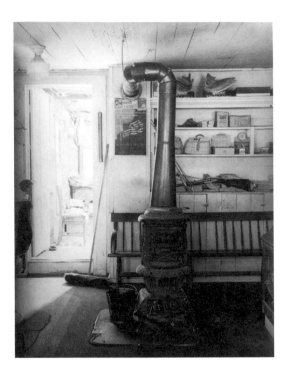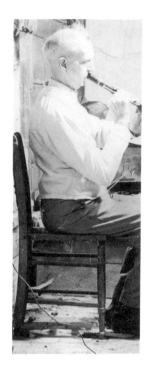

everything drawn correctly and determining whether the
story came across as planned, the design had to have strong
graphic quality.

Step five — color sketches — was carried out in oil paint on
matte photographs of the charcoal drawing. These sketches
were usually blown up to *Post* cover size but were generally
smaller than the charcoal. On the subject of size, Rockwell
felt that "serious subjects demand large size, light or
humorous small size."

Before step six could begin, the charcoal was transferred
to the canvas — either by tracing it, rubbing charcoal on the
back and retracing as with carbon paper, or by projecting a
photograph of the drawing directly on the canvas with a
Baloptican. Several grades of canvas were used from very
smooth to very rough. Generally speaking, the rough were
used for the largest sizes but fine textures were also used;
the desired degree of finish seemed to have little to do with
which texture was chosen.

With the drawing transferred to the white canvas
Rockwell might paint directly from a full palette, do a
monochromatic underpainting (usually in mars violet), or
start by covering the entire surface with one color much
diluted with rectified turpentine so the drawing showed
through. If he did an underpainting over this general tone

he worked by varying the thickness of the paint — where it was opaque it would be darkest; where the white from the priming underneath was still visible it would be lighter. When dry enough — overnight — the underpainting was isolated by covering it with undiluted French retouching varnish, given half an hour or so to set, and then painted over with color mixed with turpentine and Grumbacher's Oil Medium No. 2. Each successive paint layer was separated from the next with a layer of varnish. It was a method worked out to give Rockwell the flexibility and finish he needed, not to guarantee the survival of his pictures — another reminder of the fact that he painted to be reproduced, not preserved. As a matter of fact, many of his original paintings are already in poor condition, with bits of paint flaking off or incurable yellowing through the use of varnish between the paint layers.

His technique varied enormously and it is difficult to find consistencies beyond the one of separating drawing from painting. In general, he painted whites and extreme lights very thickly and almost every tone from there down so thinly that the canvas provides the dominant texture. Some of his most famous pictures are disappointing in the original because of meager paint quality on very rough canvas. His handling of lights is brilliant — not only the variety of whites he used as local colors but his capacity to make things sparkle. This is partly achieved by a fascinating treatment of contours and edges, as well as by building layers of varying thickness.

Despite the slick paper destination of almost all of his work, Rockwell had been interested in paint texture from his earliest days. Color texture was also important, and what might seem to be a flat tone at first glance frequently turns out to be full of variegated bits of bright color. Rockwell treated most flesh tones as values of roughly the same hue — that is, the flesh is one color that gets lighter or darker depending on how the light falls. The other approach was to vary the color itself between reddish and greenish tones. He did use color opposites in painting other things, particularly folds in clothing, but rarely on heads, hands, or Boy Scouts' knees. In some cases, particularly where the flesh area is light surrounded by darks, it looks tinted rather than painted.

Norman Rockwell was obviously a brilliant craftsman — in watercolor and chalk as well as in charcoal and oil. His techniques changed just as his subject preferences and aesthetic values did. The technical differences are as interesting as the changes in Rockwell's viewpoint.

Walking the Baby. Rockwell's first *Post* cover, May 20, 1916

1914-1929

Norman Rockwell began by being successful. He executed his first commission before he was sixteen (four Christmas cards for Mrs. Arnold Constable), illustrated his first book when he was seventeen *(Tell Me Why Stories)*, became art director of *Boys' Life* at nineteen, and reached the pinnacle of his profession by doing a cover for America's most popular magazine, the *Saturday Evening Post*, when he was twenty-two—at which point he married Irene O'Connor.

Illustrations for a book on Samuel de Champlain published in 1912 by the American Book Company were followed by a prodigious effort for Edward Cave, editor of *Boys' Life:* one hundred illustrations for the *Boy Scouts Hike Book* in 1913 and fifty-five more for the *Boys Camp Book* in 1914. In the same years he illustrated at least four novels by Ralph Henry Barbour and, as *Boys' Life* art director, did seventy-eight illustrations for that magazine in 1915 alone. During this period his drawings began to appear regularly in *St. Nicholas,* the *Youth's Companion, Everyland,* and the *American Boy.* This enormous productivity began in the family apartment in Mamaroneck, but by 1912 Rockwell was in his first studio—the attic of a brothel on the Upper West Side. In less than a year he was in his second, near the Brooklyn end of the Brooklyn Bridge. His third studio was beside the boarding house in which his parents lived and the fourth was in New Rochelle, to which they moved in 1915.

The most important single event of this decade was the publication of his first *Post* cover, which appeared in print on May 20, 1916. As a cover artist he ascended to a new plateau in the world of illustration; as a cover artist for the *Post* he competed with the best: Howard Chandler Christy, A. B. Frost, the Leyendecker brothers, Coles Phillips, N. C. Wyeth, Maxfield Parrish and, of course, that prolific punster, James Montgomery Flagg, whose powerful *Uncle Sam Wants You* is fortunately more memorable than his humor. There were many fine artists working in styles and

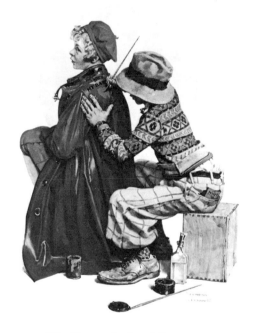

The Young Artist. Oil painting for *Post* cover, June 4, 1927. Collection Mr. and Mrs. William M. Young, Jr.

Illustration for "The Magic Football." *St. Nicholas*, December 1914. Collection Norman Rockwell

opposite page:
Man Painting Flagpole. Oil painting for *Post* cover, May 26, 1928. Collection the McCullough Family

with ideas that obviously had great appeal for Norman Rockwell.

He had done covers of the children's magazines for which he illustrated stories prior to his appearance on the *Post*. Immediately afterward, he began "covering" other national adult publications—many with *Post* rejects. *Collier's, Life* (then a humor magazine), *Leslie's, Judge, Country Gentleman*, the *Literary Digest, People's Popular Monthly, Farm and Fireside* (from Des Moines), and *Popular Science* were among them. While in the navy, he worked for *Afloat and Ashore* two days a week, did portraits of officers, and continued to serve his regular clients. The ever present signature on covers done between July, 1917, and November, 1918, is sometimes followed by U.S.N.R.F. His first painting for advertisements also appeared during this period. Perfection oil heaters, Fisk bicycle tires, Overland automobiles, Jell-O, and Orange Crush were among them.

In Rockwell's work for children's publications, his own youth and inexperience as well as the tastes of the times determined his subject matter—youth. Of his first twenty-five covers for the *Post* (1916–1919), twenty-two have to do with childhood. But in working for major magazines with distinct editorial policies, he chose different subjects for different publications. The war, for example, plays a minor role on the cover of the *Post* but a major one for the *Literary Digest* and the old *Life* magazine. But even when depicting doughboys he injected children wherever possible—in French and Belgian costumes.

The Reginald series for *Country Gentleman* is obviously specially tailored—a city boy being bested by his contemporary from the country.

Certain themes emerge during this period that provided Rockwell with subject matter for more than half a century. They are interesting to follow because his treatment of them changed as he grew older. Other themes are less enduring, and new ones appear all along the way. Situations involving small embarrassments, discomforts, and humiliations provided humorous covers all the way through. Growing up is another and, closely related, budding love. Old-fashioned patriotism persists as well as the recording of fads and historical events. Youth contrasted with age is a major category, recurring almost as often as depictions of simple joys for the vicarious delight of the reader. More specific long-term subject matter introduced in this first decade includes Santa Claus, Boy Scouts, circus people, dogs, and bandaged big toes. Rockwell's particular ability to combine humor and pathos had not yet appeared as a strong characteristic.

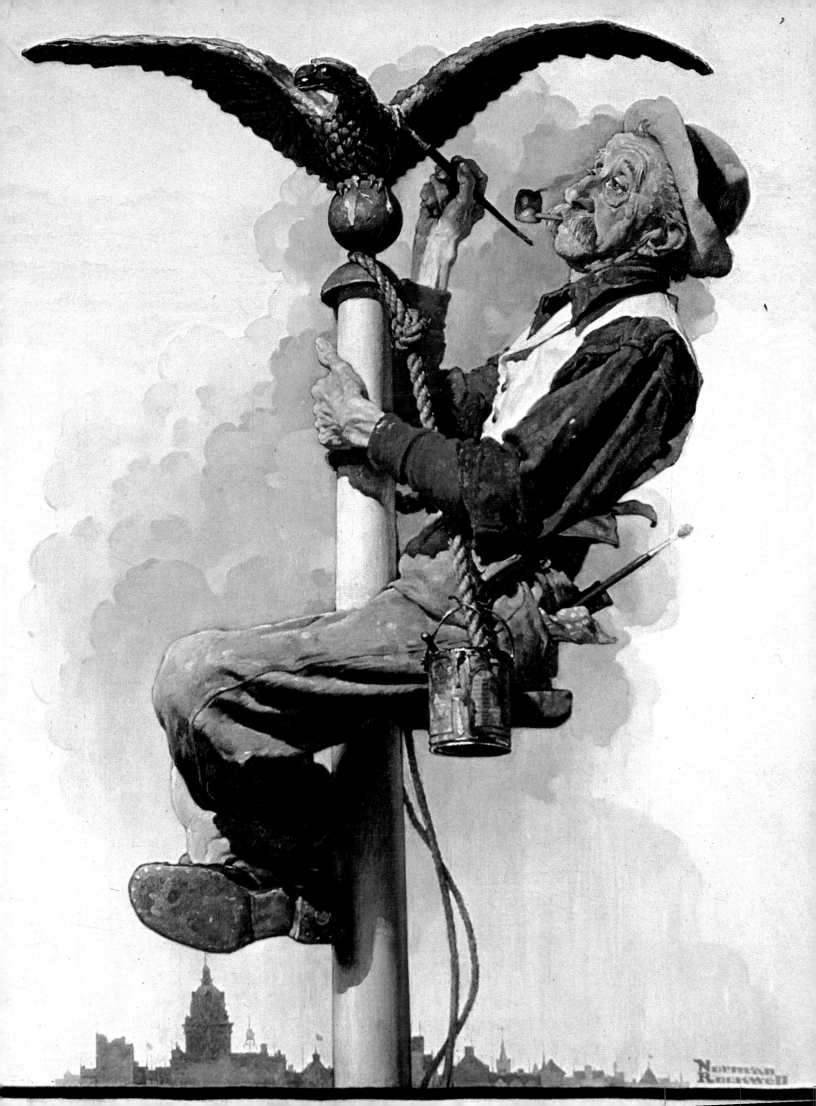

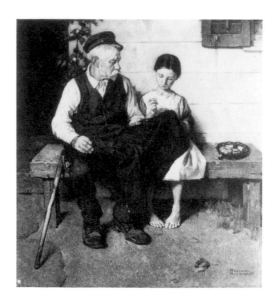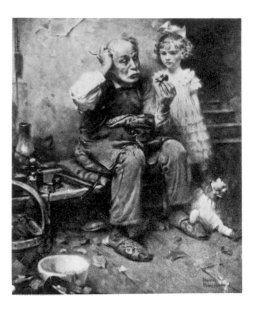

Literary Digest covers, 1921–1923:
Mending the Coat; Dolly's
Shoe; Playing the Banjo; The
Hopeless Case; Reading Hour

It is difficult to separate Rockwell's style from those of his contemporaries at this early stage. Certain characteristics were certainly shared by others, but in combination they begin to describe his particular personality. A strong sense of contour, of the outer edge of each part, is certainly one. Rarely did Rockwell "lose" things in shadows—particularly as he became surer of himself. These edges tend to flatten out the forms they confine, giving the subject a poster-like appearance. Having a strong tendency toward design, he controlled those edges so that they made interesting lines defining large patterns. These designed shapes are often beautifully related to the subjects themselves, but rarely before 1920.

Another characteristic was his preference for a shallow depth of field. The entire subject appears to be up close; backgrounds and middle grounds are exceptions rather than the rule. He also seemed to like to place his models parallel to the picture plane, either head-on or in profile, avoiding diagonals and receding perspective lines. When backgrounds are painted in they also usually parallel the picture plane, setting up a grid of verticals and horizontals.

There are the beginnings at this early stage of one of Rockwell's most effective devices—the foreground invitation. At its height, from the *Huckleberry Finn* illustrations onward, it involves placing people and objects in such a way that the viewer feels he is entering the picture.

Detailed attention to all parts was a Rockwell hallmark from the very beginning, with extra attention given to faces. Capturing just the right expression was one of Rockwell's great if not unique strengths. He often overemphasized what the facial features were doing in an effort to convey the

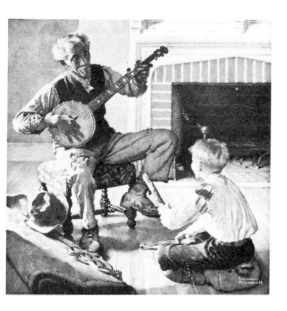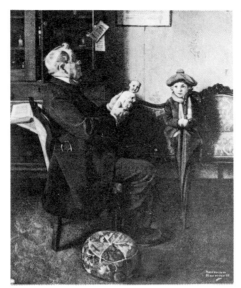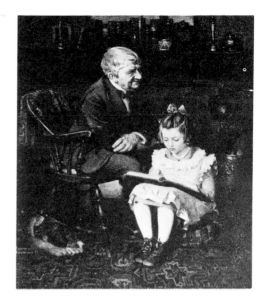

proper emotion—particularly with children. It took a good many years to master this most important aspect of his work. Rockwell became rich and famous. He took up golf and sailing, joined clubs, found his own bootlegger, and spent as much time partying as painting. He toured South America and steamed back and forth across the Atlantic six times. He saw students dueling in Heidelberg, Riffs rebelling in Morocco, and Venezuelans revolting in Caracas. He was accepted by society, pursued by publishers, and divorced by Irene. His work continued to improve.

He became the top cover artist for the *Post*. His work appeared almost every month, and beginning in 1919 he did a Christmas cover every year without interruption until 1943—but he was tempted by other offers. In 1924, Patterson and McCormick in Chicago founded *Liberty* in competition with the *Post* and *Collier's*. The art director of the new magazine came to New Rochelle and offered to double whatever the *Post* was paying. Rockwell hesitated, went to Philadelphia, and described the situation to George Horace Lorimer, *Post* editor from 1899 through 1936. Mr. Lorimer's only response was to ask Rockwell what he had decided to do. He decided to stay and Mr. Lorimer decided to double his price. Rockwell's respect for George Horace Lorimer was awesome—no other personality in his autobiography is the subject of such thorough admiration. After this meeting, he illustrated very few covers for other magazines but took on more advertising—at twice his fee for a *Post* cover. Temptation came from that quarter too: Lennen and Mitchell, an advertising agency, offered $25,000 a year for his exclusive services. But under a contract signed in 1921 Rockwell had thought up and

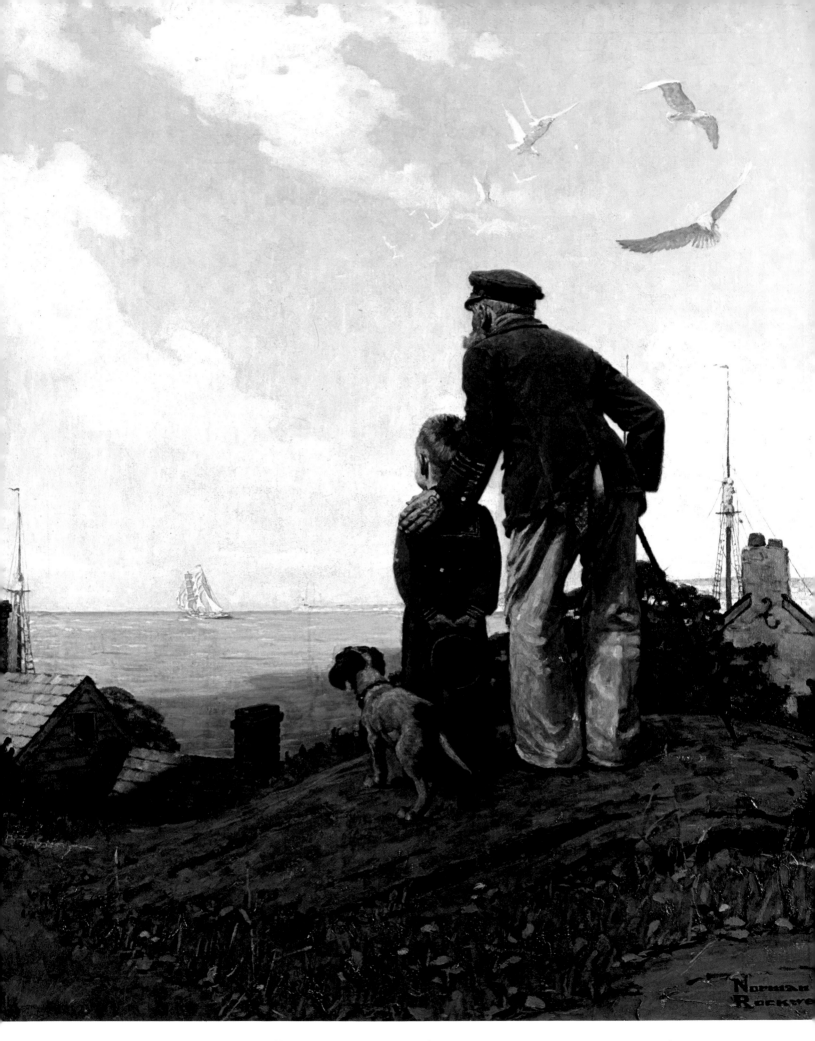

Looking Out to Sea. 1919. Oil painting. Collection Norman Rockwell

Gramercy Park. 1918. Oil painting. Collection Mr. and Mrs. George J. Arden

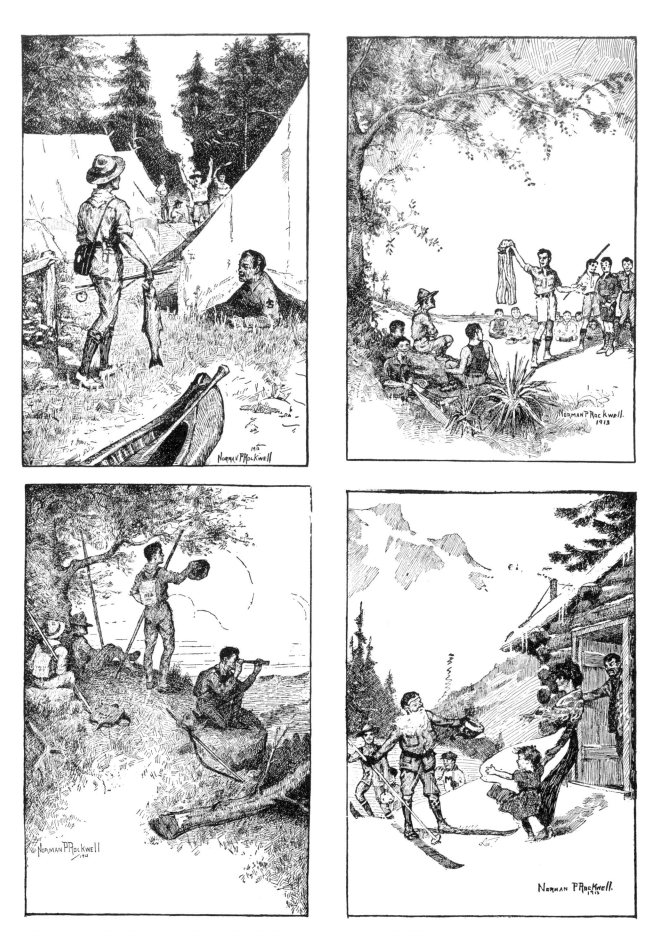

Illustrations for *Boy Scouts Hike Book*, 1913, and *Boys Camp Book*, 1914

painted twelve Orange Crush ads (at $300 each) with great effort and awful anguish; he wanted no more long-term commitments. The series for Edison Mazda and the Encyclopaedia Britannica are among the best Rockwell ads of this period.

The only association to equal the *Post's* in longevity was that with Brown & Bigelow, who began publishing Rockwell's Boy Scout calendars in 1923. The paintings for these were at first donated as contributions to a cause in which Rockwell thoroughly believed. Unrivaled in popularity (except by Andrew Loomis's painting of the Dionne quintuplets), his subjects soon brought economic rewards to him as well as to B & B — without an apparent loss of enthusiasm: half a century of depicting the dynamics of the Boy Scout Oath is indeed a remarkable achievement.

Things were happening fast in the twenties: new clothes, new music, new morals, new art. While in Paris in 1923, Rockwell had enrolled in Colarossi's school. His approach suddenly seemed hopelessly old-fashioned. He tried to do a "modern" cover emphasizing abstract color. It was rejected by the *Post* and he settled back into what he loved to do best — telling stories. In a sense, he became two artists and painted in two quite separate styles. One was in the Victorian tradition, sentimental and pretty, full of atmosphere and charm — a direct link with the past and extremely well done. The other style reflected the changes that were taking place, strong silhouettes backed by simple geometric shapes — art deco circles and squares, design instead of atmosphere, character instead of idealization, humor instead of sentiment. The *Post* came to prefer the latter and with Rockwell's departure from the covers of other magazines, his traditional style barely survived the decade.

Illustrations for
Boys' Life, 1915

23

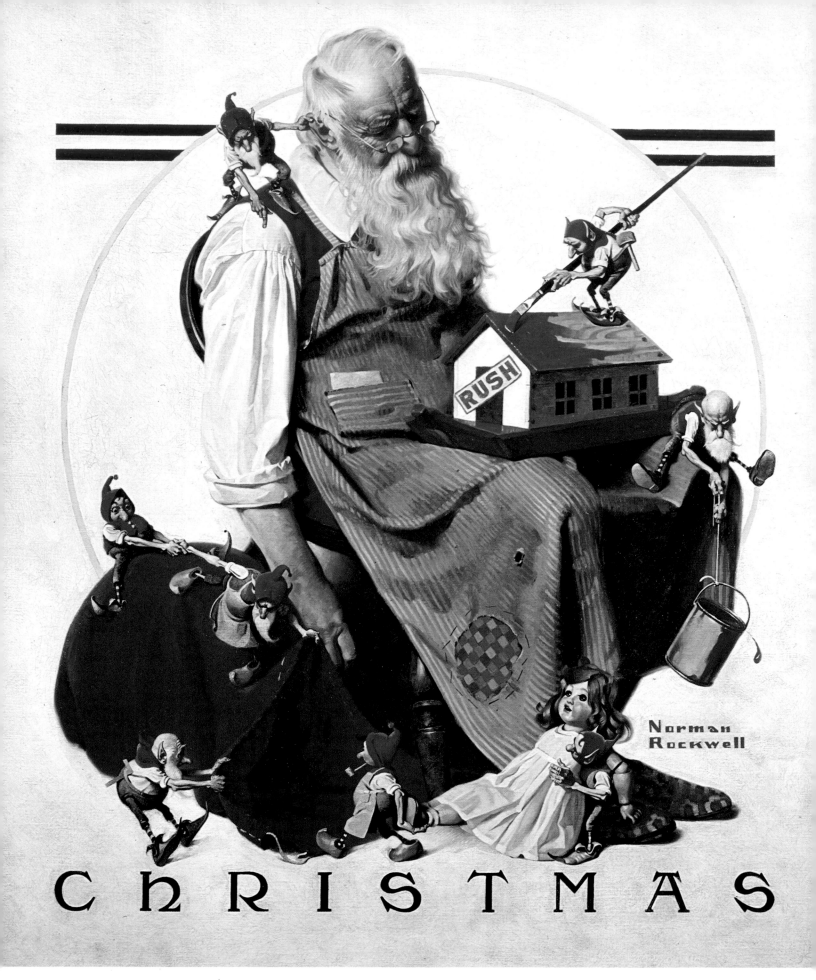

Christmas: Santa with Elves. Oil painting for *Post* cover, December 2, 1922. Collection Jarvis Rockwell

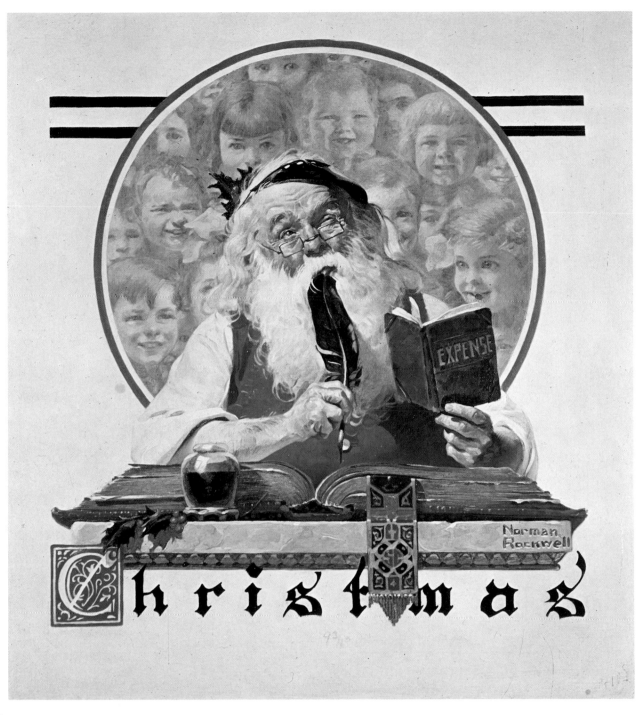

Santa. Oil painting for *Post* cover, December 4, 1920. Collection Patricia and Howard O'Connor

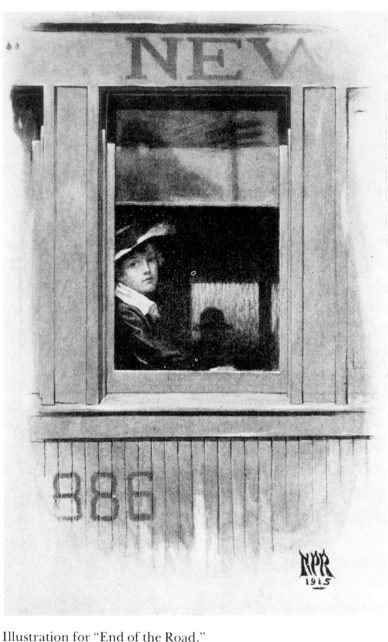

Illustration for "End of the Road."
St. Nicholas, November 1915

Illustration for *St. Nicholas*, May 1915

Winter. Sketch for *St. Nicholas* cover, January 1916

27

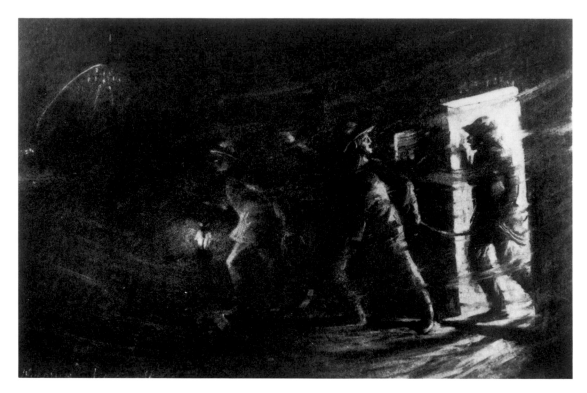

To the Rescue. 1916. Drawing. Collection Patricia and Howard O'Connor

Party Line. 1918. Oil painting.
Collection Mr. and Mrs. Harold
Konner

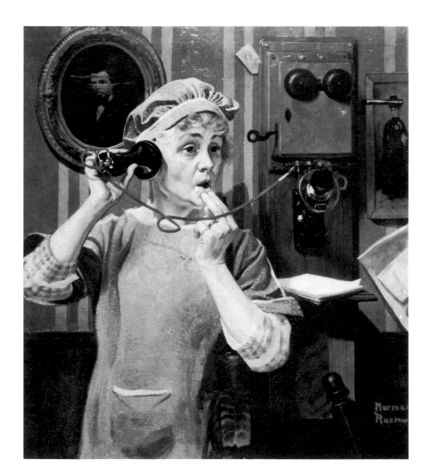

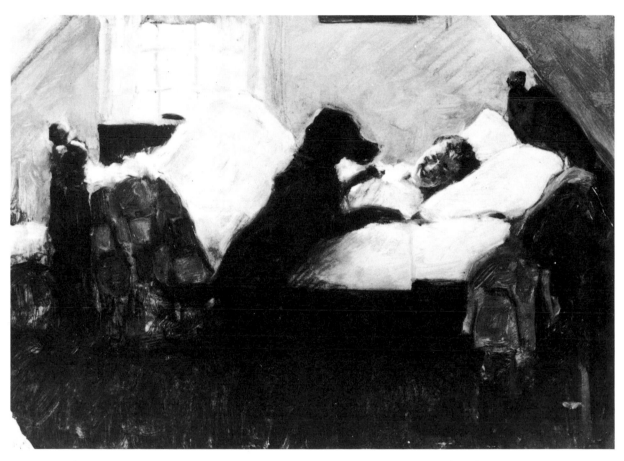

Waking Up Master. 1922. Oil on cardboard. Collection Patricia and Howard O'Connor

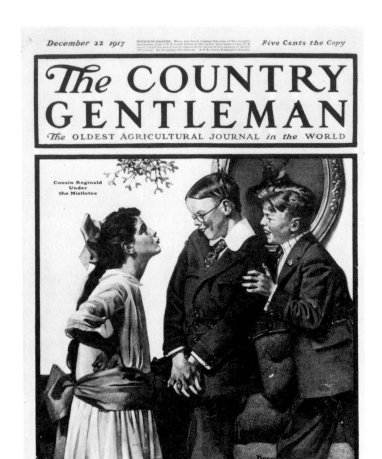

Country Gentleman cover, December 22, 1917.
© 1945, The Curtis Publishing Company

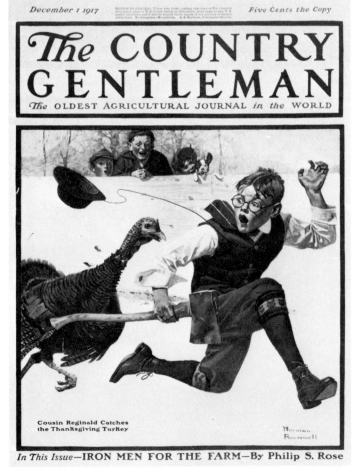

Country Gentleman cover, December 1, 1917.
© 1945, The Curtis Publishing Company

30

Two A.M.—Watch Your Step. *Judge* cover, January 13, 1917

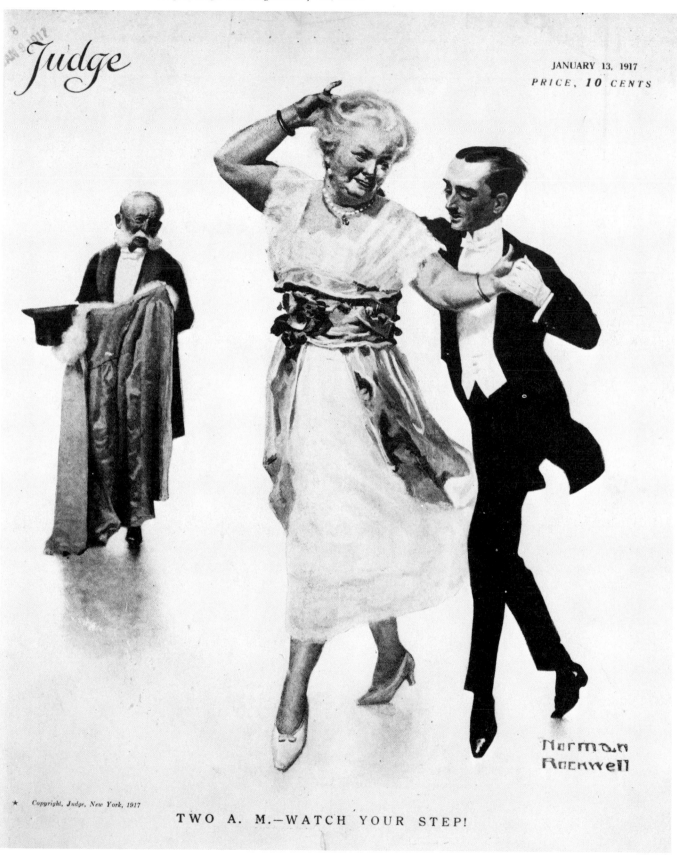

overleaf:
Boy and Girl on a Horse. Oil painting for *Literary Digest* cover,
September 4, 1920. Collection Mrs. Elmer E. Putnam

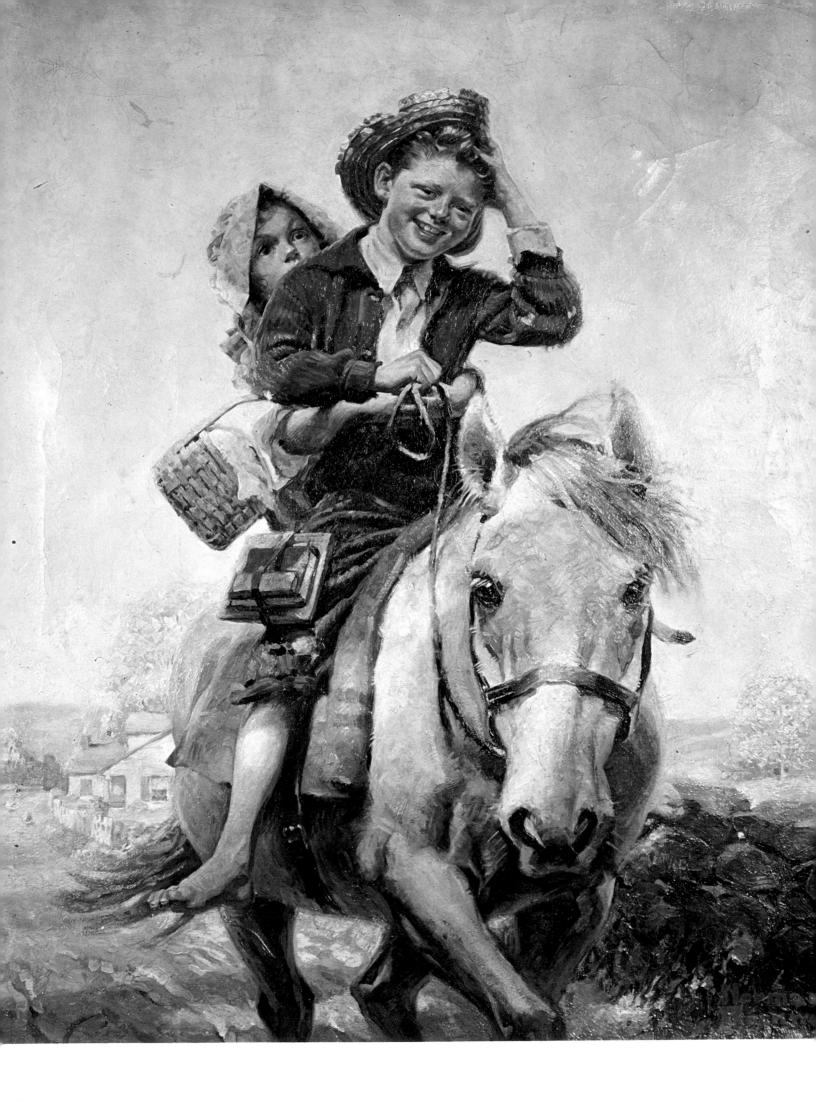

Courting Couple at Midnight. Oil painting for *Post* cover, March 22, 1919.
Private collection

Illustration for *St. Nicholas*, January 1917

Illustration for "The Ungrateful Man." *St. Nicholas*, January 1917

34

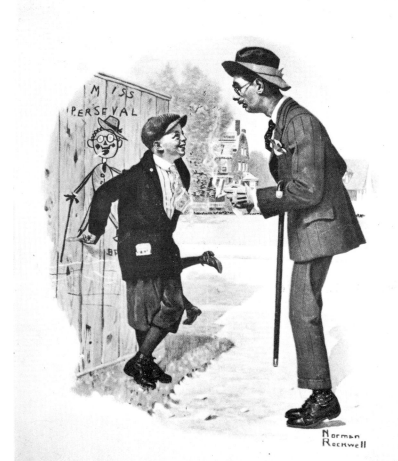

Li𝑓e

PRICE 10 CENTS
Vol. 69, No. 1802. May 10, 1917

Life cover, May 10, 1917

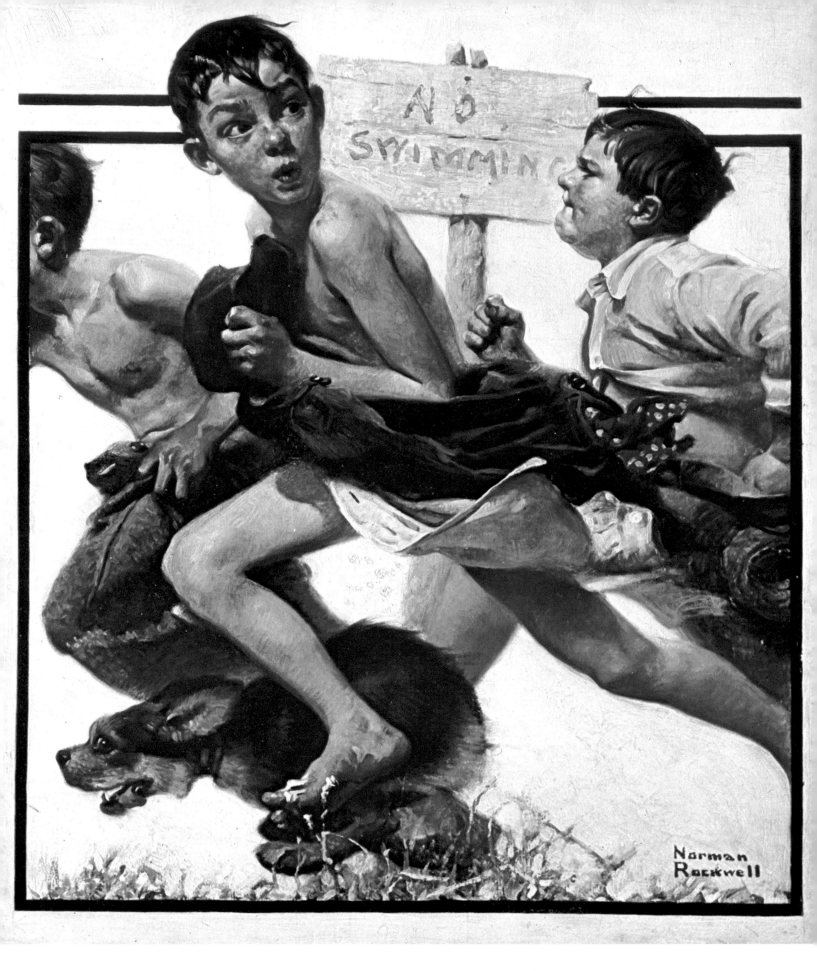

No Swimming. Oil painting for *Post* cover, June 4, 1921. Collection Norman Rockwell

Crackers in Bed. Oil painting for advertisement for the Edison Mazda Lamp Works, 1921.
Collection Mr. and Mrs. George J. Arden

Advertisement for Fisk bicycle tires,
Boys' Life, September 1919

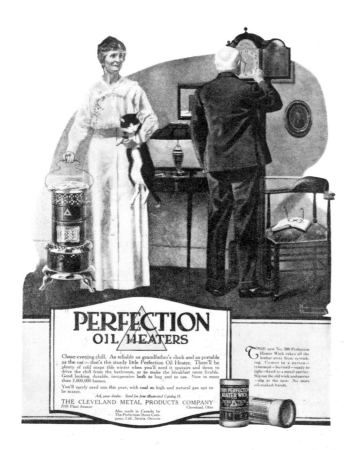

Advertisement for Perfection oil heaters,
Post, September 15, 1917

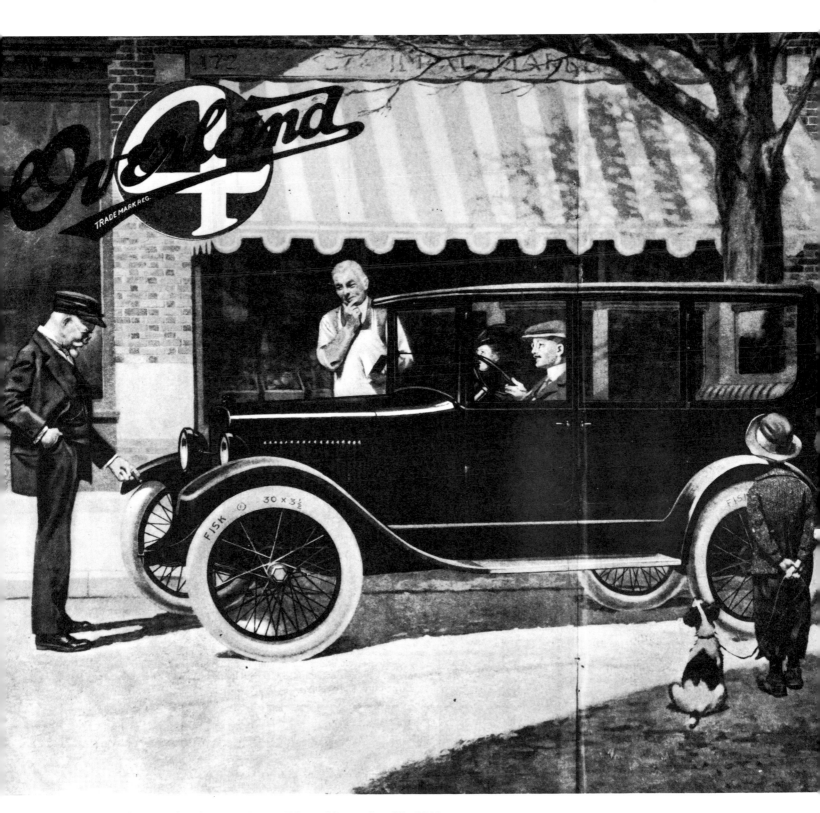

Advertisement for Overland cars, *Literary Digest,* November 22, 1919

Fortune Teller. Oil painting for *Post* cover, March 12, 1921.
Collection Mr. and Mrs. Jerome D. Mack

Paying the Bills. Oil painting for *Literary Digest* cover, February 26, 1921.
Collection Mr. and Mrs. Jerome D. Mack

41

THE SATURDAY EVENING POST

WHAT OF THE EAST—By SAMUEL G. BLYTHE
THE SUB-DEB—By MARY ROBERTS RINEHART

THE SATURDAY EVENING POST

In This Number: Carl W. Ackerman—Maximilian Foster—Will Irwin—Basil King
Charles E. Van Loan—Elizabeth Jordan—Nalbro Bartley—Eleanor Franklin Egan

THE SATURDAY EVENING POST

FOLLOWING THE RED CROSS—By Elizabeth Frazer

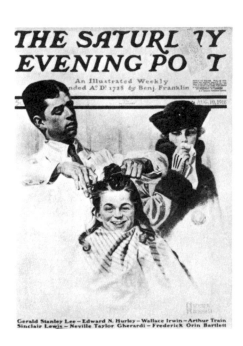

THE SATURDAY EVENING POST

Gerald Stanley Lee—Edward N. Hurley—Wallace Irwin—Arthur Train
Sinclair Lewis—Neville Taylor Gherardi—Frederick Orin Bartlett

THE SATURDAY EVENING POST

THE ZERO HOUR—By GEORGE PATTULLO

THE SATURDAY EVENING POST

Edith Wharton—Octavus Roy Cohen—Peter Clark Macfarlane
Isaac F. Marcosson—Basil King—Albert W. Atwood—Rob Wagner

THE SATURDAY EVENING POST

MORE THAN TWO MILLION A WEEK

THE SATURDAY EVENING POST

In This Number: Juliet Wilbor Tompkins—Nina Wilcox Putnam—Everett Rhodes Castle
Mary Roberts Rinehart—Temple Bailey—Sinclair Lewis—Pelham Granville Wodehouse

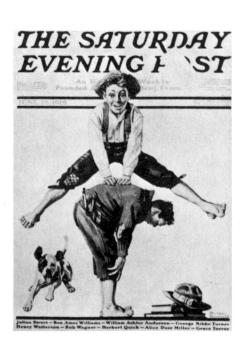

THE SATURDAY EVENING POST

Julian Street—Ben Ames Williams—William Ashley Anderson—George Hibbs Turner
Henry Watterson—Rob Wagner—Herbert Quick—Alice Duer Miller—Grace Torrey

THE SATURDAY EVENING POST

An Illustrated Weekly
Founded A.º D.ʳ 1728 by ... Franklin

JANUARY 13, 1917

5c. THE COPY

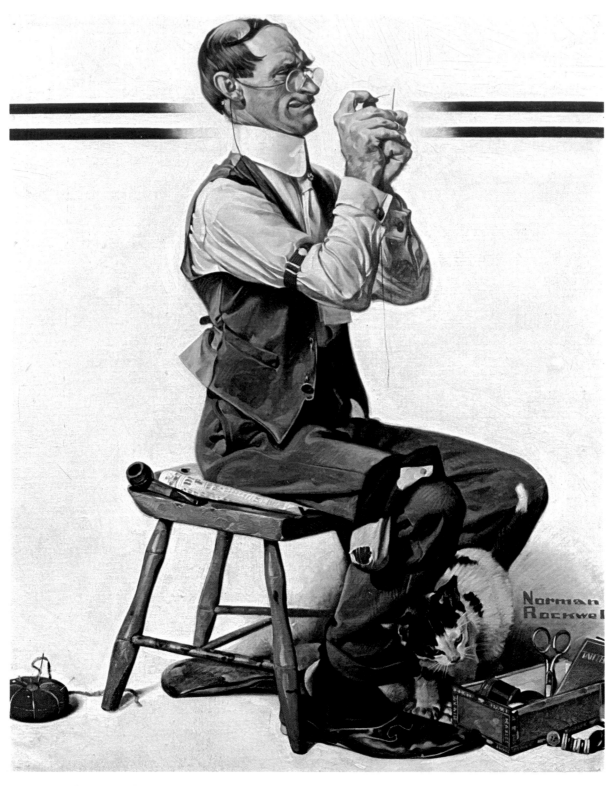

Man Threading a Needle. Oil painting for *Post* cover, April 8, 1922.
Collection Interwoven Socks, New York

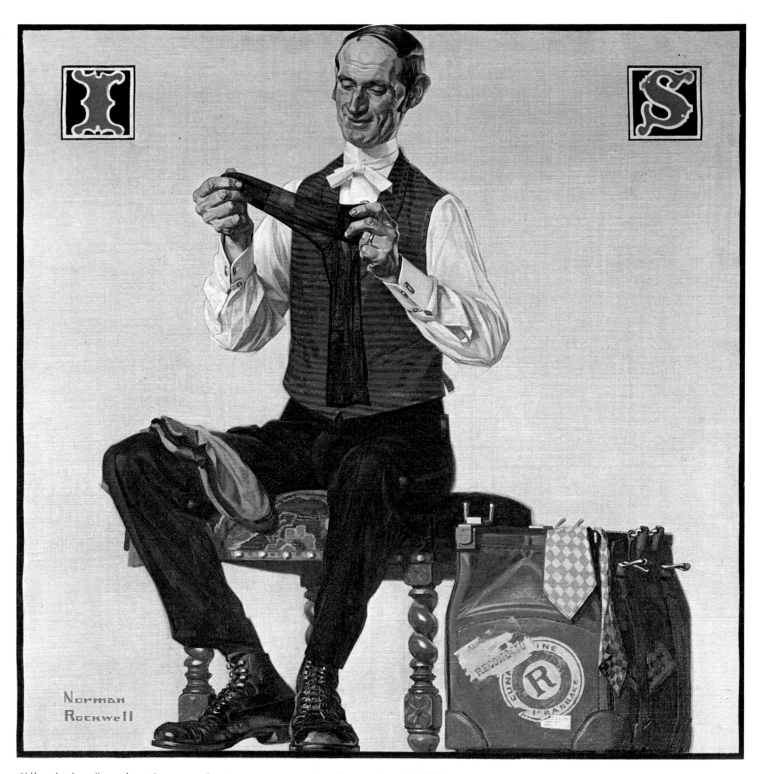

Oil painting for advertisement for Interwoven socks, September 9, 1922

Bully Before. *Country Gentleman*
cover, June 4, 1921. © 1949,
The Curtis Publishing Company

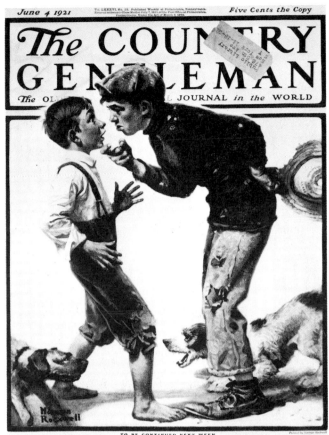

The COUNTRY GENTLEMAN

The OLDEST AGRICULTURAL JOURNAL *in the* WORLD

TO BE CONTINUED NEXT WEEK

What is a Farm Wife Worth? — By Freeman Tilden

Bully After. *Country Gentleman*
cover, June 11, 1921. © 1949,
The Curtis Publishing Company

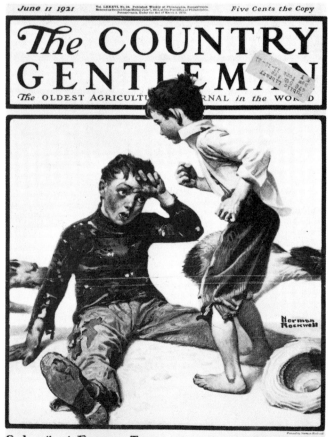

The COUNTRY GENTLEMAN

The OLDEST AGRICULTURAL JOURNAL *in the* WORLD

Salvaging Frozen Trees — By Benjamin Wallace Douglass

Merrie Christmas. *Post* cover,
December 3, 1921. © 1949,
The Curtis Publishing Company

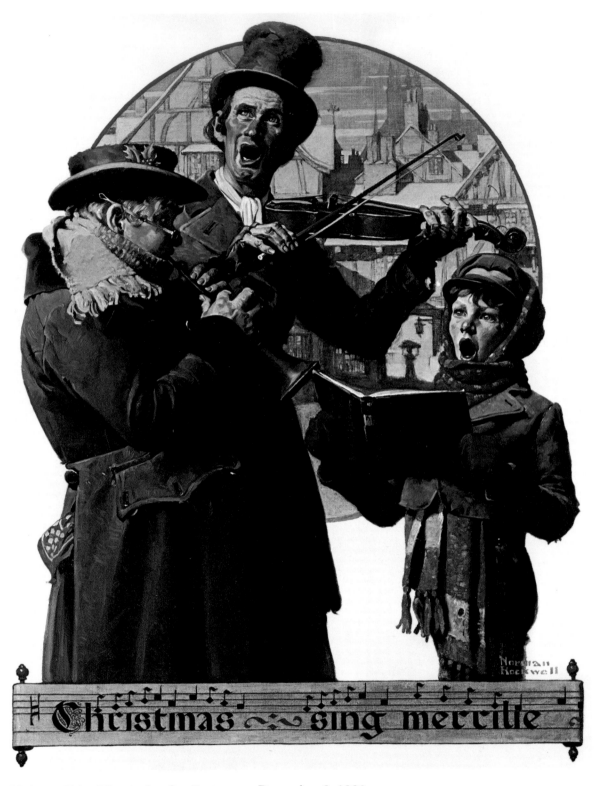

Christmas Trio. Oil painting for *Post* cover, December 8, 1923.
Collection Norman Rockwell

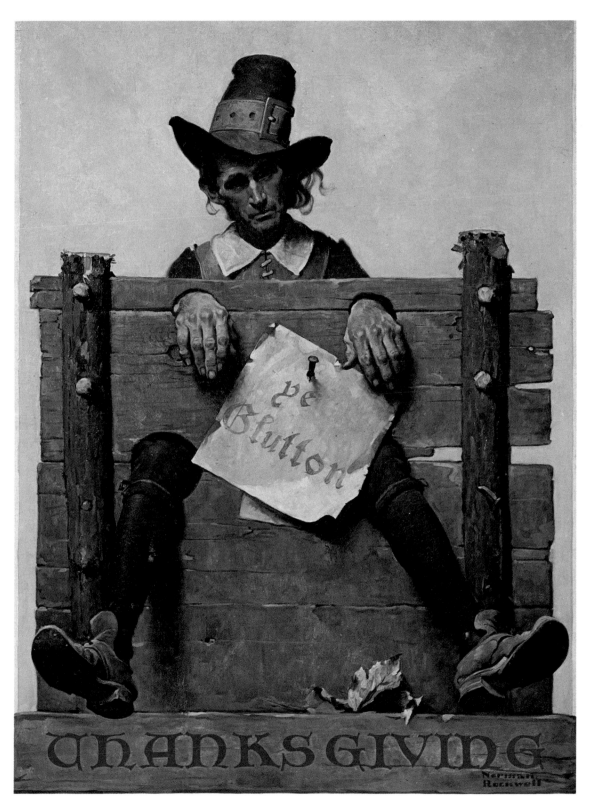

Thanksgiving (The Glutton). Oil painting for *Life* cover,
November 22, 1923. Private collection, New York

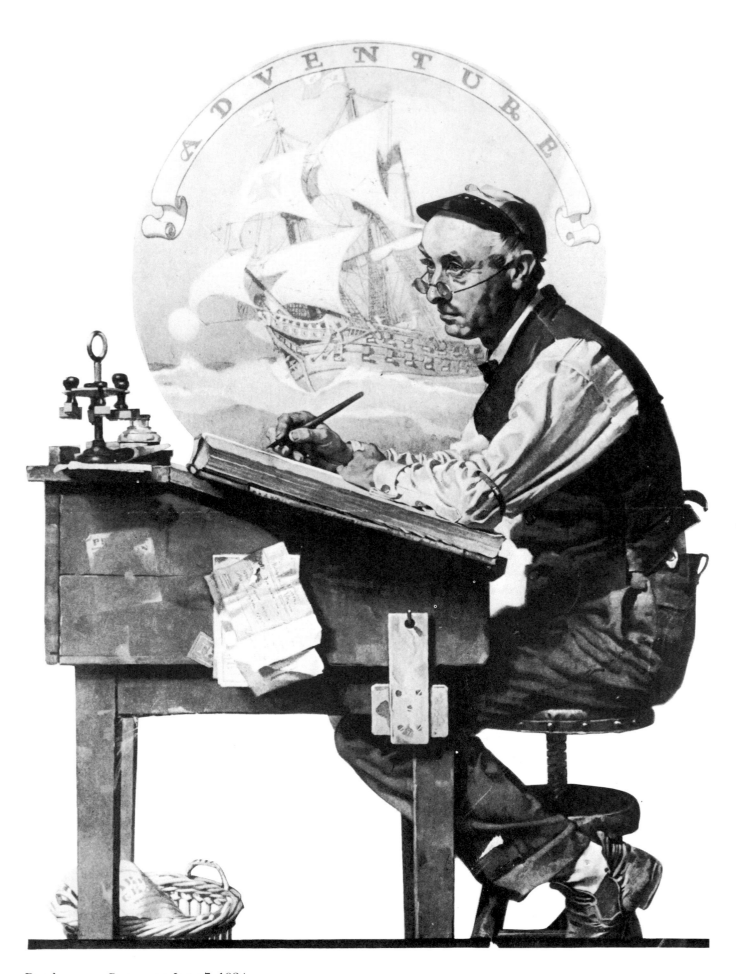

Daydreamer. *Post* cover, June 7, 1924

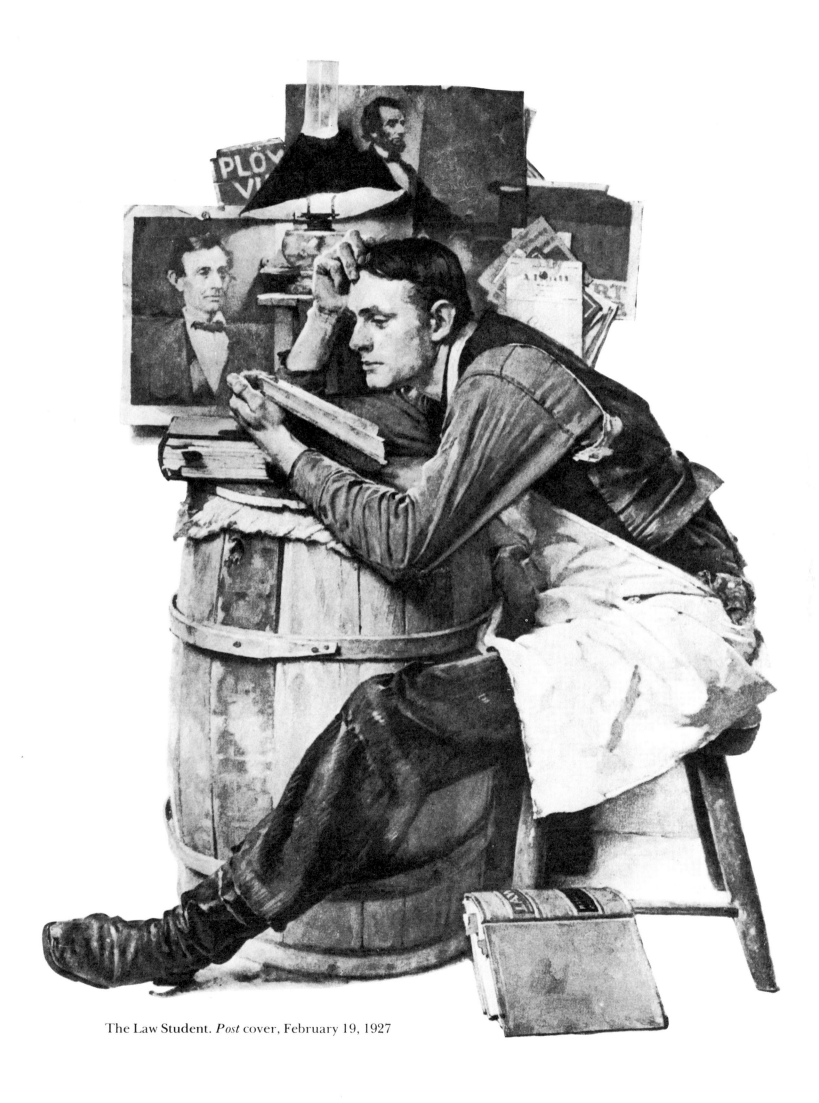

The Law Student. *Post* cover, February 19, 1927

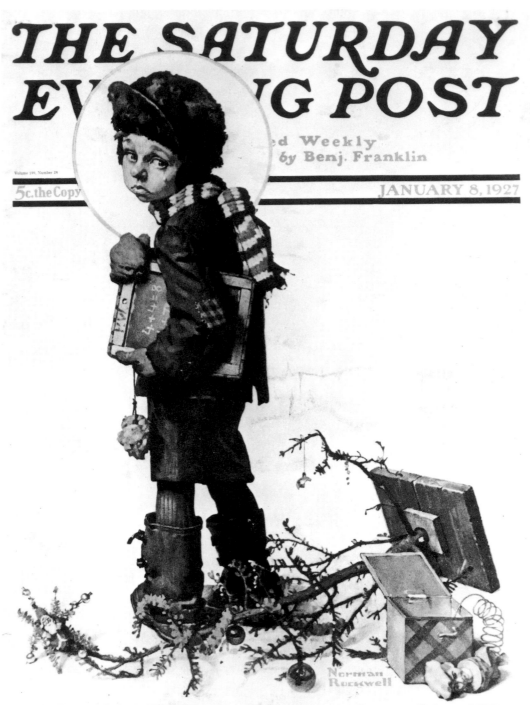

Post cover, January 8, 1927

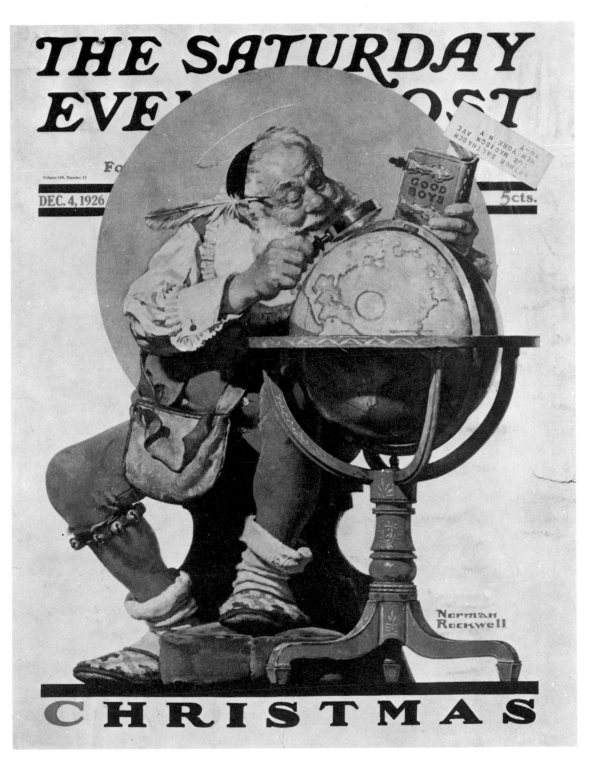

Post cover, December 4, 1926.
© 1954, The Curtis Publishing Company

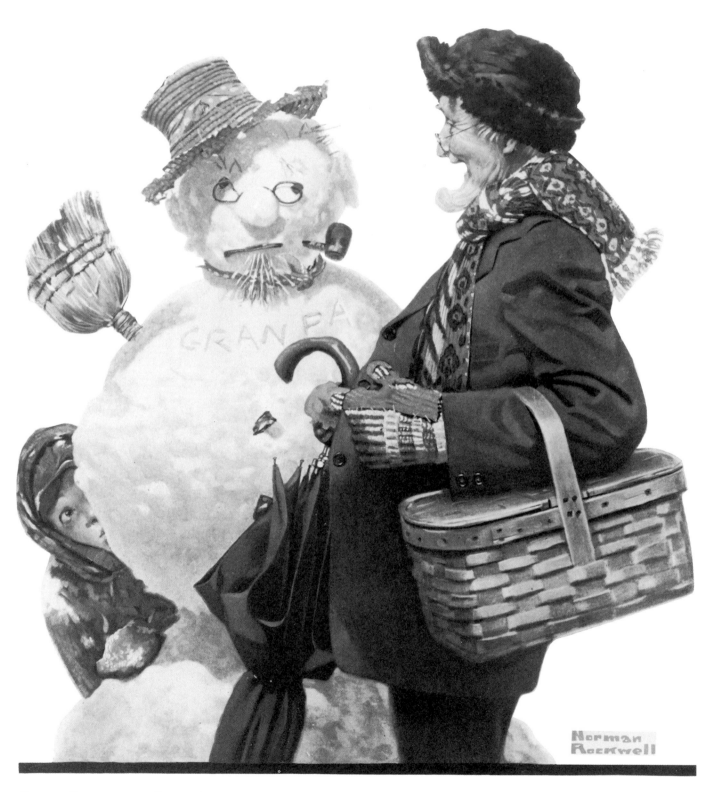

Gramps Encounters—Gramps? *Post* cover, December 20, 1919

Christmas. *Country Gentleman* cover, December 18, 1920

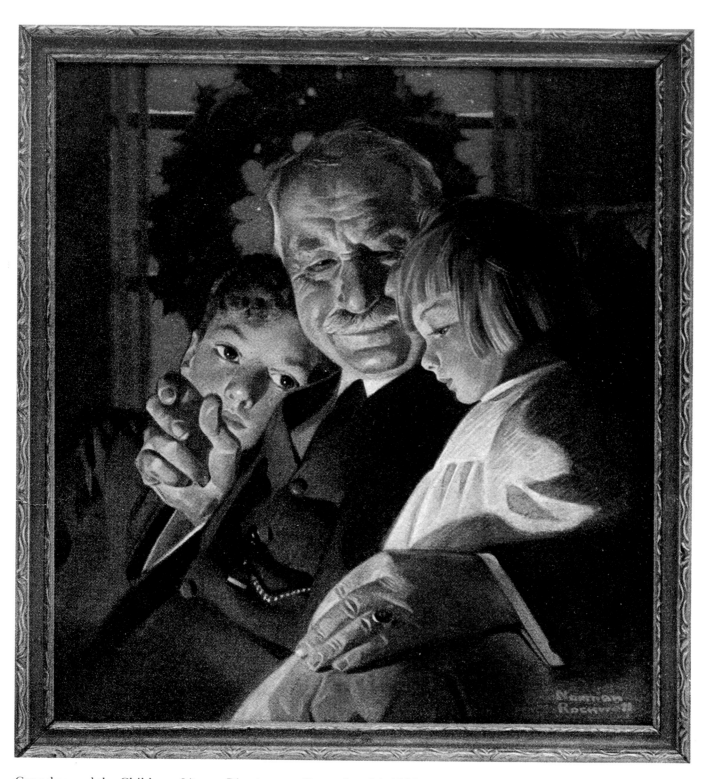

Grandpa and the Children. *Literary Digest* cover, December 24, 1921

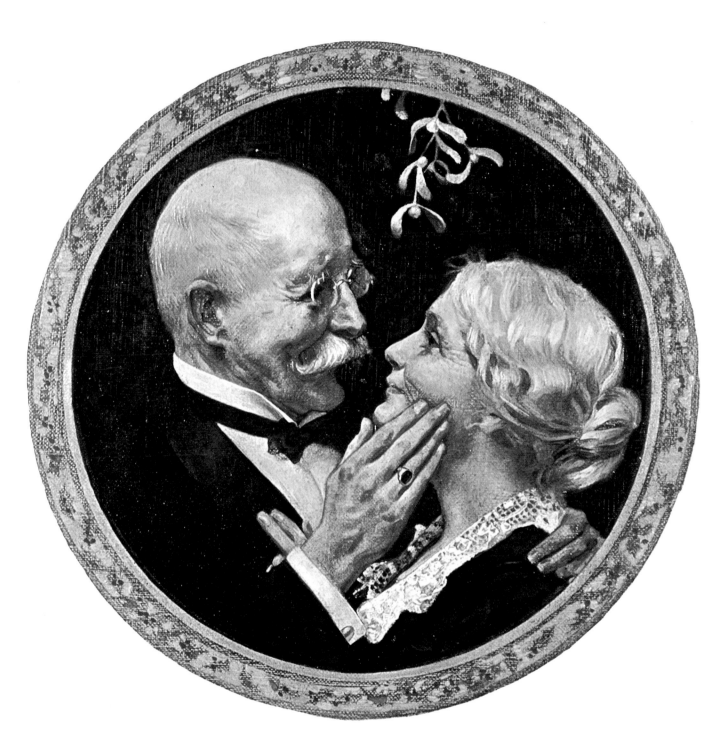

Under the Mistletoe. 1924. Oil painting.
Collection Patricia and Howard O'Connor

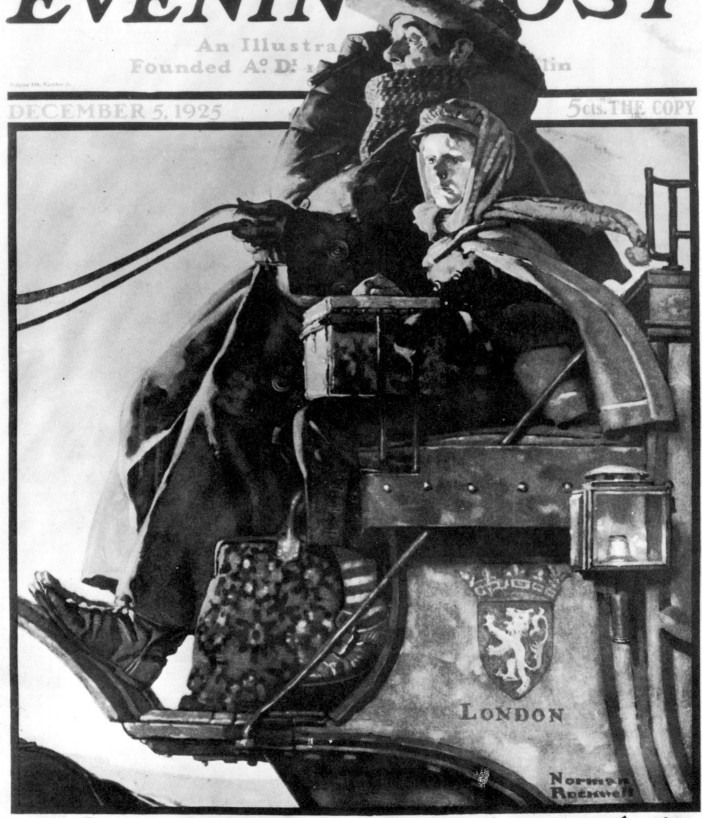

THE SATURDAY EVENING POST

An Illustra
Founded A.º D.ª 1

Volume 198, Number 26

DECEMBER 5, 1925

5 cts. THE COPY

LONDON

Norman Rockwell

Merrie Christmas

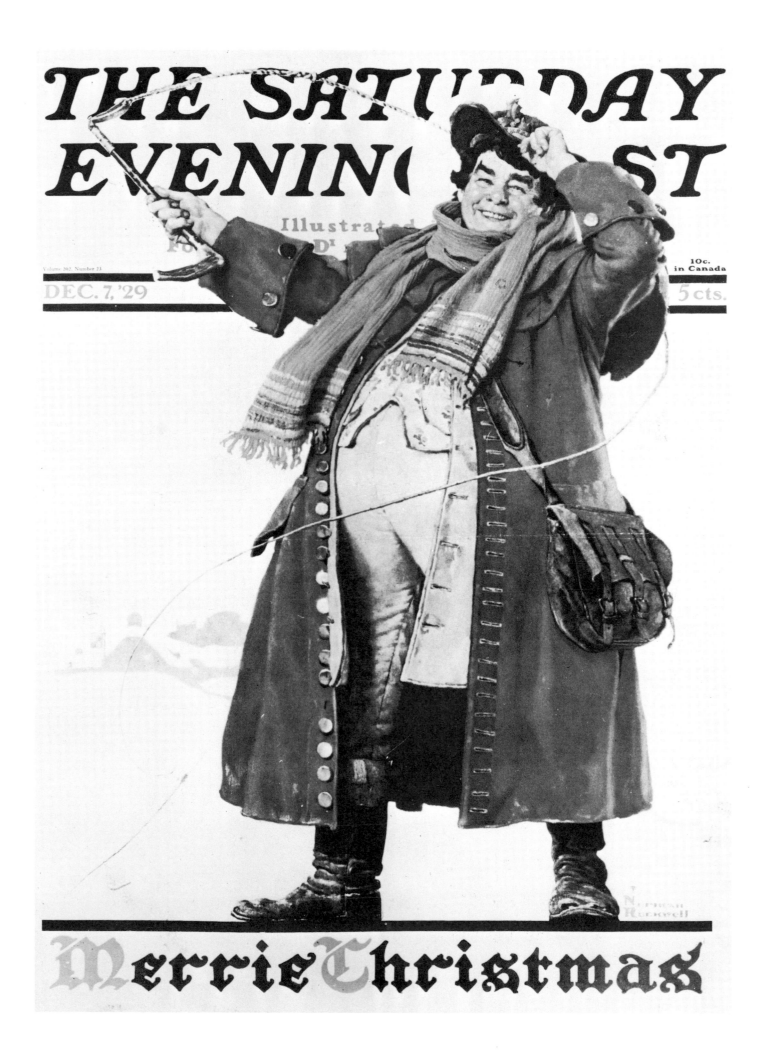

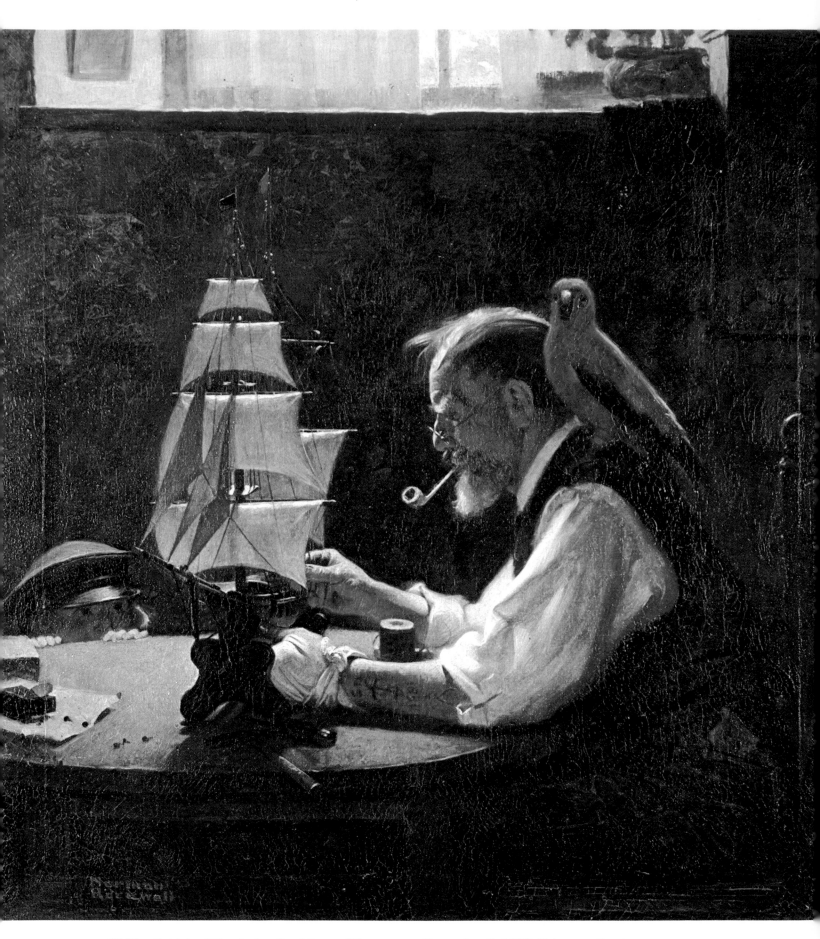

Old Sea Captain. Oil painting for *Literary Digest* cover, December 2, 1922. Private collection

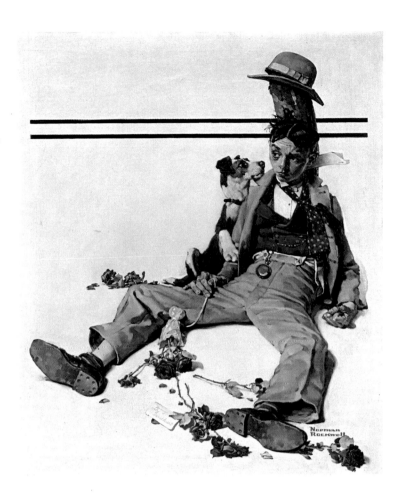

In Need of Sympathy.
Oil painting for *Post* cover,
October 2, 1926.
Collection E. A. Elder

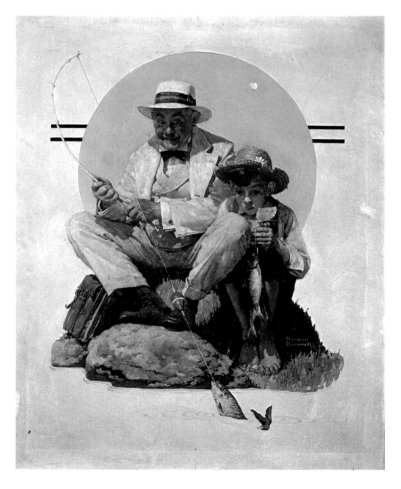

Catching the Big One.
Oil painting for *Post* cover,
August 3, 1929. Private collection

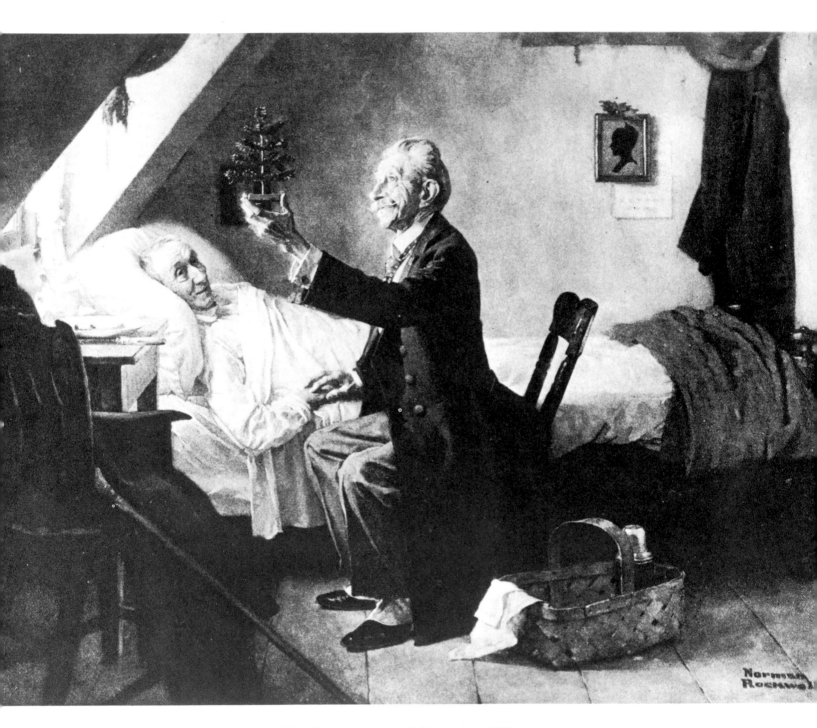

Illustration for "A Christmas Reunion." *Ladies' Home Journal*, December 1927

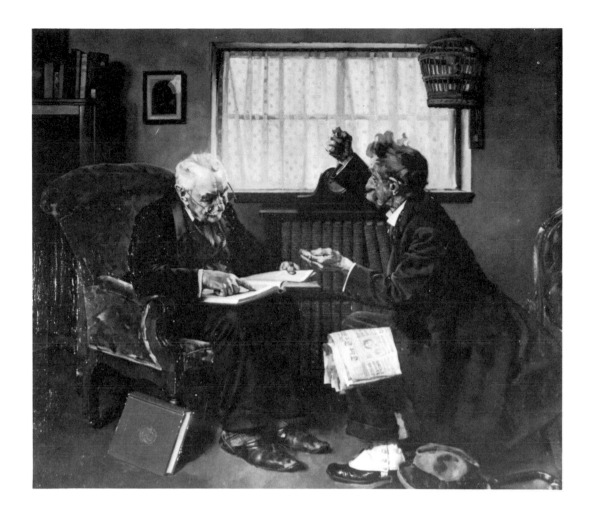

Advertisement for the
Encyclopaedia Britannica

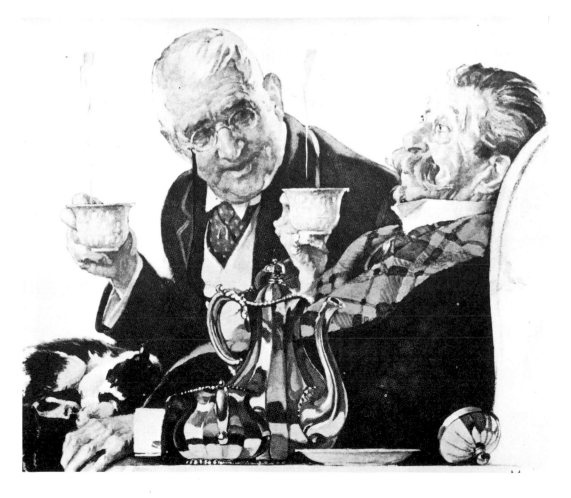

Advertisement for
Maxwell House coffee

63

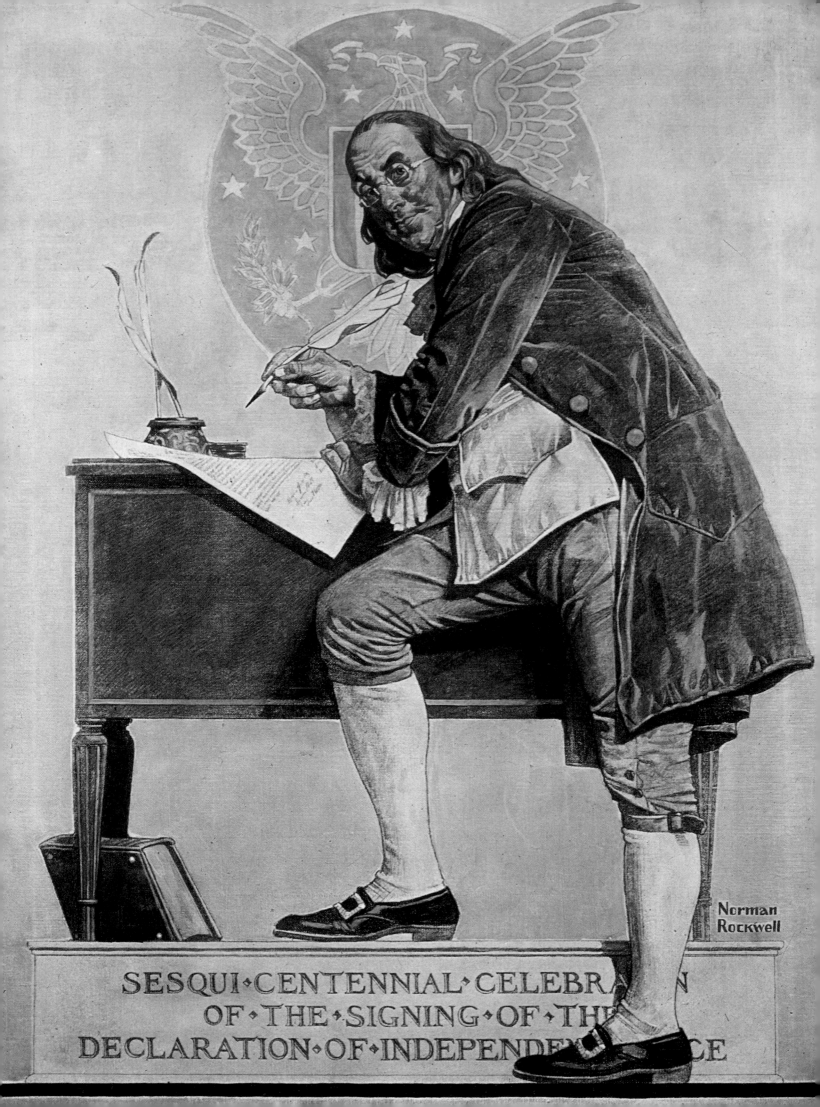

SESQUI·CENTENNIAL·CELEBRATION
OF·THE·SIGNING·OF·THE
DECLARATION·OF·INDEPENDENCE

Uncle Sam. Oil painting for *Post* cover, January 21, 1928. Collection Paul C. Wilmot

Ben Franklin's Sesqui-Centennial. Oil painting for *Post*
cover, May 29, 1926. Collection Mr. and Mrs. Joseph H.
Hennage

65

Advertisement for Massachusetts Mutual
Life Insurance Company

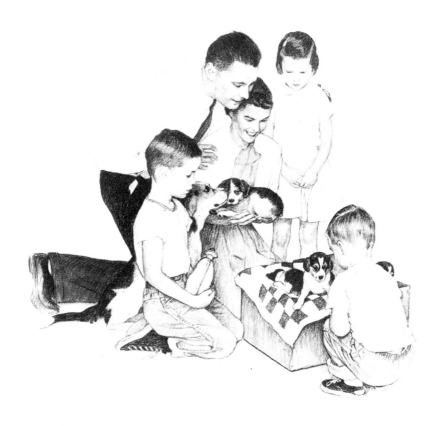

Advertisements for
Massachusetts Mutual Life
Insurance Company

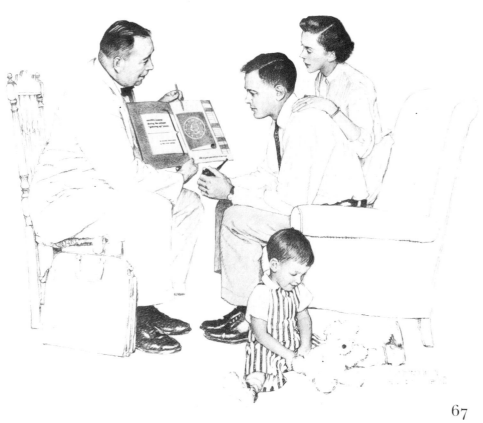

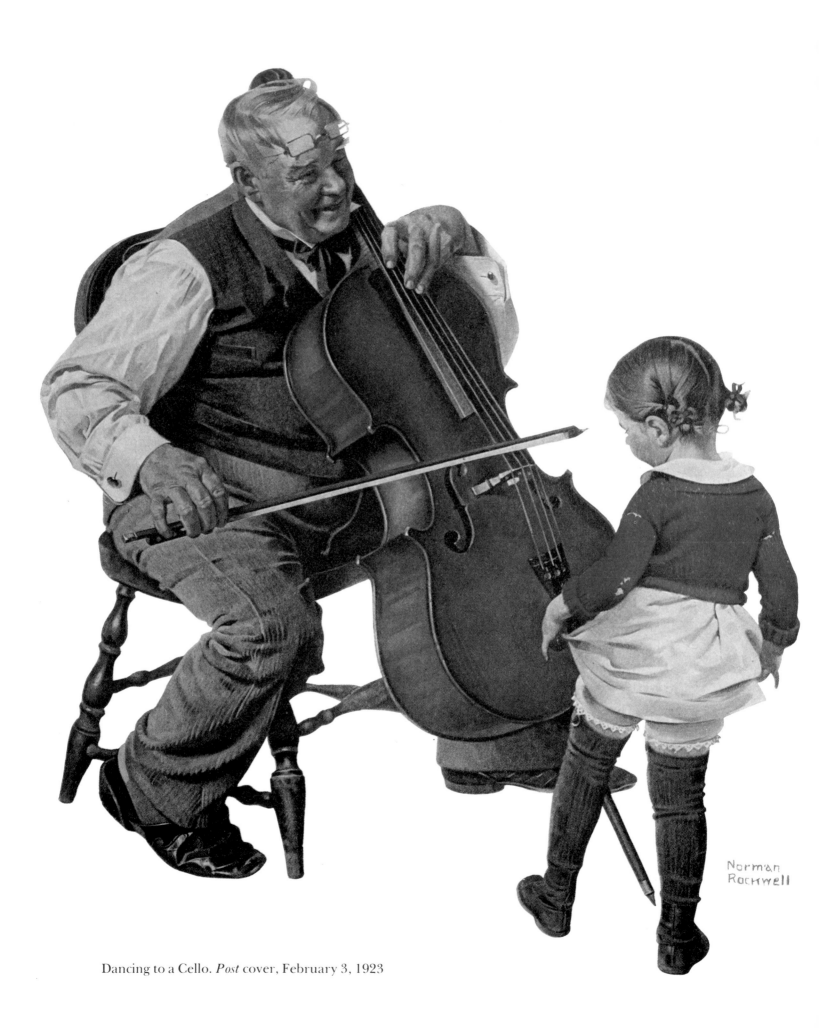

Dancing to a Cello. *Post* cover, February 3, 1923

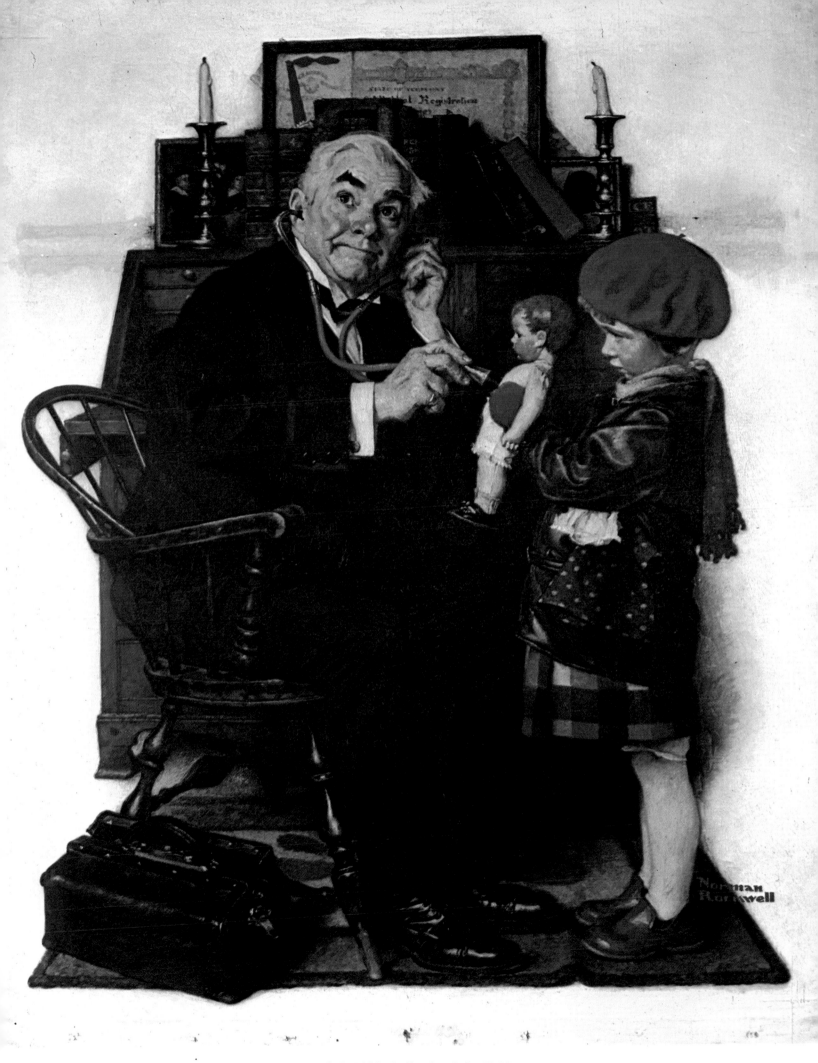

Doctor and Doll. Oil painting for *Post* cover, March 9, 1929. Collection John E. Newman

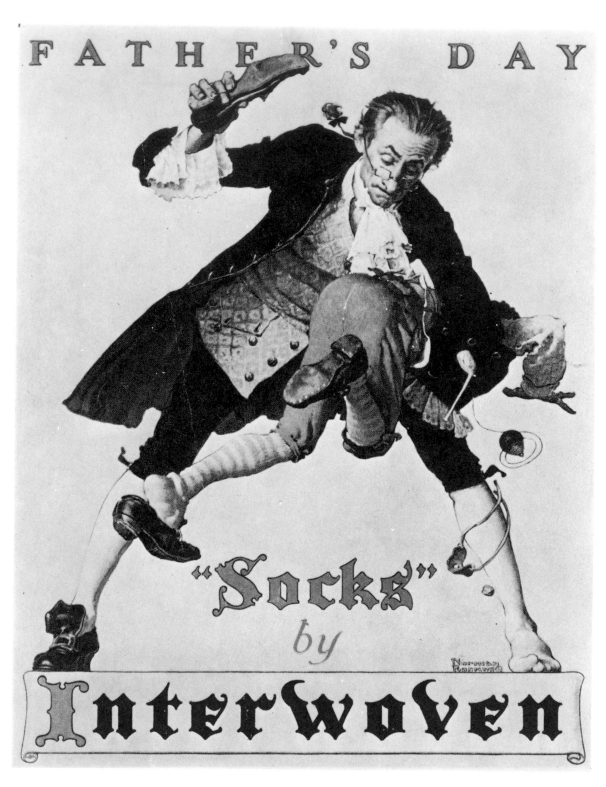

Advertisement for Interwoven socks

A Pilgrim's Progress. *Life*
cover, November 17, 1921

THANKSGIVING

Life

NOVEMBER 17, 1921

PRICE 15 CENTS

A PILGRIM'S PROGRESS

Norman Rockwell

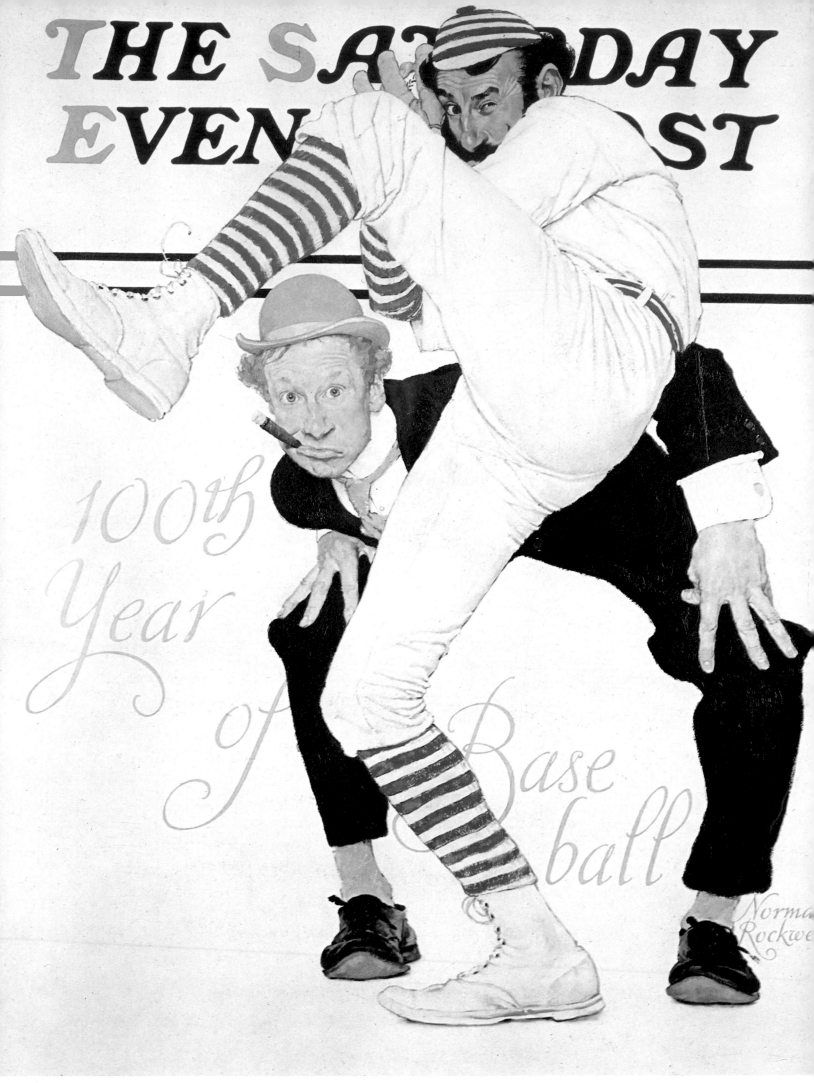

THE SATURDAY EVENING POST

100th Year of Baseball

Norman Rockwell

1930 - 1945

Norman Rockwell began painting from photographs, returned to illustration, married, and had three sons. From a miserable bachelorhood at the Hotel des Artistes at Sixty-seventh Street near Central Park West following his divorce, he fled to Los Angeles to escape the art editor of *Good Housekeeping,* who insisted he illustrate the life of Christ. There he painted Gary Cooper for the May 24, 1930, cover of the *Post* and married Mary Barstow. Back in New Rochelle, at 24 Lord Kitchener Road, he began to have trouble with his work. Waning self-confidence, indecision, and procrastination reduced both the quality and quantity of his output. He experimented with dynamic symmetry, had another modern art approach rejected, and, in real desperation, left his own charming world for the sordid and ugly: he painted a dead gangster — never published and now lost. In 1932, the Rockwells went to Paris with their newly born first son, Jerry. Only three *Post* covers of his appeared that year; the one for January 30 appropriately depicts a French gendarme.

The turning point was 1935. Almost as if he had been saving up for it, Rockwell suddenly began to pour out some of the finest work he had done: illustrations for *Tom Sawyer,* *Huckleberry Finn,* and the life of Louisa May Alcott, the Yankee Doodle mural for the Nassau Tavern in Princeton, and a superb series of magazine illustrations. The *Post* covers done between 1936 and 1939 include some of his very best work.

The howling infant on the October 24, 1936, cover of the *Post* reflects Rockwell's experience with that subject: Tommy was born in 1933, Peter in 1936. For purposes of authenticity (if not escape) he traveled whenever possible to the actual site where the story he was to illustrate took place. The whole family traveled to England in 1938, and Rockwell met some of his famous colleagues — Arthur Rackham among them. Twenty-three years earlier, Rockwell had illustrated *The Magic Football* for *St. Nicholas* magazine; Rackham had done the frontispiece for the same issue.

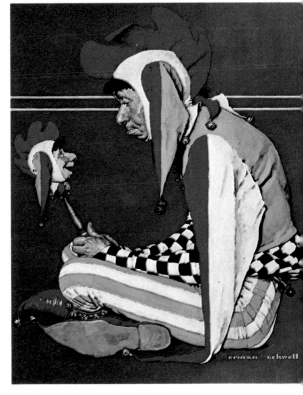

Jester. Oil painting for *Post* cover, February 11, 1939. Collection Mrs. G. A. Godwin

opposite page:
100th Year of Baseball. Oil painting for *Post* cover, July 8, 1939. National Baseball Hall of Fame and Museum, Inc., Cooperstown, N.Y.

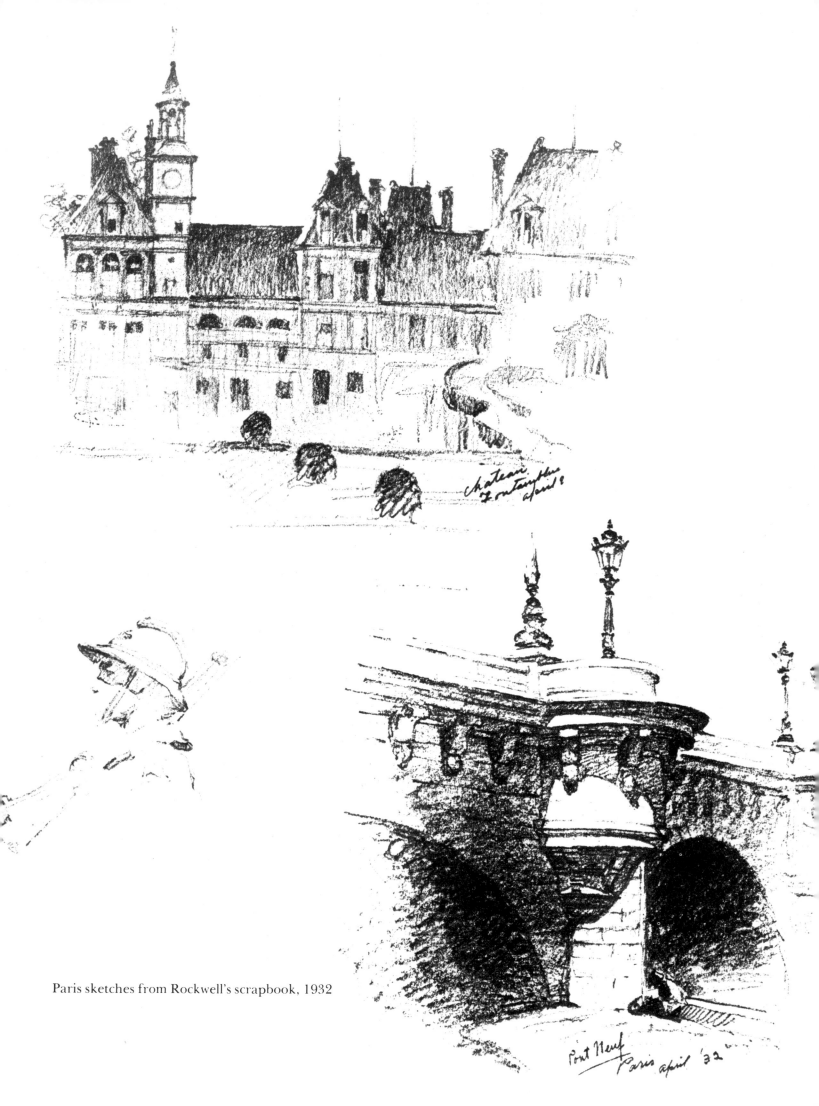

Paris sketches from Rockwell's scrapbook, 1932

Paris sketch from Rockwell's scrapbook, 1932

Bridge over the Seine. Watercolor sketch from Rockwell's scrapbook, 1932

During all that period — from *Don Strong of the Wolf Patrol* to the Nassau Tavern mural — Rockwell had lived in New Rochelle. In 1939 the family moved to Arlington, Vermont.

The two major factors affecting Rockwell's work of the thirties were a new interest in illustrating other people's stories and a final surrender to the convenience of the camera. The photographer started to help about 1937, but illustrations were painted both from living models and from photographs. There is an important but hard-to-define difference. Those painted from photographically supplied information are generally more realistic; forms look flatter, they do not have the same sense of bulk, and, in the beginning at least, the details contribute little to the quality of the design; individual items become less important, and the eye wanders more freely over the surface. The covers painted immediately after January, 1937 — with some exceptions — are softer in their graphic impact than any of those done before. The camera also made new angles possible; the viewer looks down on the policeman painting the street line on the October 2, 1937, cover. If Rockwell found himself too dependent on his photographs at first, he

got over it very quickly. The *100th Anniversary of Baseball* cover would be hard to beat for caricature, design, and graphic impact. It is not easy — perhaps it is impossible — to tell the difference between paintings from life and paintings from photographs. On the other hand, Rockwell's work is considered by many to be too photographic. Was that criticism made before 1937 when he was painting directly from the model? Or did he become "too photographic" in the course of working from photographs?

Although he began as an illustrator, assignments for cover designs and commissions for advertisements left little time for less glamorous and less well-paid story illustration. The revival of his interest came in 1935 with the commission to do eight color paintings for a deluxe edition of *Tom Sawyer* and another eight for *Huckleberry Finn,* to be published by Heritage Press. The right job at the right time — twenty years of experience painting barefoot boys, the opportunity to join the grand tradition of illustrating classics, and a welcome change from thinking up his own stories. The results are remarkable. The paintings are free and spontaneous; each has an immediacy about it as if the viewer were there. The picture of Huck finding his father in his room conveys the kind of terror Twain's words evoke — and introduces Rockwell's ability to build dramatic atmosphere.

Norman Rockwell took on World War II as if he had discovered it. Twenty-four years earlier he had pictured America's fighting men as Boy Scouts on bivouac — sewing on buttons, thinking of Mom, and singing "Over There." Now he saw soldiers and sailors as civilians in uniform — and the war itself as everybody's fight. It began innocently enough with Willie Gillis, a quiet little guy who got caught in the first draft (before Pearl Harbor) and turned up on the cover of the *Post* as a G. I. with a food parcel and hungry friends. Before Willie had a chance to battle his way through USO hospitality, Rockwell's war got serious: *Let's Give Him Enough and on Time* appeared below a painting of a machine gunner who was neither humorous nor quaint. His commitment escalating, Rockwell conceived the idea of explaining through pictures what the war was all about. The Four Freedoms were the result. Millions of copies were printed and distributed by the government and private agencies all over the world; the Treasury Department toured the four originals to sixteen cities where they were seen by 1,222,000 people and used in selling $132,999,537 worth of war bonds. For many Americans World War II

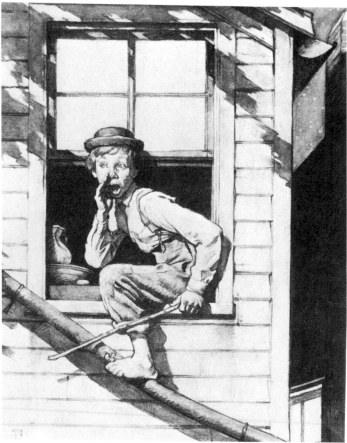
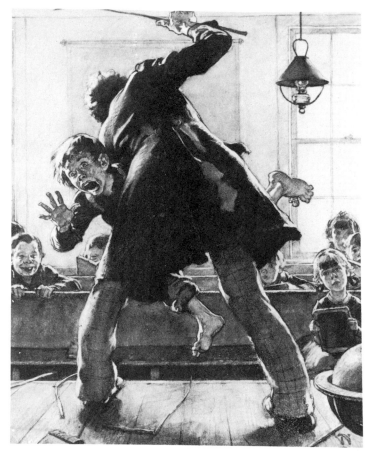

Illustrations for *The Adventures of Tom Sawyer* by Mark Twain, 1936, 1964.
© The George Macy Companies, Inc.

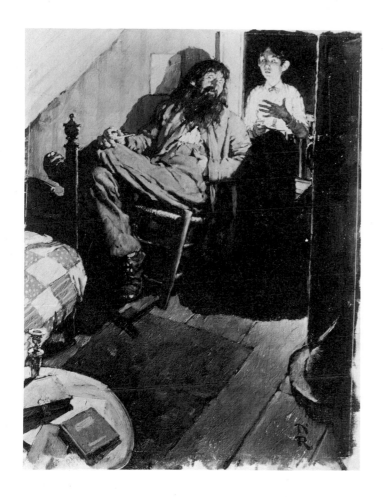
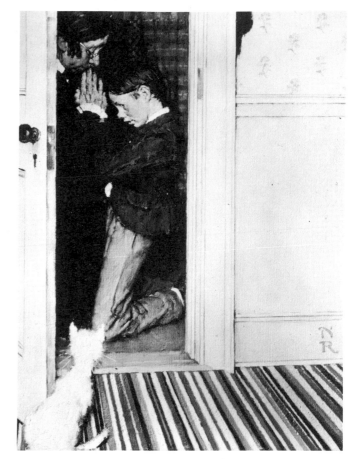
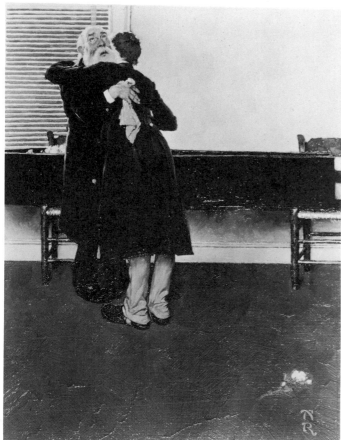
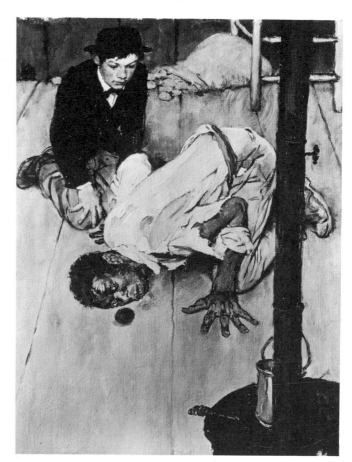

Illustrations for *The Adventures of Huckleberry Finn* by Mark Twain, 1940, 1968.
© The George Macy Companies, Inc.

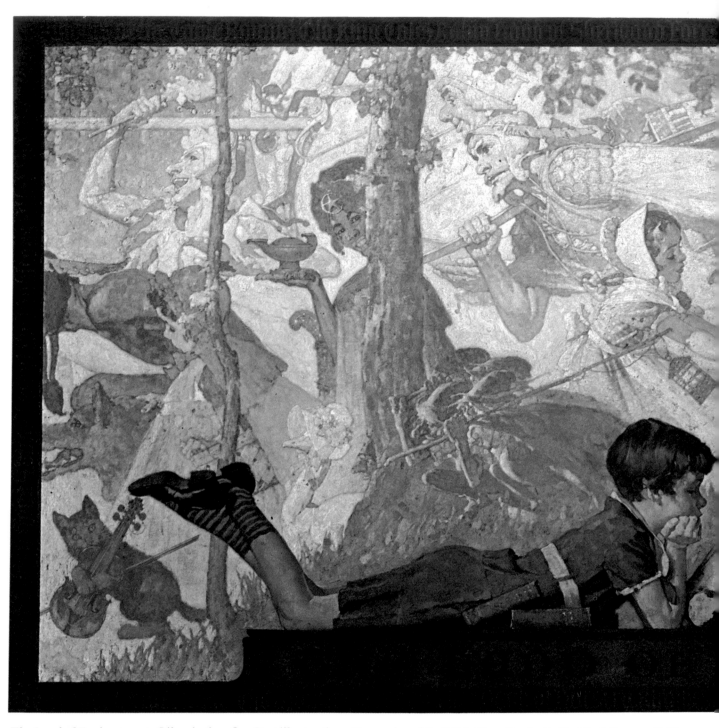

The Land of Enchantment. Oil painting for *Post* illustration, December 22, 1934. New Rochelle Public Library, N.Y.

made sense because of the goals depicted in the Four Freedoms. Having explained what America wanted in the most serious of terms, Rockwell proceeded with the adventures of Willie Gillis, the soldier who never fought, and other lighthearted tales. But the departure from reassuring entertainment had been made and was made again: one cover dealt with being wounded, another with

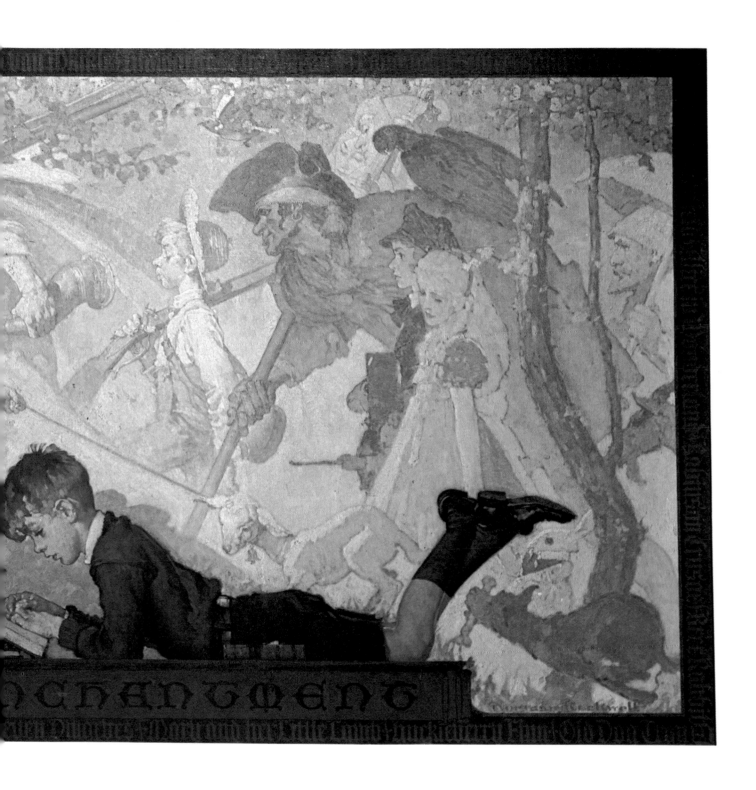

bombing—and the person kneeling in the ruins was not even an American! Rockwell extended his fight through posters and calendars and ads. Time devoted so successfully to doing illustration in recent years was assigned to pictorial reporting, the nonfiction phase of storytelling. Photographer in tow and sketchbook in hand, Rockwell visited the President, rode a troop train, and stood before his

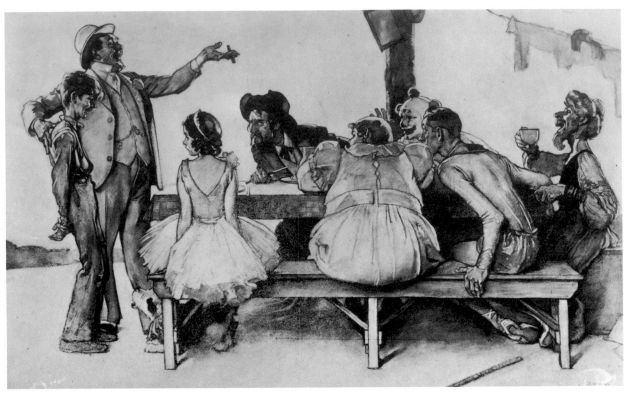

Charcoal drawing for "Willie Takes a Step" by Don Marquis. *American Magazine*, January 1935. Collection Mr. and Mrs. Carl Wulff

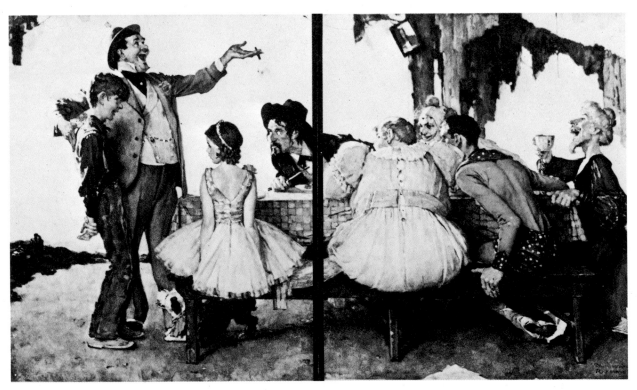

Final illustration for "Willie Takes a Step" by Don Marquis. *American Magazine*, January 1935. Whereabouts unknown

ration board, all of which appeared within the *Saturday Evening Post*. The simplest measure of his involvement is that twenty-five of the thirty-three covers done during this period relate to the war; twenty-four years earlier only four out of eighteen did. G. I. Joe was one of Rockwell's great subjects; on the cover of the *Post* his homecoming was recorded seven times.

A personal and professional disaster occurred in 1943, just after the Four Freedoms were completed: Rockwell's studio near Arlington burned to the ground. From his point of view it was the loss of twenty-eight years of accumulated props, costumes, materials, and equipment—no more period pieces; from ours it was the loss of an unrecorded number of original paintings and his files of clippings. Today nobody has more than a vague idea of the extent of his work. There are no records.

overleaf:
Steamboat Race on the Connecticut River. 1930s. Oil painting. Whereabouts unknown

Barbershop Quartet. Sketch for *Post* cover, September 26, 1936. Collection Arts International Ltd., Chicago

Barbershop Quartet. Oil painting for *Post* cover, September 26, 1936. Collection Mr. and Mrs. J. William Holland

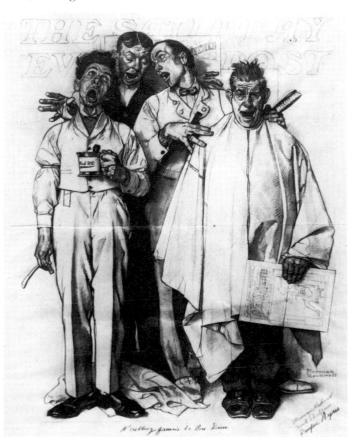

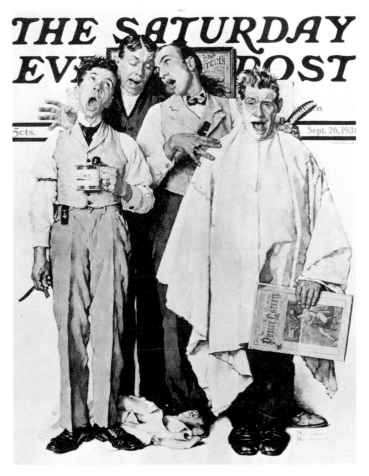

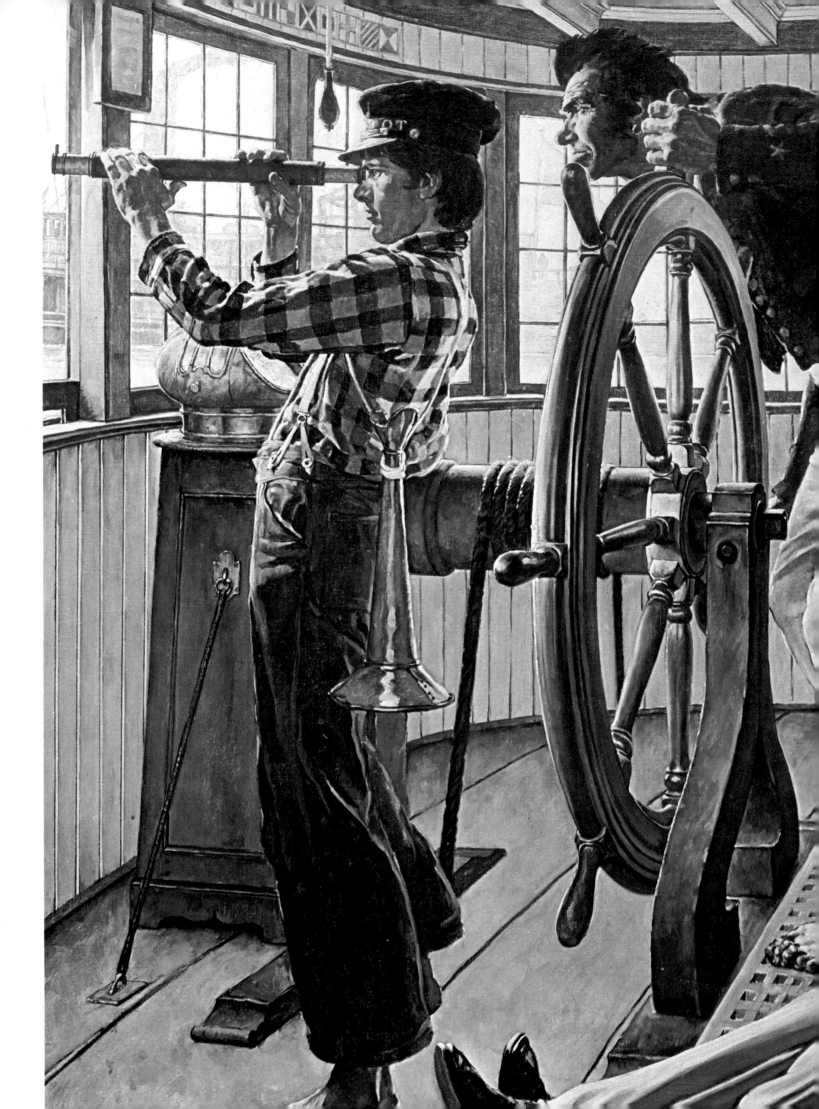

Norman
Rockwell

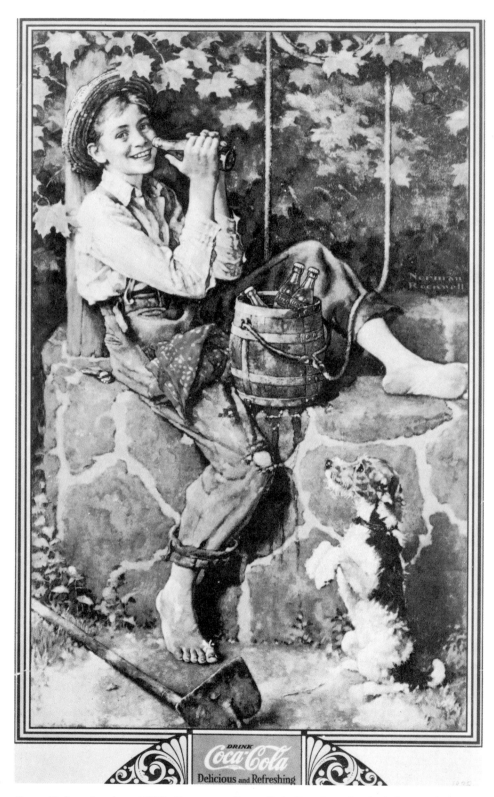

Coca-Cola calendar, 1932. Courtesy Coca-Cola Bottlers, Inc., Atlanta, Ga.

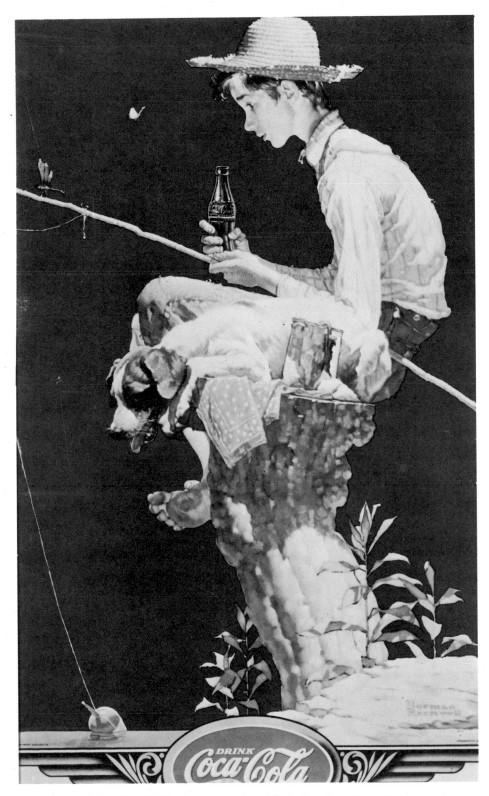

Coca-Cola calendar, 1935. Courtesy Coca-Cola Bottlers, Inc., Atlanta, Ga.

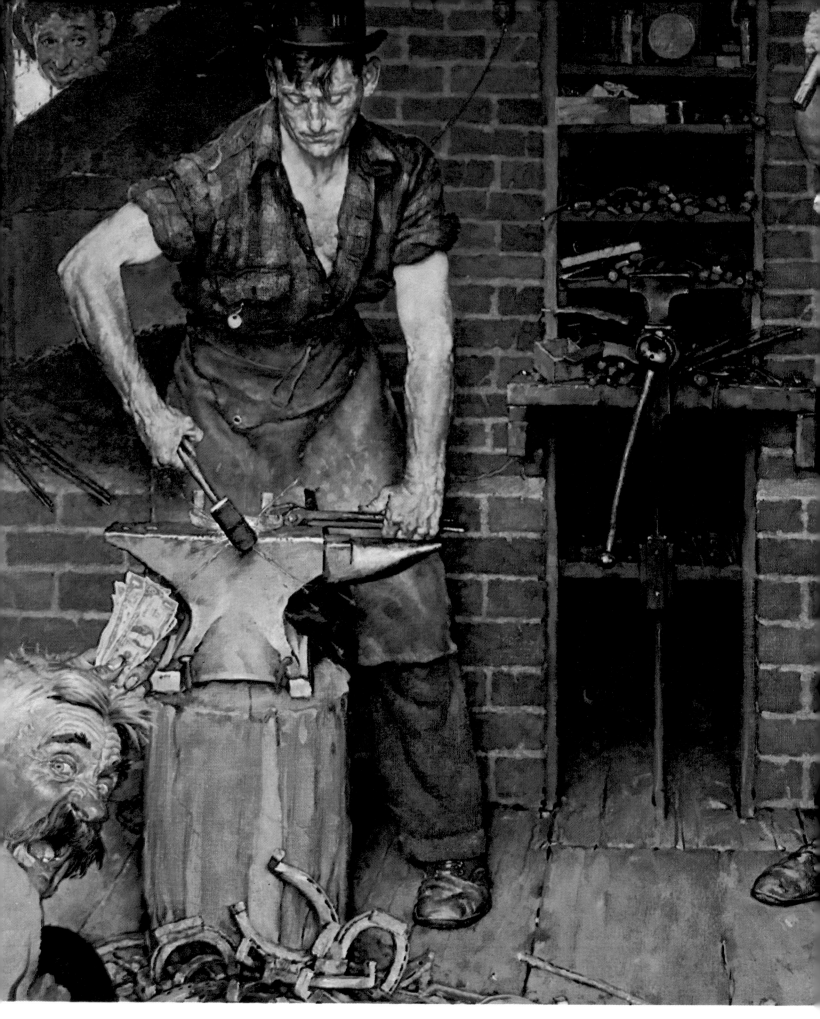

The Horseshoe Forging Contest. Oil painting for illustration for "Blacksmith's Boy—Heel and Toe"
by Edward W. O'Brien. *Post,* November 2, 1940. Collection Norman Rockwell

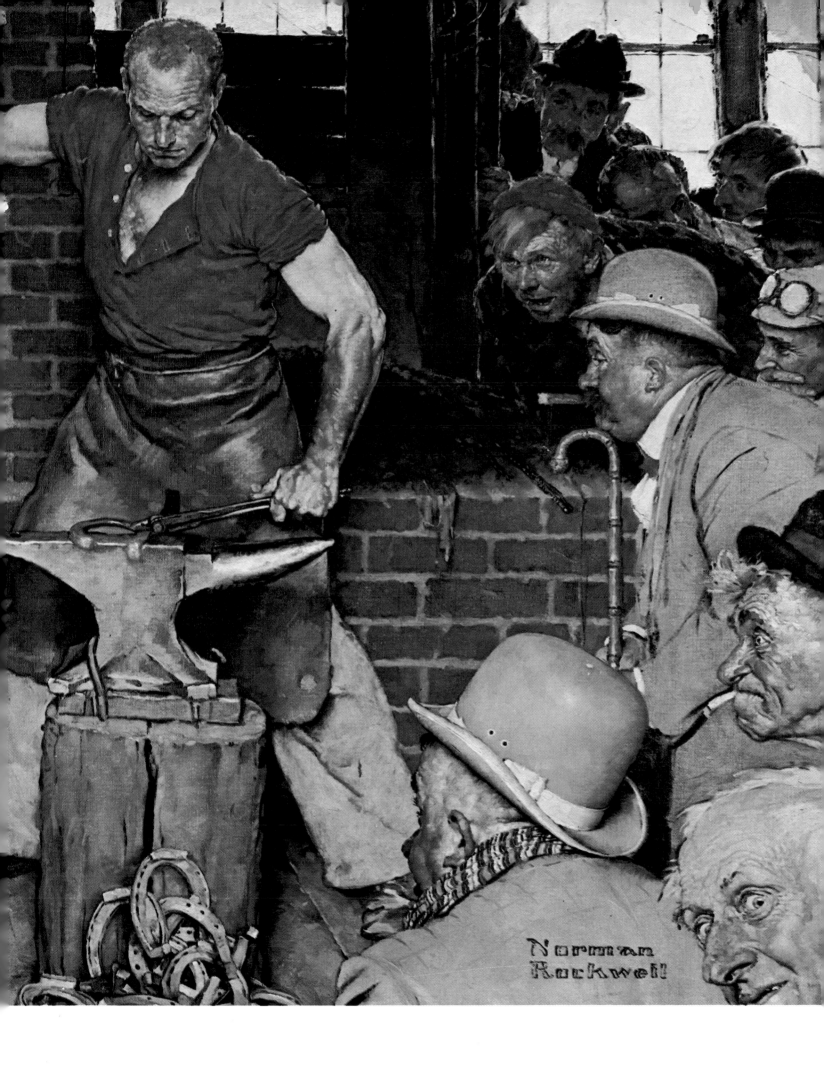

The Blacksmith's Shop. *Post* illustration, November 2, 1940

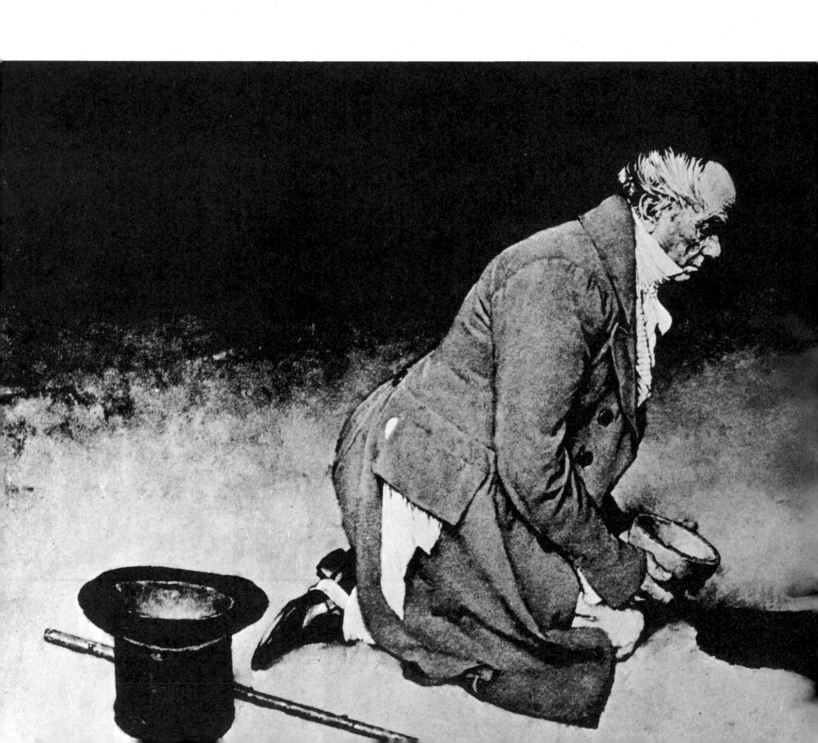

Illustration for "Daniel Webster and The Ides of March" by Stephen Vincent Benét. *Post,* October 28, 1939

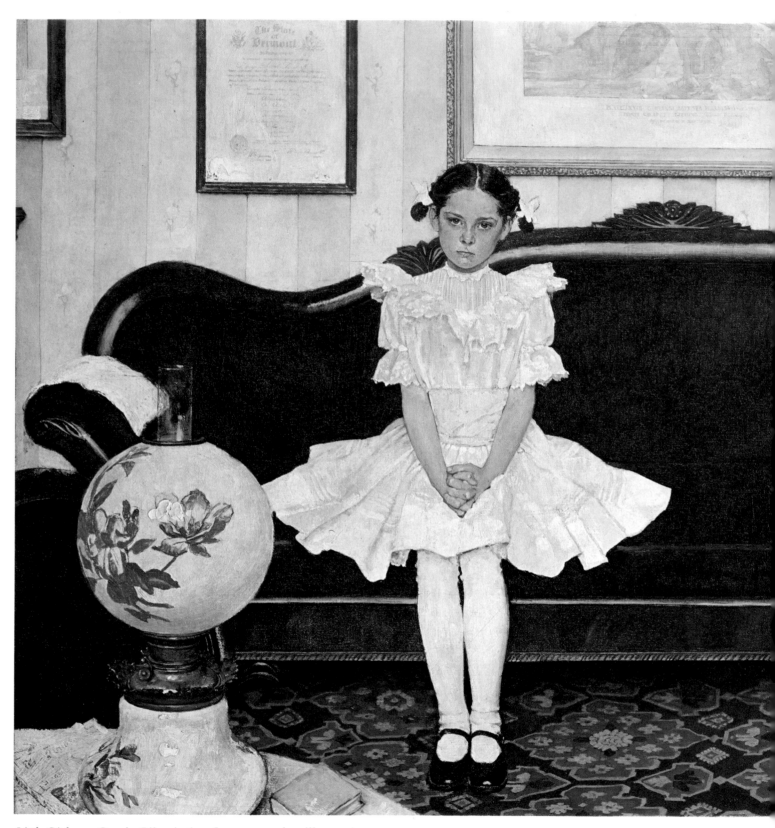

Little Girl on a Couch. Oil painting for a magazine illustration

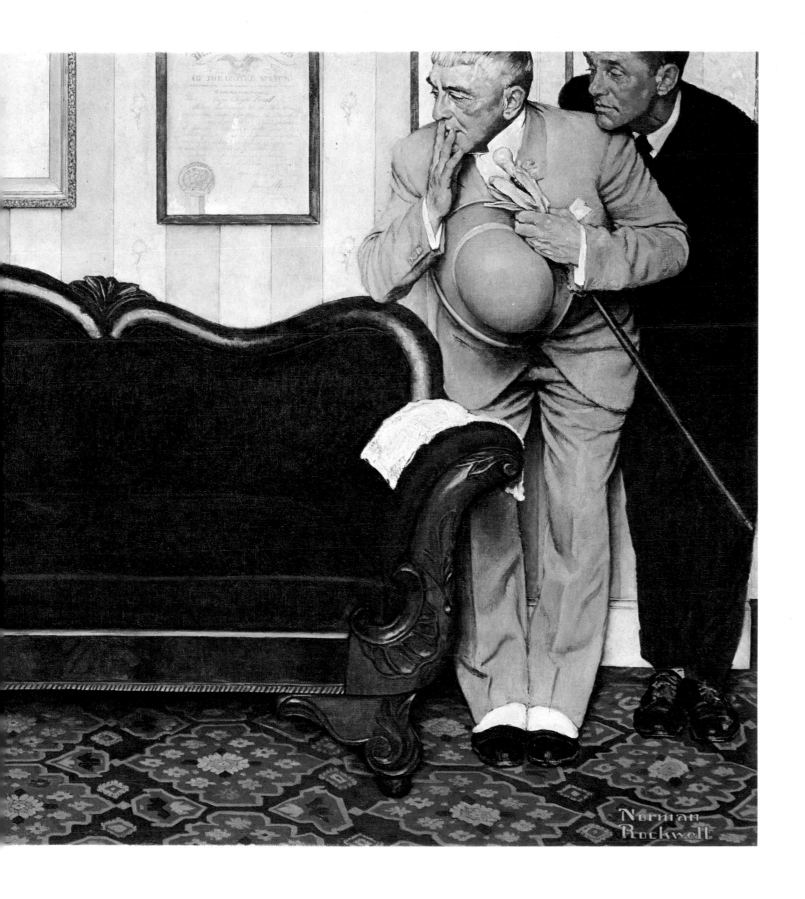

Illustration for "Louisa May Alcott: Most Beloved American Writer" by Katharine Anthony.
Woman's Home Companion, December 1937–March 1938

His teaching embraced everything, from how to sit in the little chair he bought her to how to tell good from evil

Illustration for "Louisa May Alcott: Most Beloved American Writer" by Katharine Anthony. *Woman's Home Companion,* December 1937–March 1938

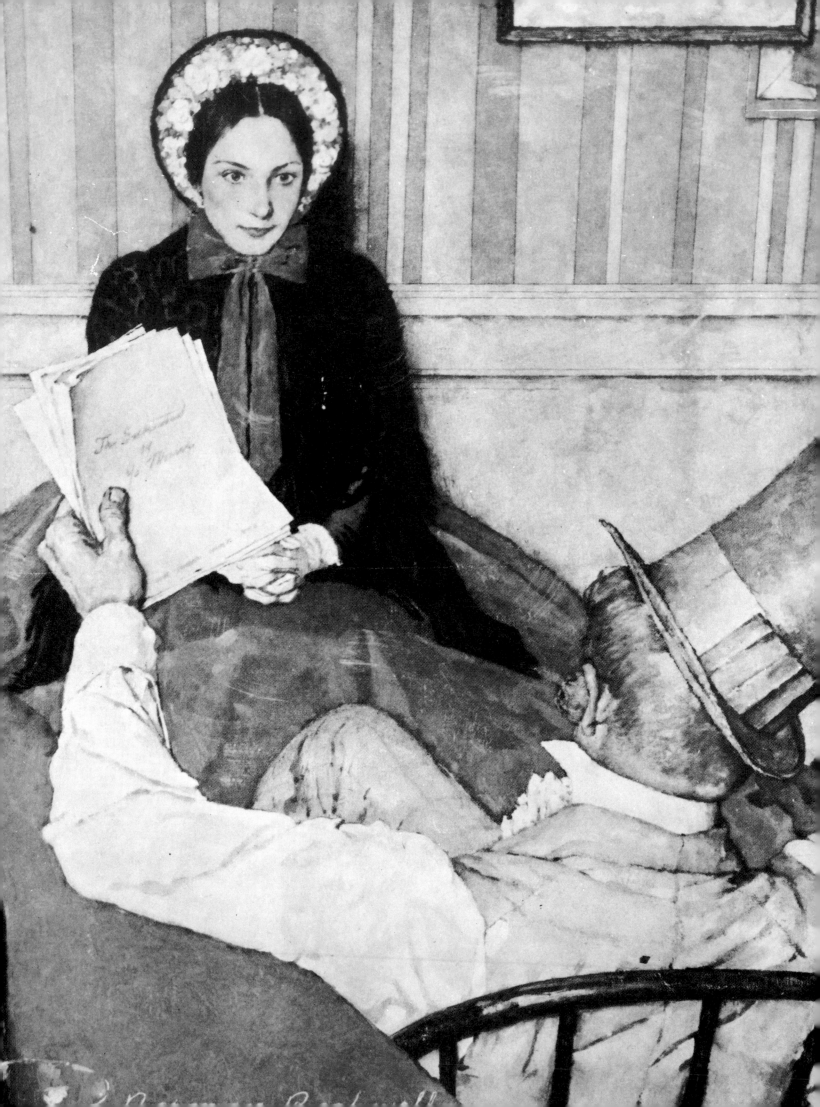

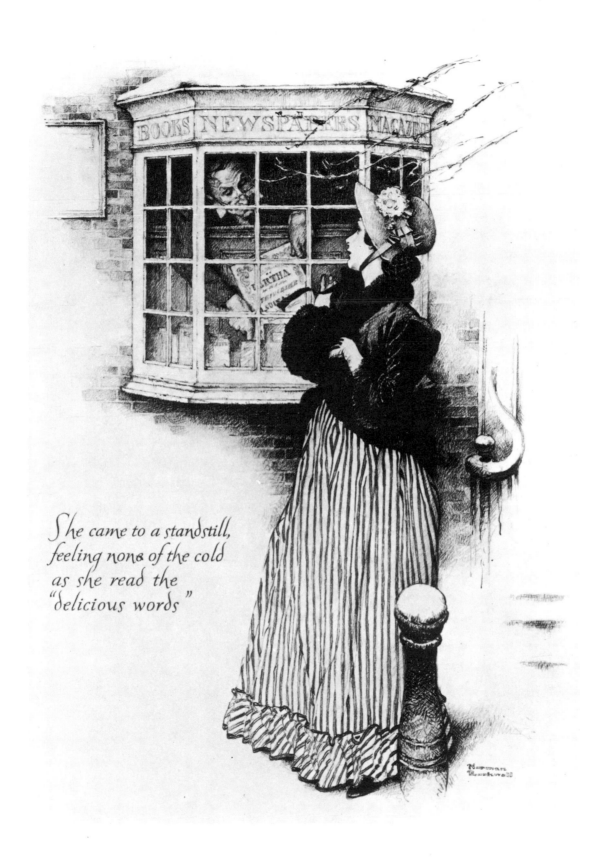

She came to a standstill,
feeling none of the cold
as she read the
"delicious words"

Illustrations for "Louisa May Alcott: Most Beloved American Writer" by Katharine
Anthony. *Woman's Home Companion*, December 1937– March 1938

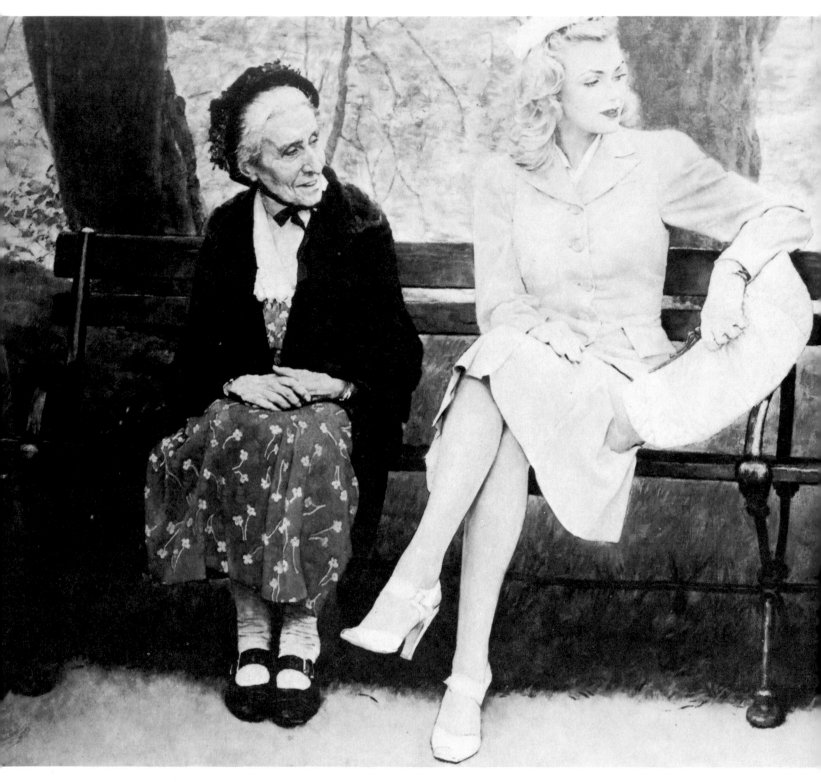

The Meeting. Oil painting for *Good Housekeeping* illustration, September 1942. Collection R. L. Spencer and Mr. Blackwell

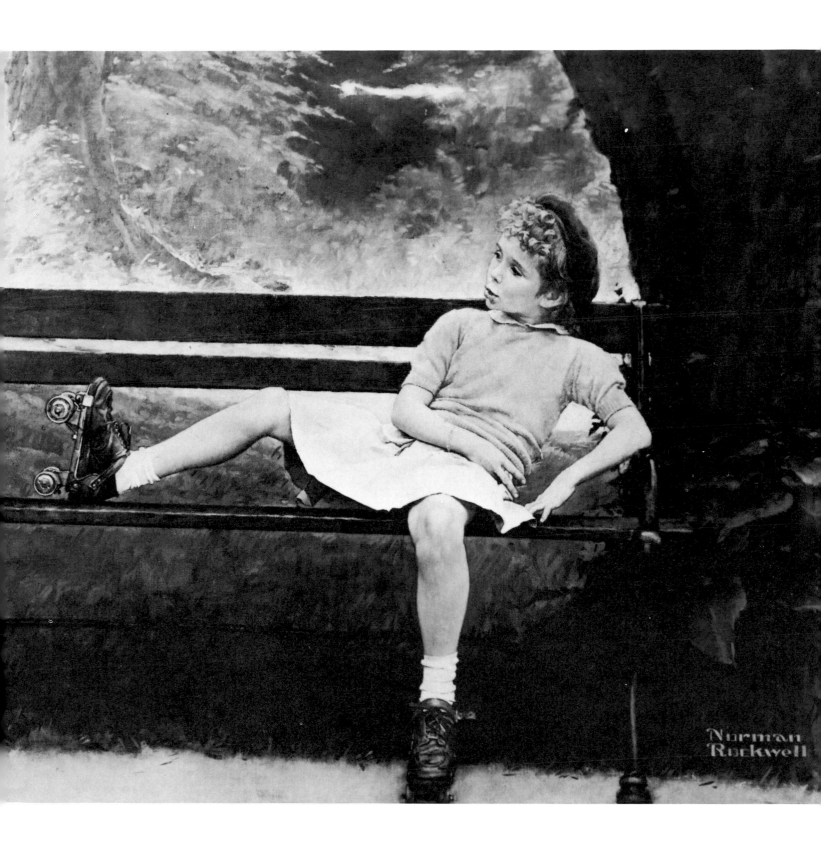

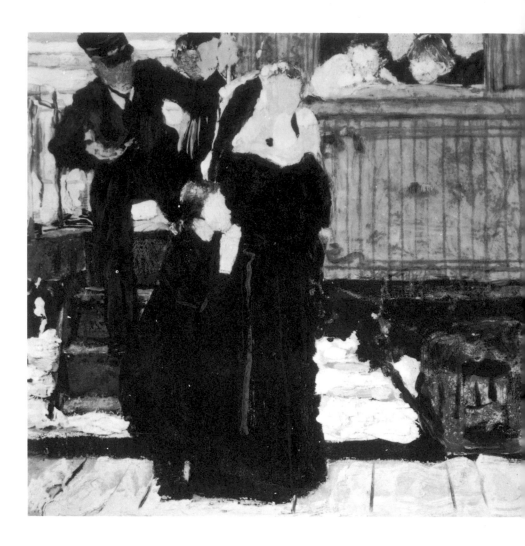

Orphans at the Train. Color
sketch. Collection Mr. and Mrs.
Peter Lind Hayes

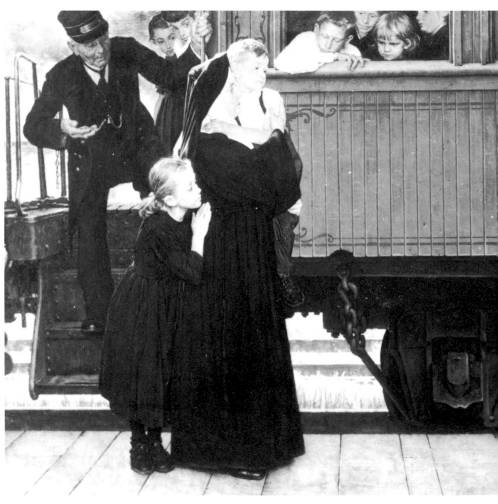

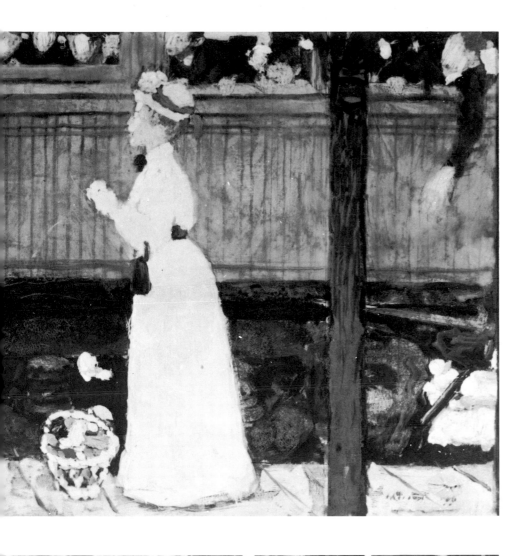

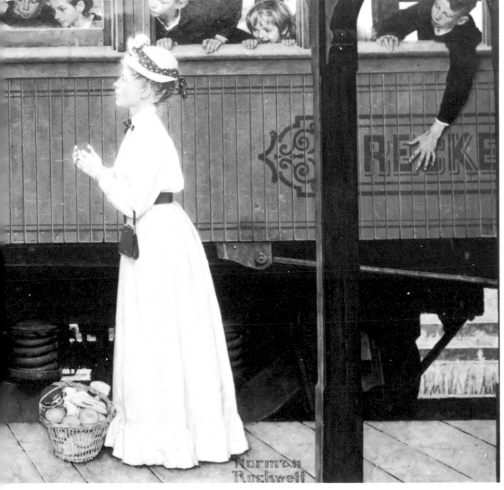

Orphans at the Train. Final
printed version

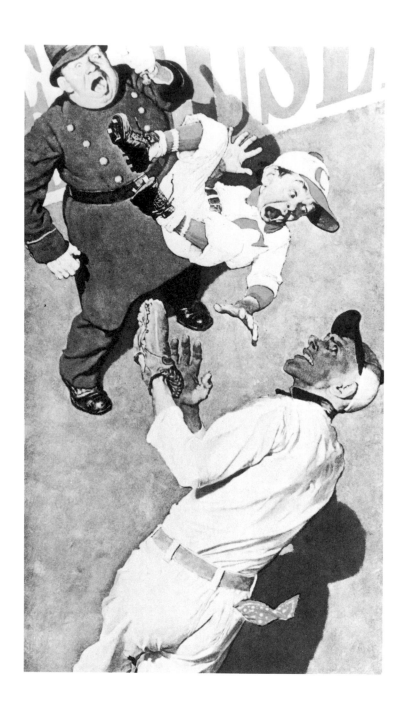

Illustrations for "You Can Look It Up in the
Record." *Post,* April 5, 1941

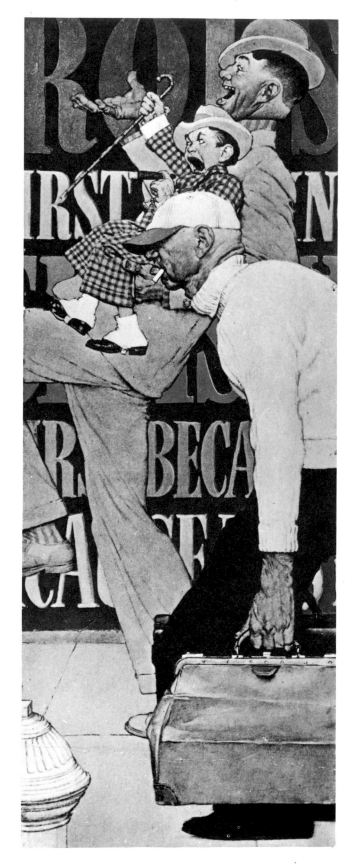

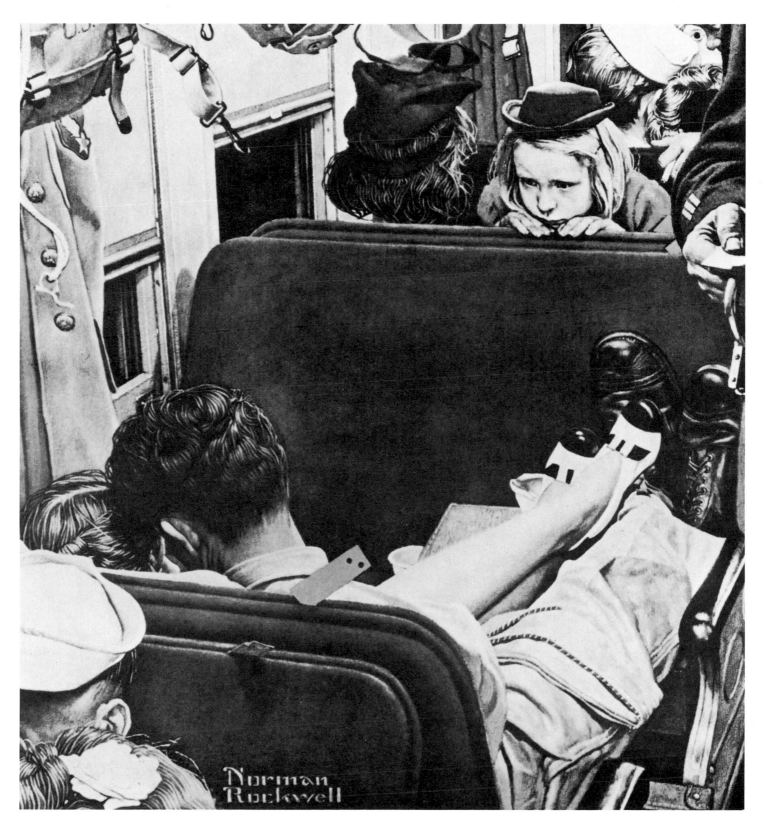

Voyeur. *Post* cover, August 12, 1944

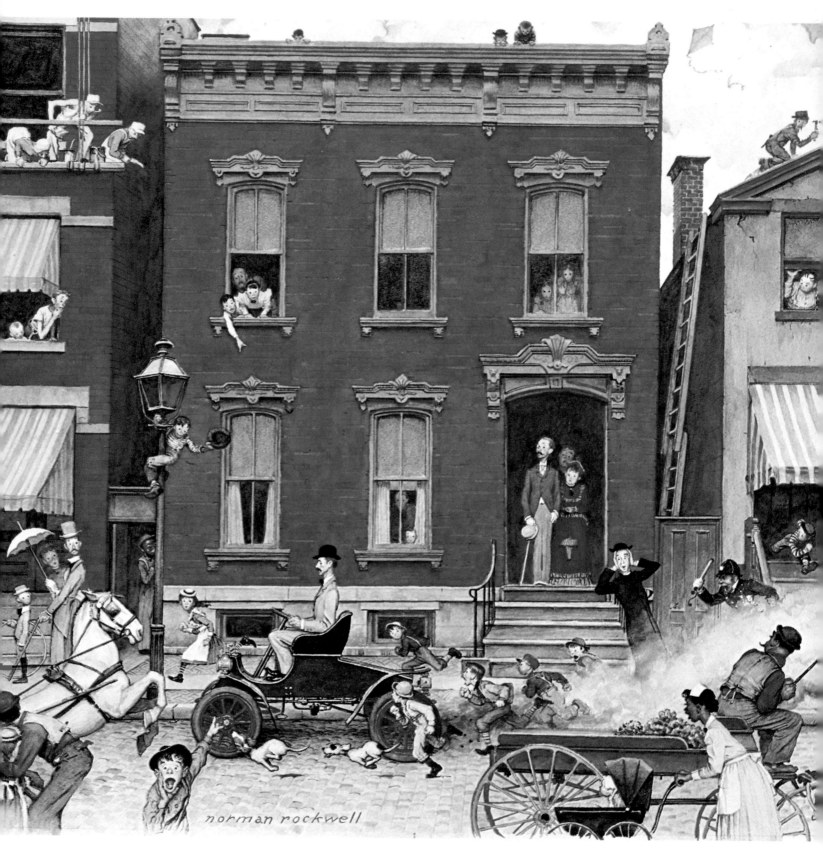

50th Anniversary calendar of the Ford Motor Company. Oil painting.
Detroit Historical Museum, Industrial History Division

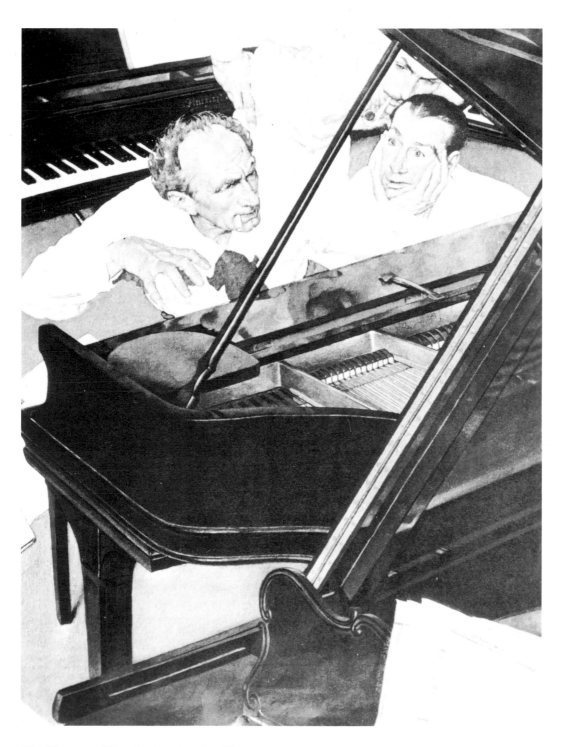

The Virtuoso. Oil painting for *Post* illustration, May 27, 1939.
Collection Mr. and Mrs. Frank M. Rubinstein

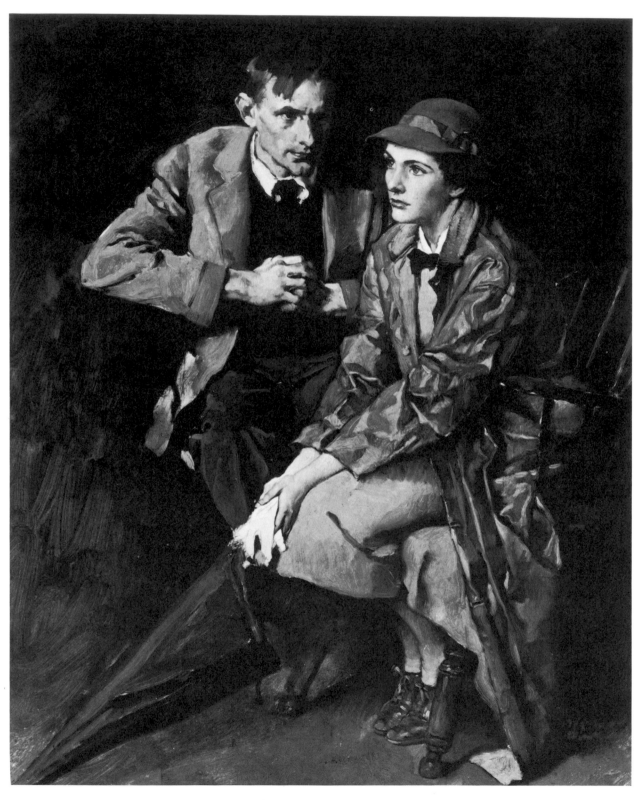

Commiserating Couple. Preliminary study of an illustration for *American Magazine*

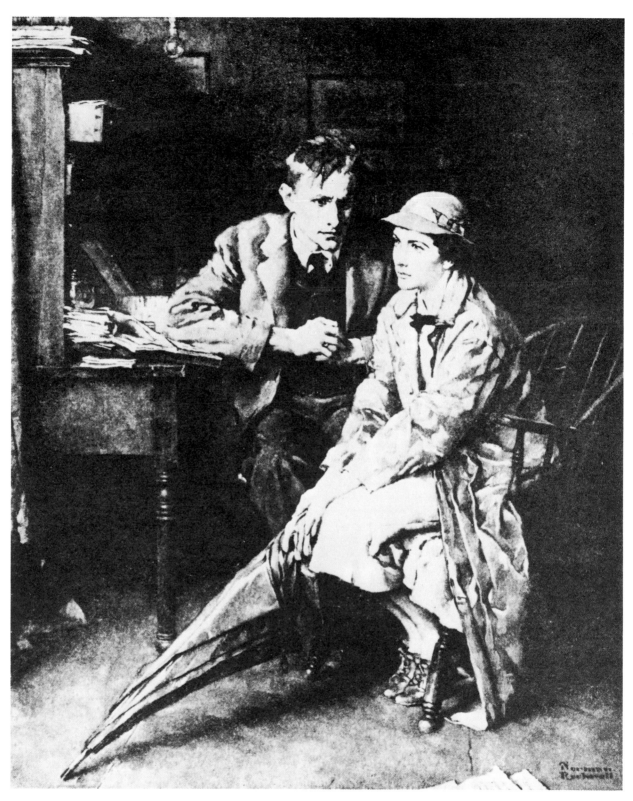

Commiserating Couple. Final version of an illustration for *American Magazine*

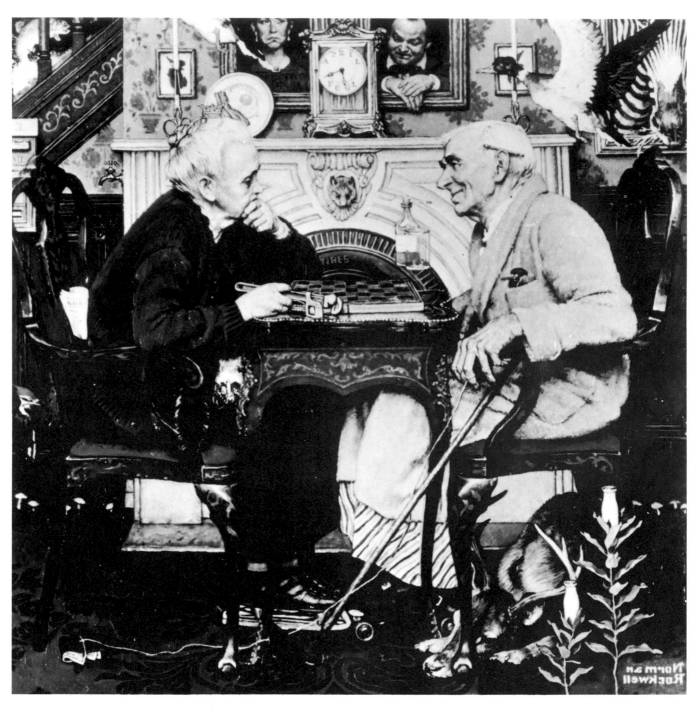

April Fools. Oil painting for *Post* cover, April 3, 1943.
Collection J. and R. S. Schafler

Illustration for "The Handkerchiefs."
Post, May 11, 1940

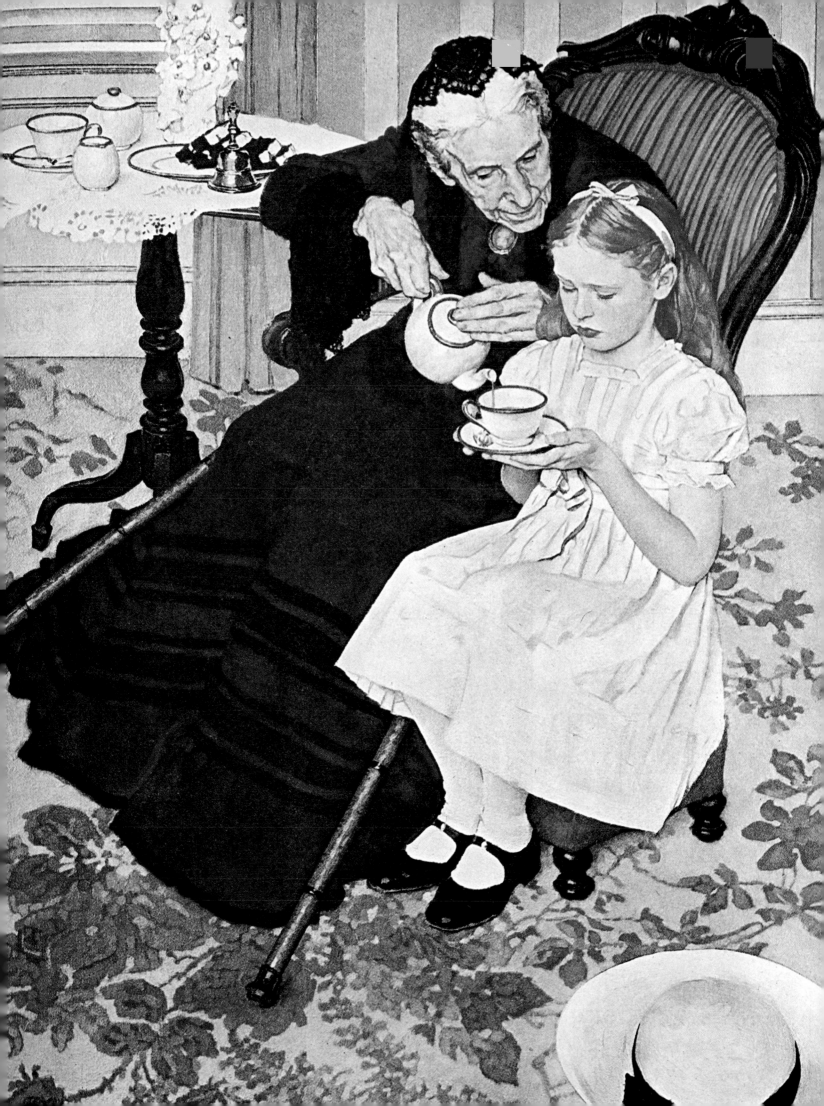

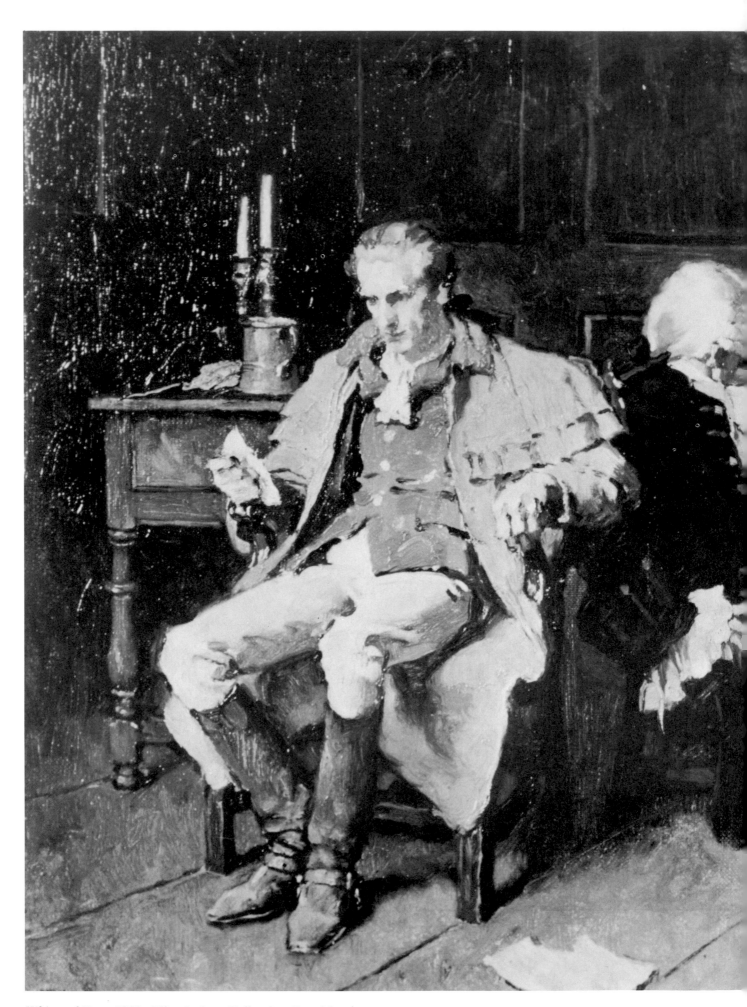

Whig and Tory. 1938. Oil painting. Collection Pete Martin

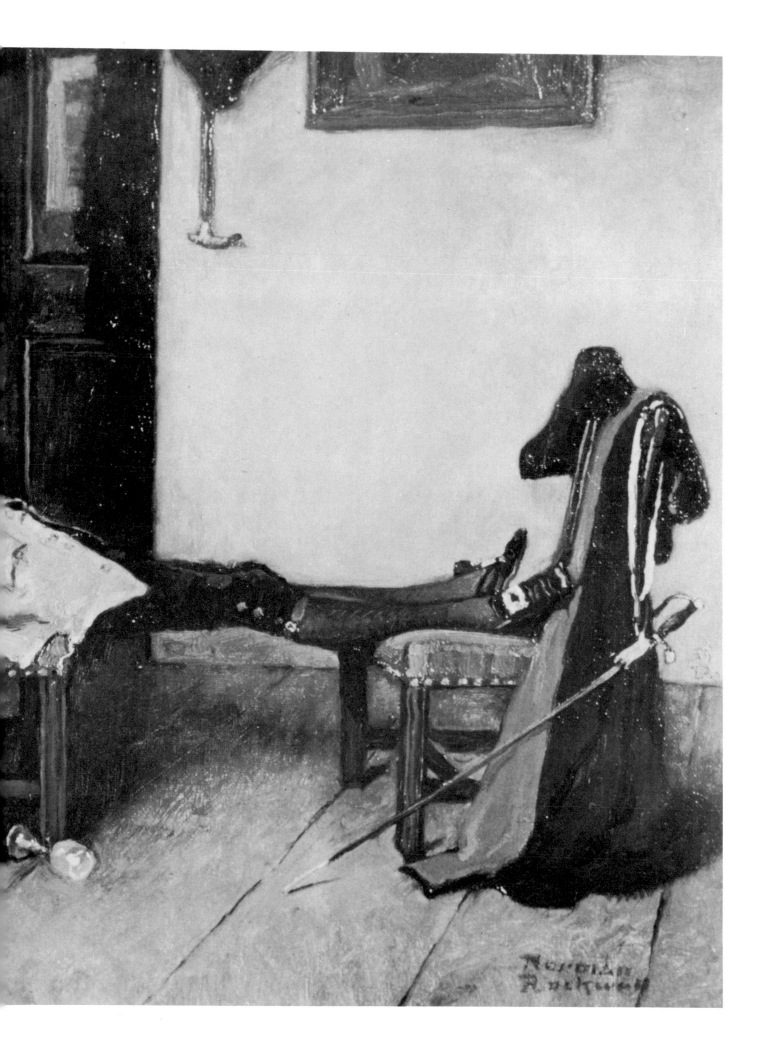

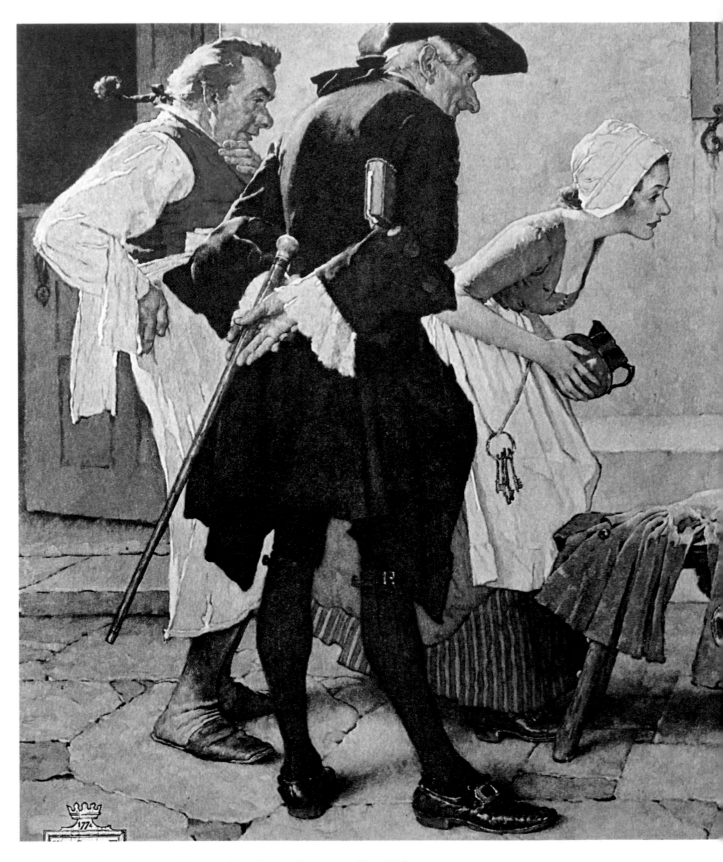

Illustration for "The New Tavern Sign." *Post*, February 22, 1936

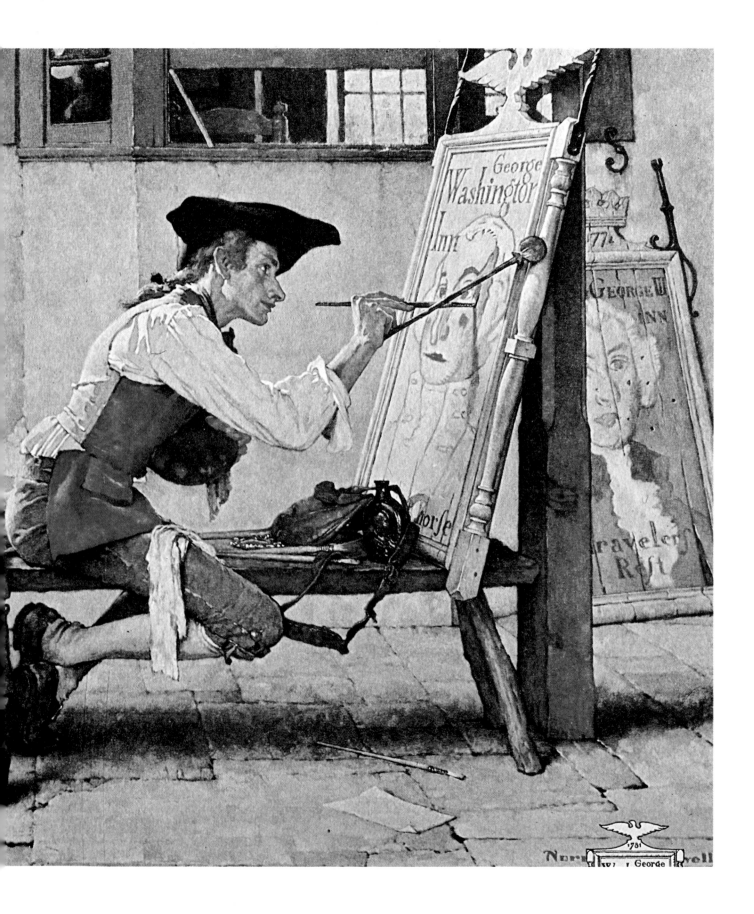

Yankee Doodle. 1937.
Mural for the Nassau Tavern,
Princeton, N.J.

THE FOUR

FREEDOMS

following pages:

Freedom of Speech. 1943. Oil painting.
Collection Norman Rockwell

Freedom of Worship. 1943. Oil painting.
Collection Norman Rockwell

Freedom from Fear. 1943. Oil painting.
Collection Norman Rockwell

Freedom from Want. 1943. Oil painting.
Collection Norman Rockwell

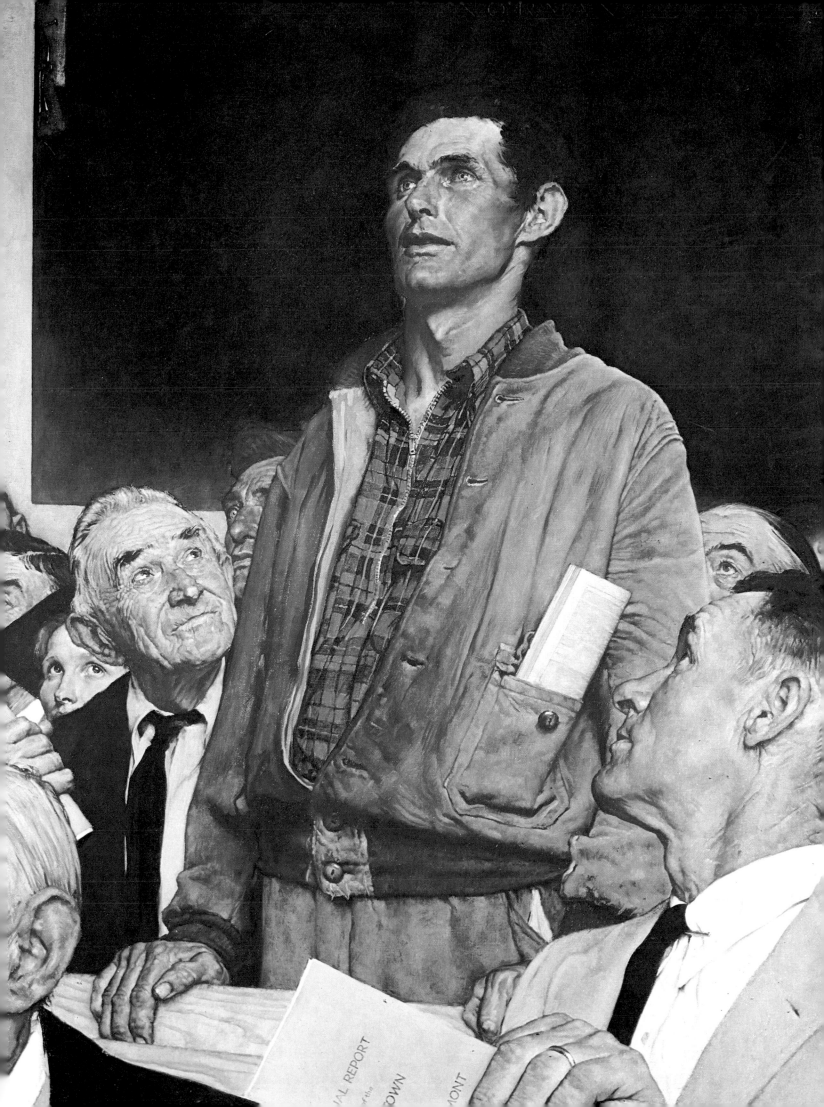

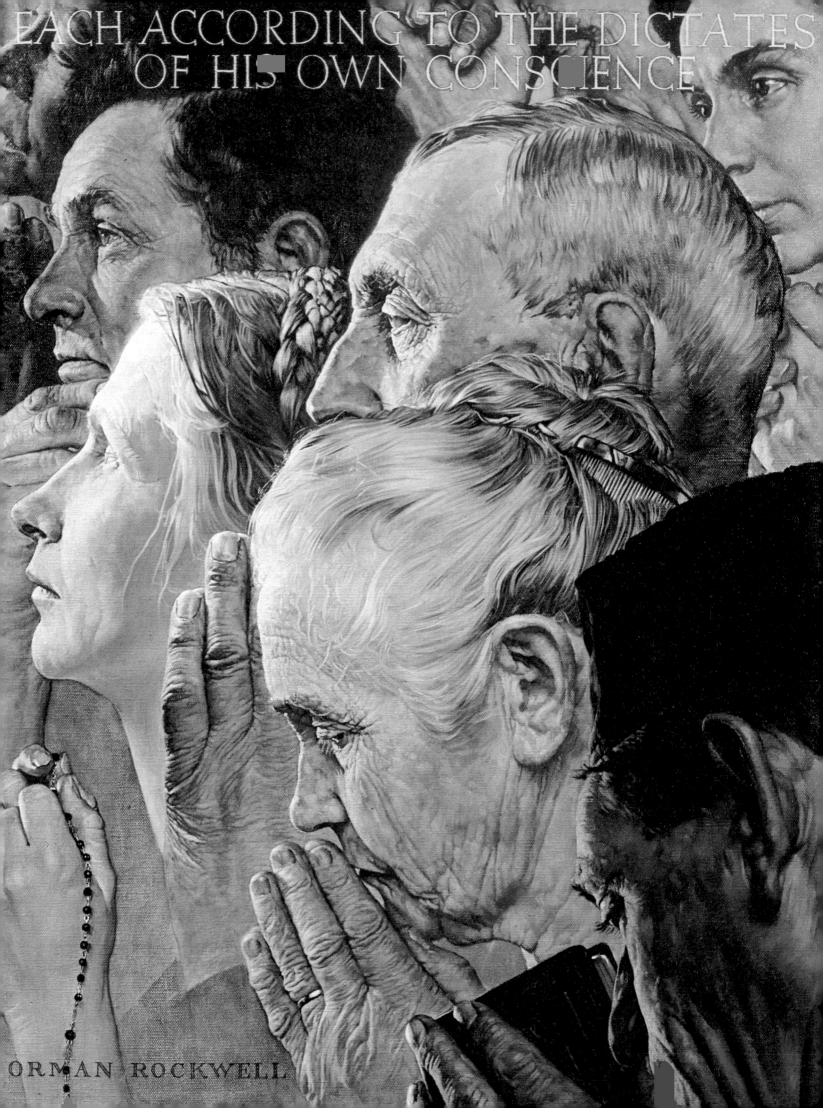

EACH ACCORDING TO THE DICTATES
OF HIS OWN CONSCIENCE

ORMAN ROCKWELL

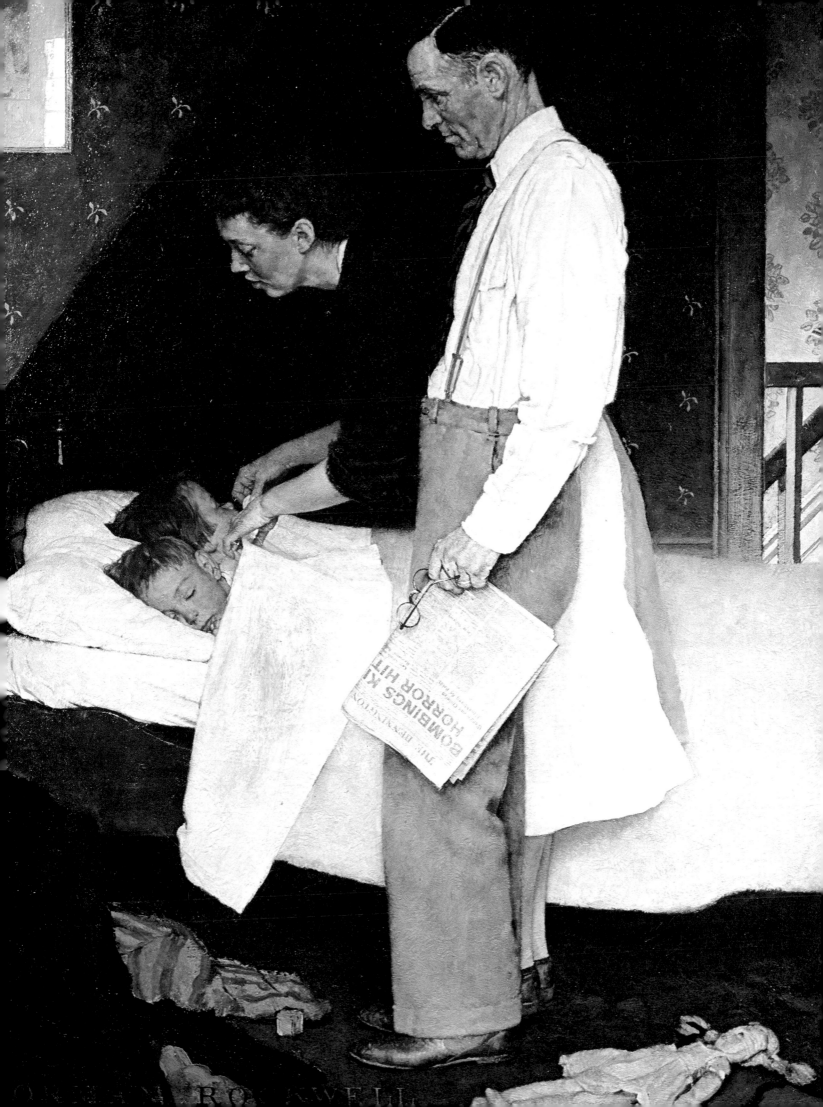

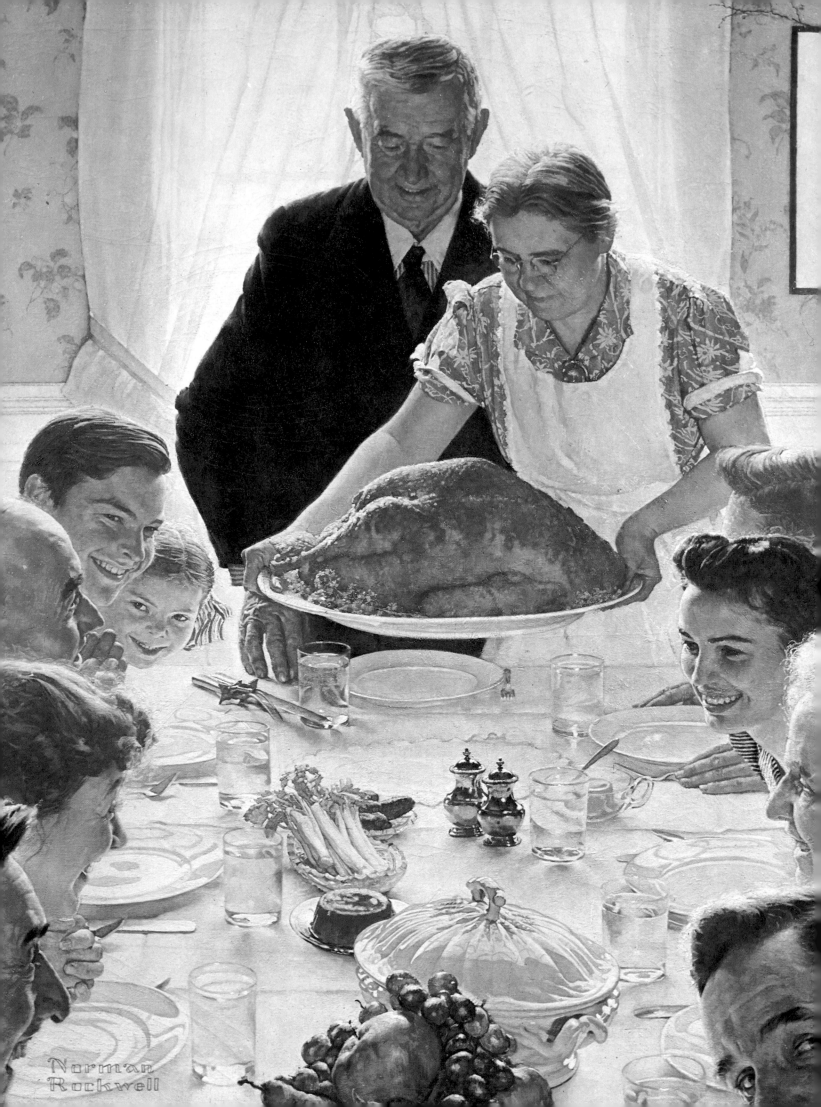

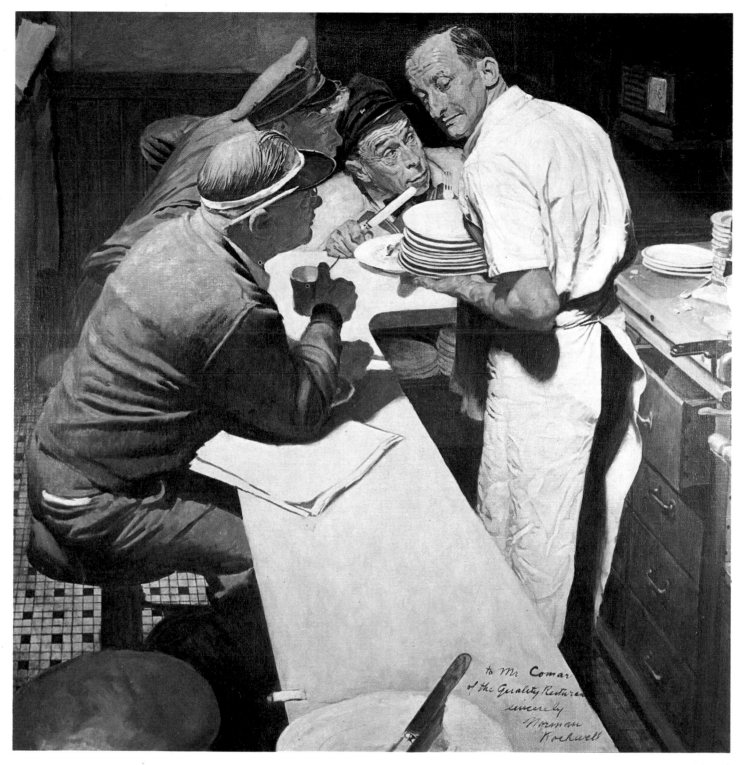

Listening for the Invasion of D-Day. Oil painting. Collection Cordelia B. Colmar, Manchester, Vt.

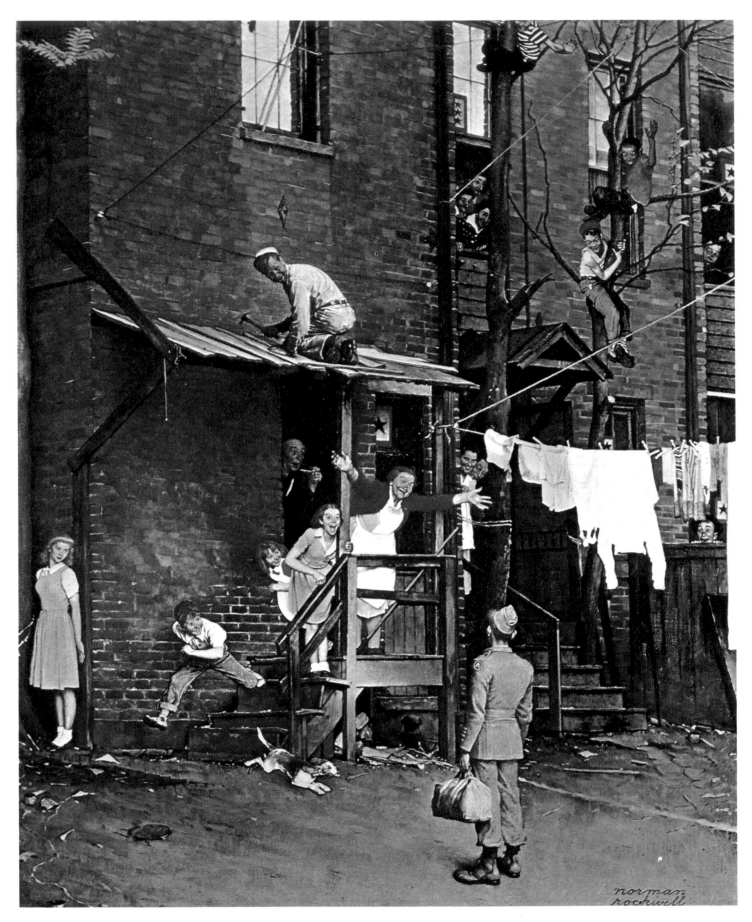

Homecoming G.I. Oil painting for *Post* cover, May 26, 1945. Collection Mrs. Ben Hibbs

The Tattooist. Oil painting for *Post* cover,
March 4, 1944. Collection The Brooklyn Museum

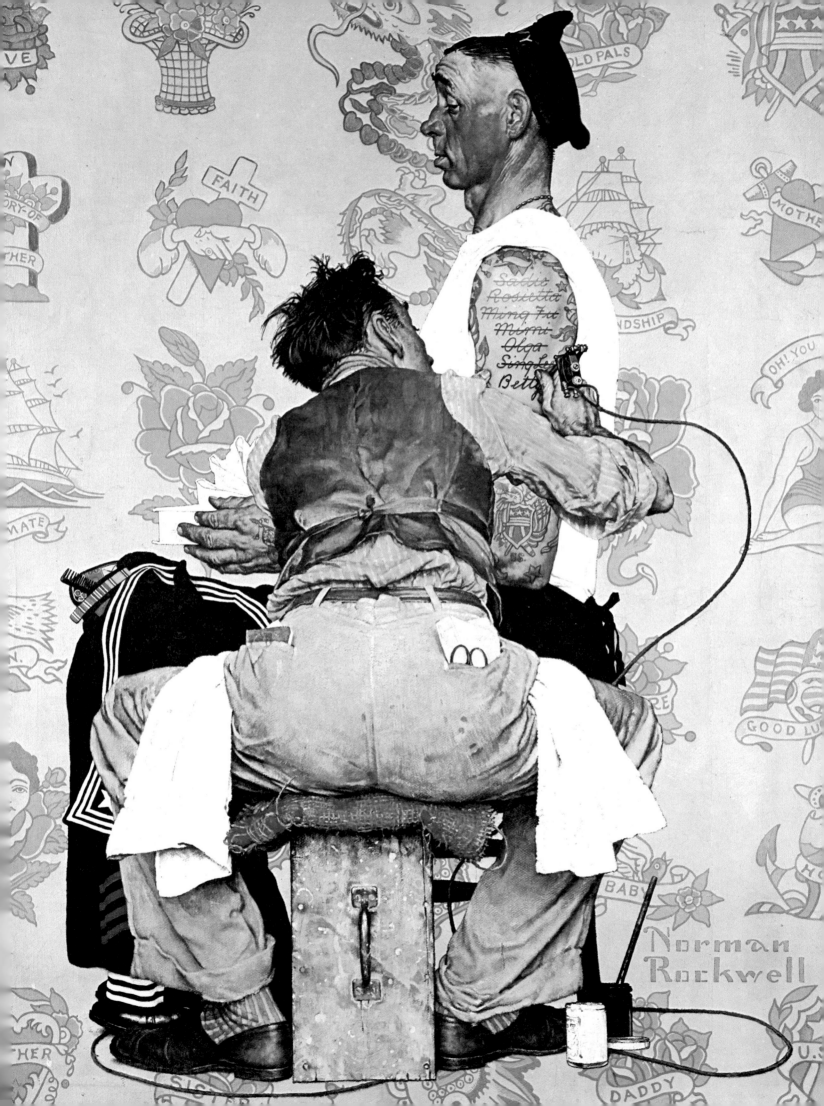

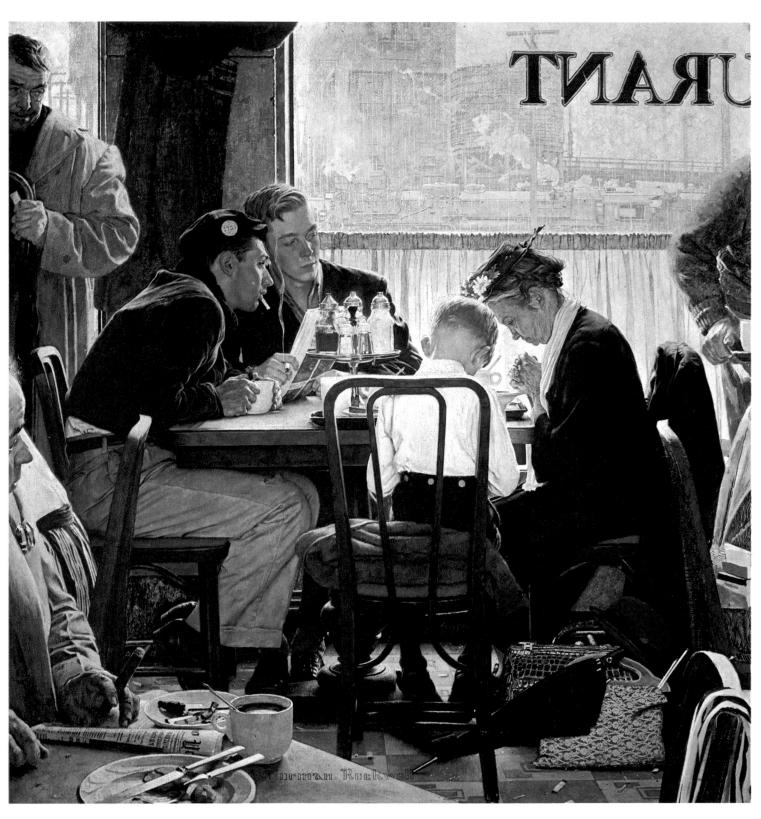

Saying Grace. Oil painting for *Post* cover, November 24, 1951. Collection Mr. and Mrs. Ken Stuart

1946 - 1960

Advertisement for Massachusetts Mutual Life Insurance Company

Norman Rockwell painted the most popular of all his *Post* covers — the grandmother and grandson saying grace in the railroad station restaurant — in 1951. In 1952, he painted President Eisenhower and painted every presidential candidate in every election since. But the decade began badly. The discouragement, uncertainty, and dissatisfaction that drove him to Europe in 1932 returned to accompany him through his move in 1953 from Arlington to Stockbridge, Massachusetts; he managed to go on meeting the endless barrage of deadlines with which he *always* lived. He also managed to paint two of his best pictures: *Breaking Home Ties*, 1954, and *Marriage License*, 1955. In 1959, his wife Mary died, and he was alone again.

It is impossible to know how, or even if, these troubles affected his work. Changes certainly occurred. The most important one was a turning back to the subject of youth, to the subjects of his youth — boys, dogs, swimming, girls, adolescence, going to church, to the doctor's, to school. An eighteen-foot mural painted with the help of Dean Cornwell for the centennial of the Berkshire Life Insurance Company even brought back his favorite Dickensian period.

A great many commissions for advertisements were completed during this period. The creative aspect of all of these illustrations seems to lie more in Rockwell's ability to select, arrange, and direct his subjects than in his abilities as a painter. A series of four cards painted for Hallmark and some sketches done for Pan American World Airways, both in 1957, are exceptions. Although as realistic as everything else, they are painted in a fresh, loose style, quite unlike anything that had come before. Just as Rockwell blossomed forth with a new approach to illustration after his first session with the doldrums, he comes to life again here with a new appreciation of the spontaneous. In 1957, he was sixty-three years old.

In knowing only part of his work, it is easy to mistake continuing interest in certain subject themes for a revival of interest. Until everything Rockwell ever did is properly fed into a data bank and a computer is programmed to distinguish all sorts of subtle changes, no one can be sure. Our only certainty is that he always worked very hard, produced a prodigious amount, and was able to keep several approaches to the same subject going simultaneously. His fascination with the dimension of time seems to be one consistent factor. Although he records precise moments, he wants the viewer to know what has just happened or will happen next—the hotel maids are cleaning up *after* a wedding; the girl looking in the mirror *had been* combing her hair; the boy in the doctor's office *will* get dressed. The two *Post* covers describing a whole day in the lives of a boy and a girl, the calendars describing a whole year in the lives of two friends, and the four ages of man describing whole lifetimes may be extensions of this fascination. In *A Family Tree* he offers us two and a half centuries.

Advertisement for
Massachusetts Mutual Life
Insurance Company

130

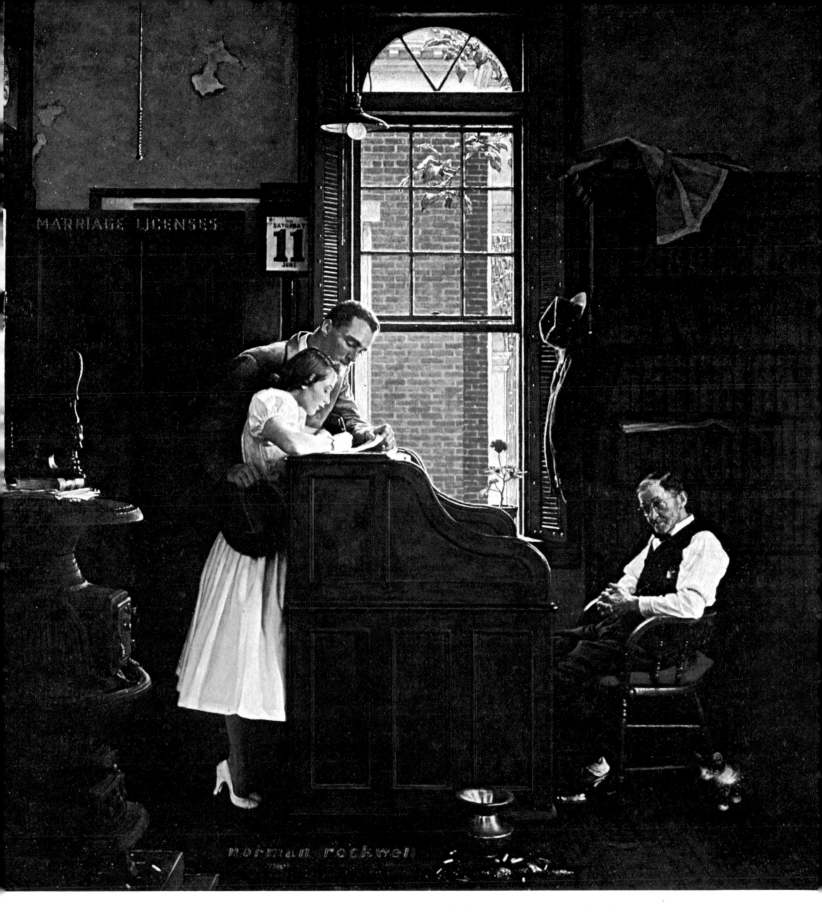

Marriage License. Oil painting for *Post* cover, June 11, 1955. Collection Norman Rockwell

The Gossips. *Post* cover, March 6, 1948

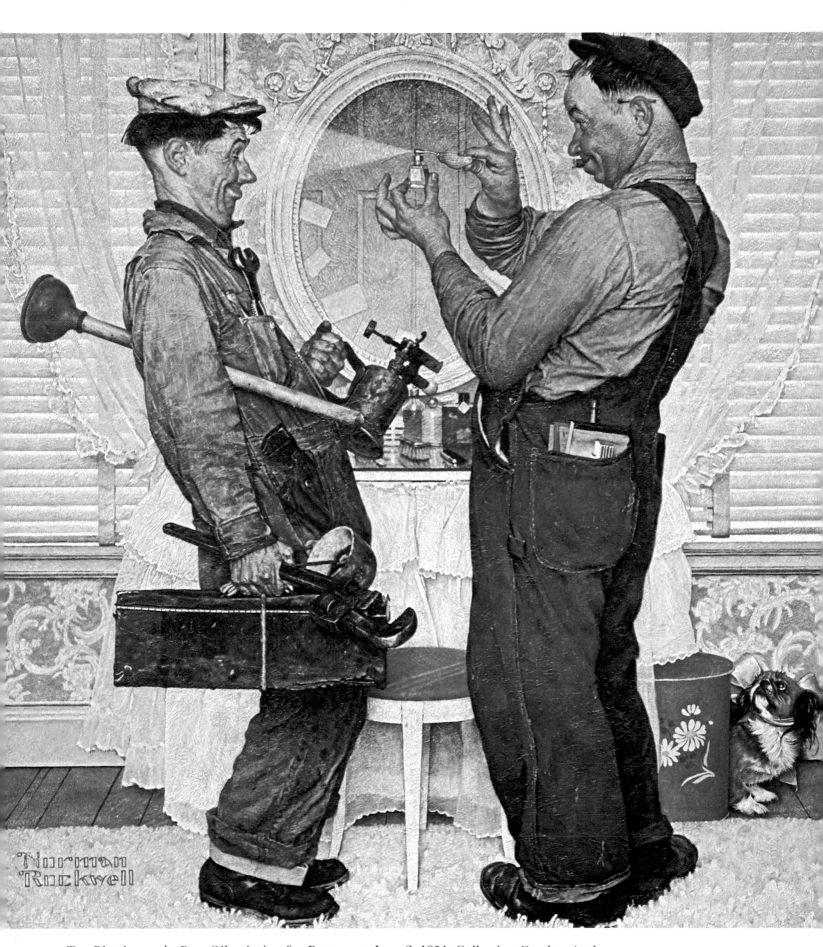

Two Plumbers and a Dog. Oil painting for *Post* cover, June 2, 1951. Collection Gordon Andrew

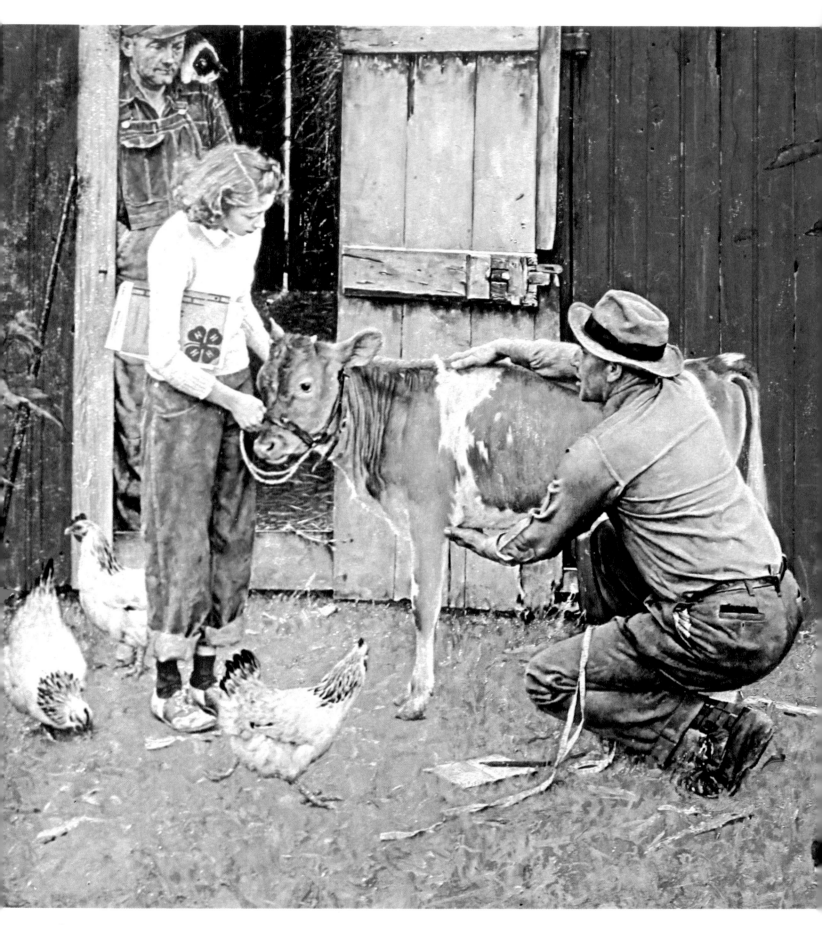

County Agricultural Agent. Oil painting for *Post* illustration, July 24, 1948.
University of Nebraska Art Galleries, Lincoln. Gift of Nathan Gold

Norman Rockwell Visits a Ration Board. *Post* illustration, July 15, 1944

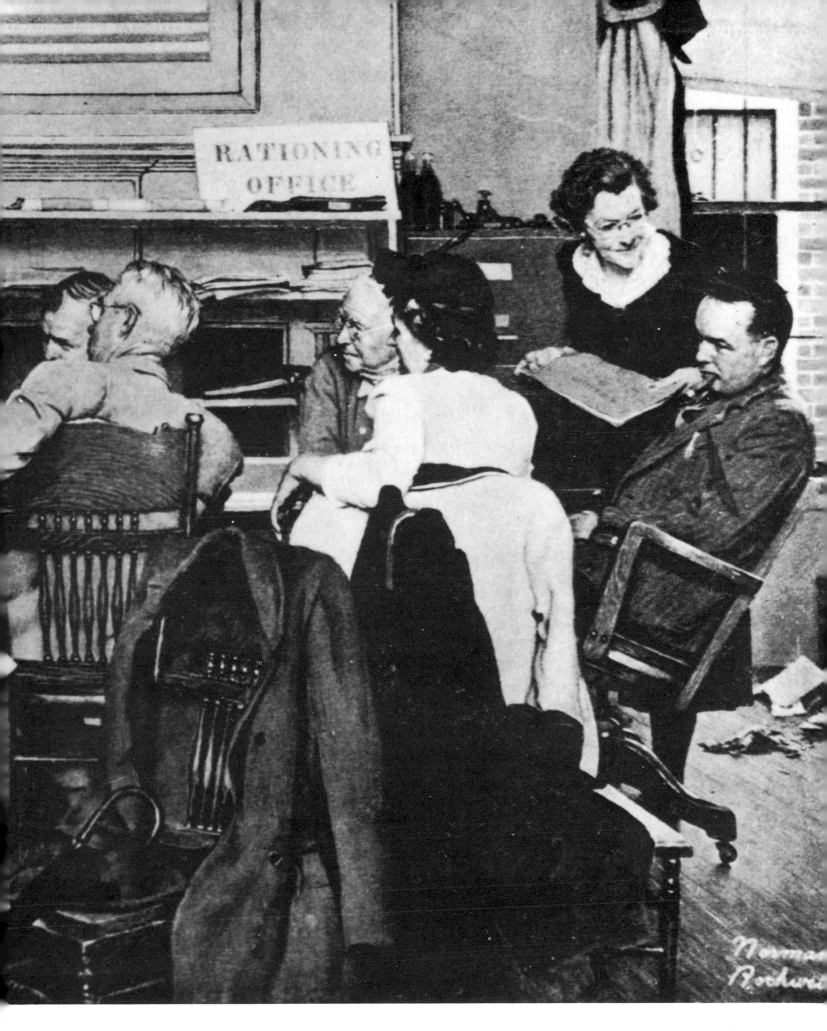

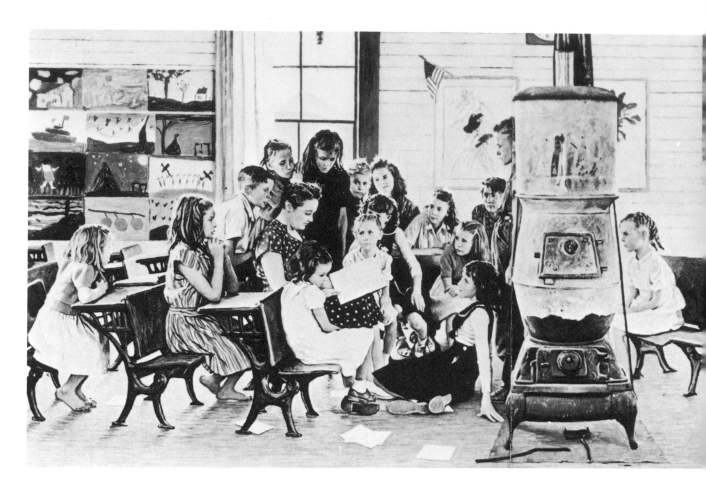

Norman Rockwell Visits His Country
Doctor. *Post* illustration, April 12,
1947

Red Oaks, Georgia Schoolroom. Oil painting for *Post* illustration, November 2, 1946. Private collection

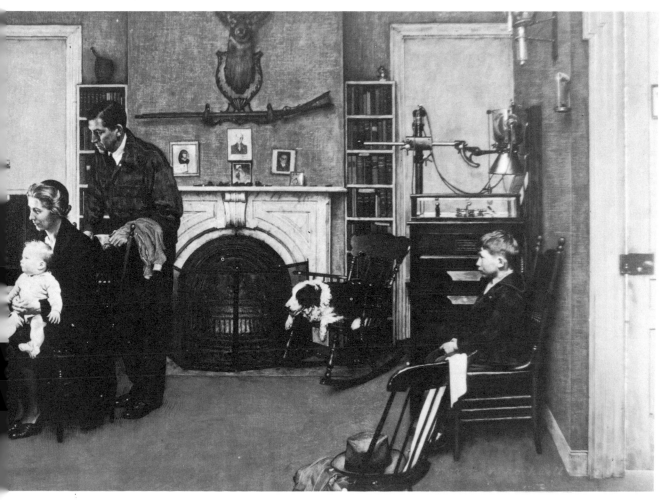

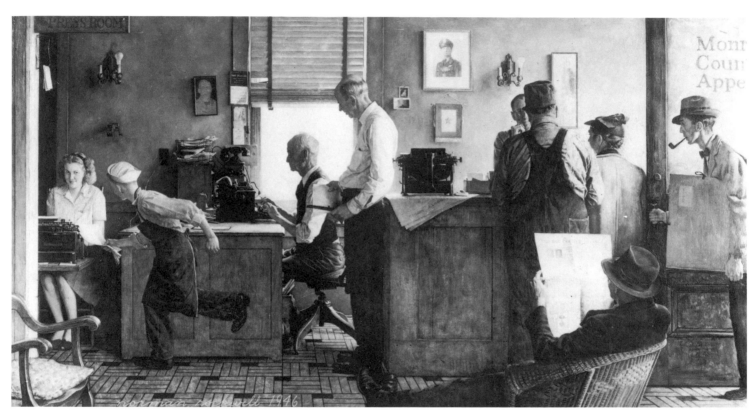

Norman Rockwell Visits a Country Editor. Oil painting for *Post* illustration,
May 25, 1946. National Press Club, Washington, D.C.

Construction Crew. Oil painting for *Post* cover, August 21, 1954. Collection *Saturday Evening Post*

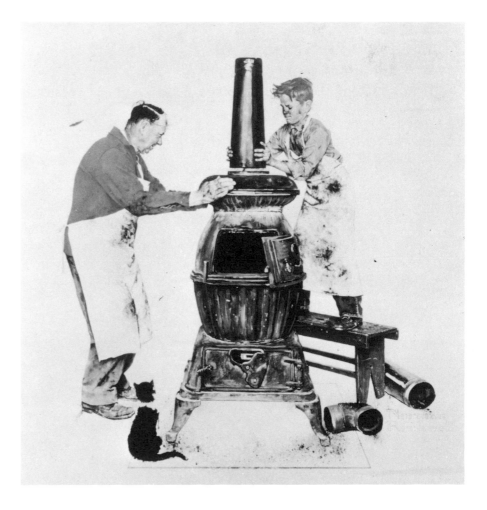

Preparing for Winter. Oil painting for Four Seasons calendar, 1960. © 1960, Brown & Bigelow, St. Paul, Minn. Saks Galleries, Denver, Colo.

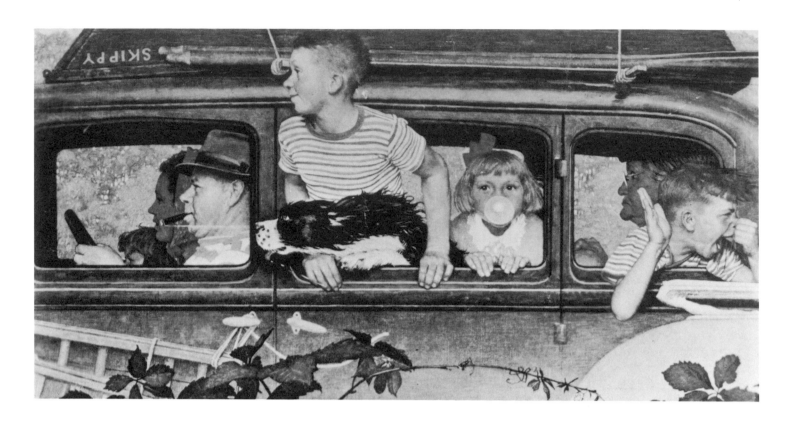

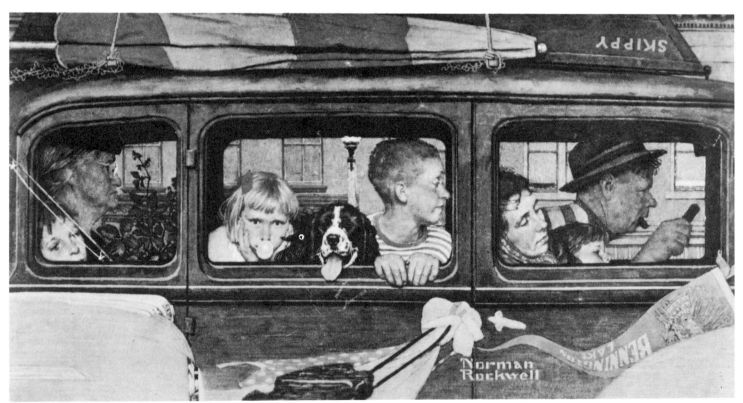

The Outing. *Post* cover, August 30, 1947

Four Seasons calendar: Four Boys, 1951. © Brown & Bigelow, St. Paul, Minn.

Hallmark Christmas card. 1948

144

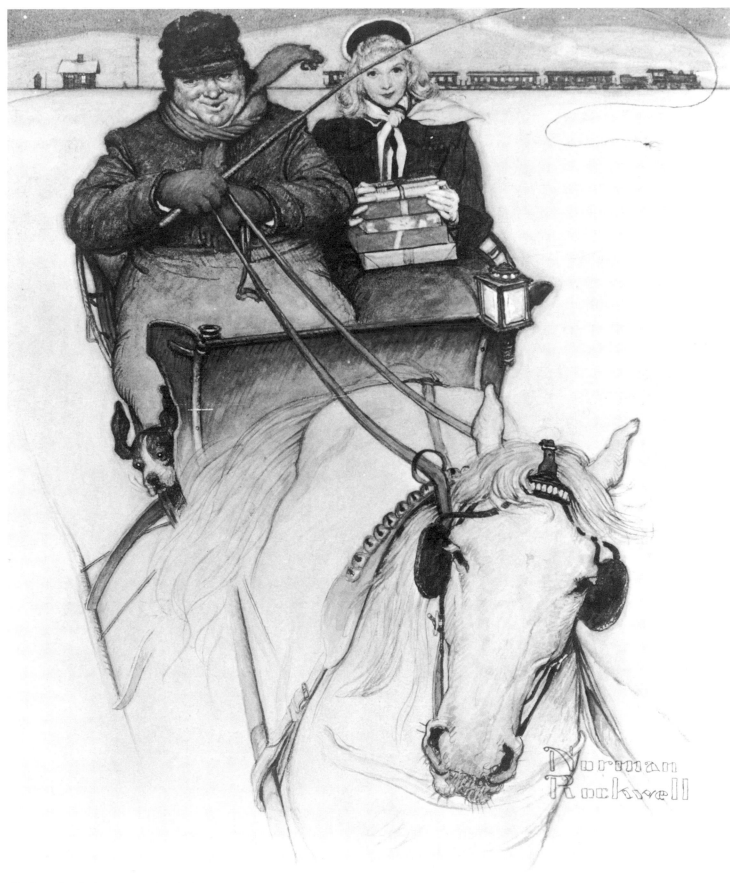

Hallmark Christmas card. 1949

145

A Day in the Life of a Girl. *Post* cover, August 30, 1952

A Day in the Life of a Boy. *Post* cover, May 24, 1952

Advertisements for Massachusetts
Mutual Life Insurance Company

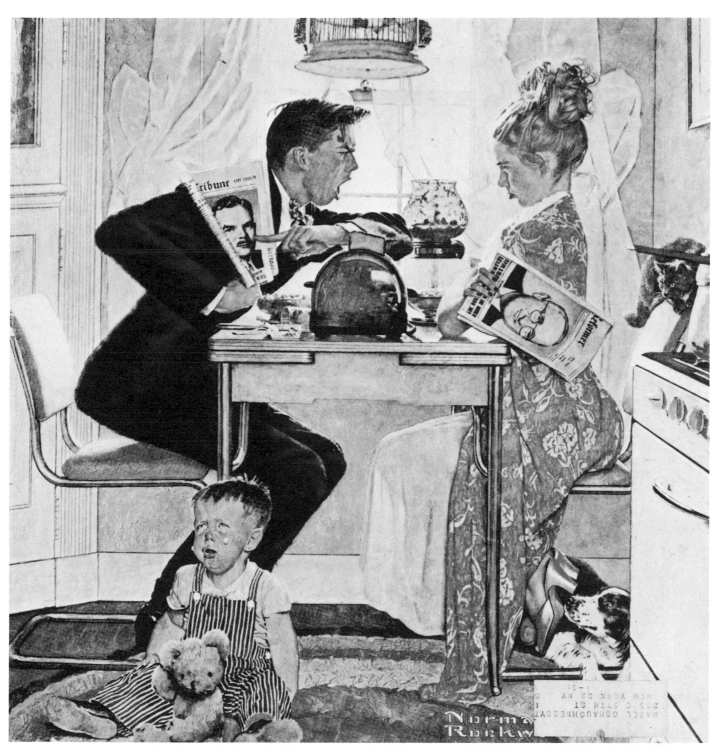

Dewey vs Truman. *Post* cover, October 30, 1948

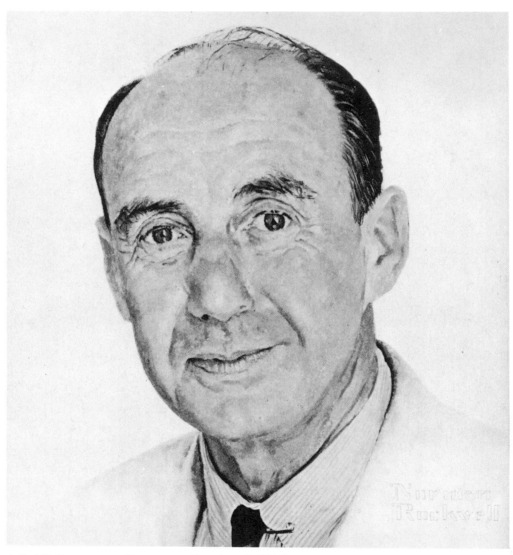

Adlai E. Stevenson. *Post* cover, October 6, 1956

Dwight D. Eisenhower. *Post* cover,
October 13, 1956

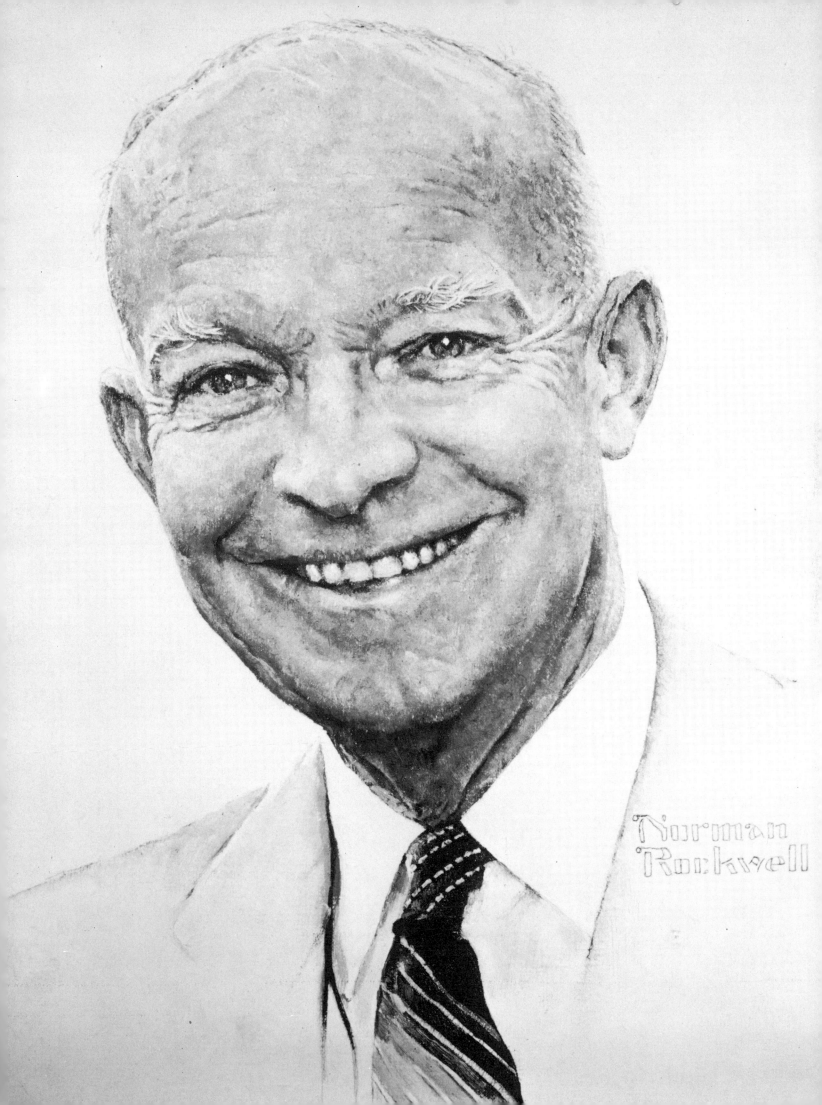

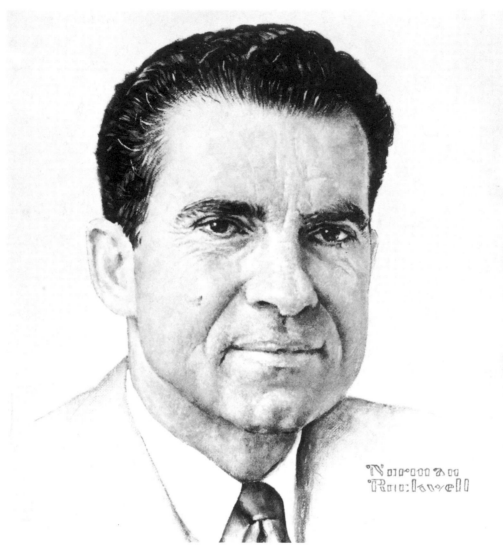

Richard M. Nixon. Oil painting for *Post* cover, November 5, 1960. Collection
University Computing Co., Dallas, Tex.

John F. Kennedy. *Post* cover,
October 29, 1960

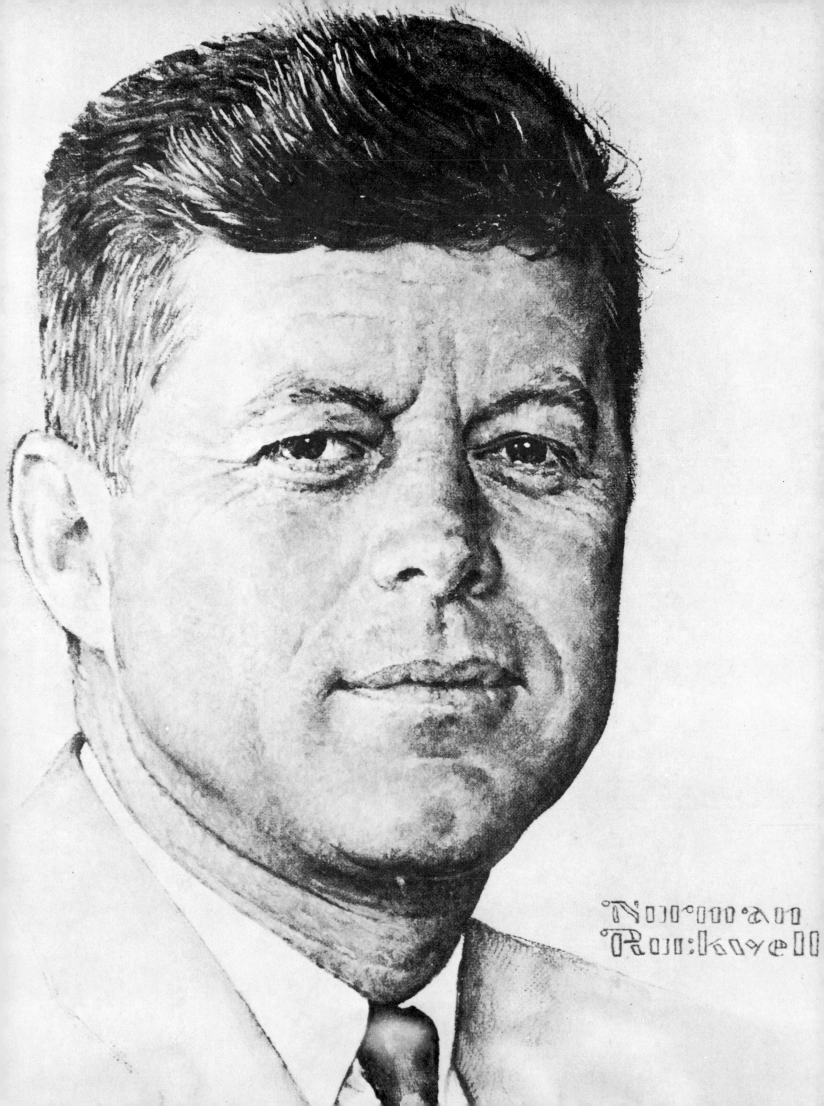

Norman Rockwell

Walking to Church. Oil painting for *Post* cover, April 4, 1953. Collection Mr. and Mrs. Ken Stuart

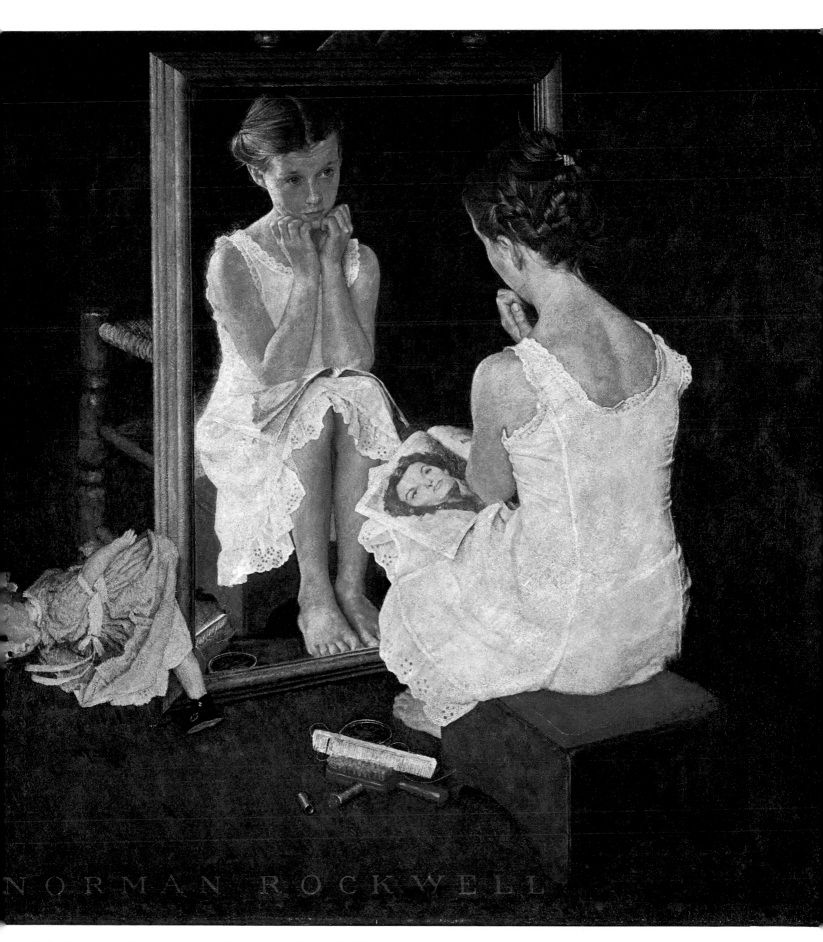

Girl at the Mirror. Oil painting for *Post* cover, March 6, 1954

Four Seasons calendar: Two Old
Friends, 1956. © Brown & Bigelow,
St. Paul, Minn.

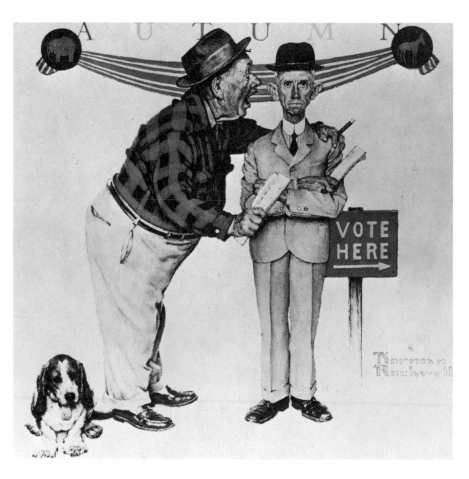

S U M M E R

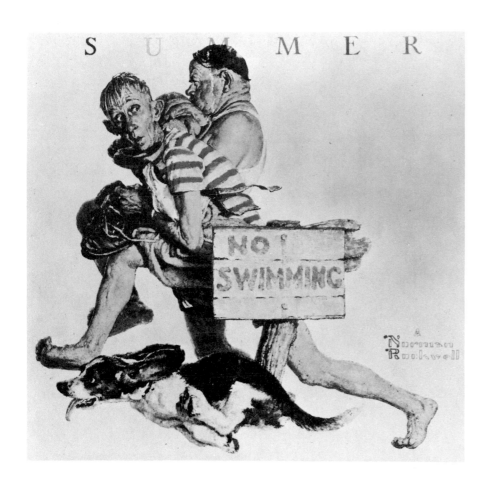

W I N T E R

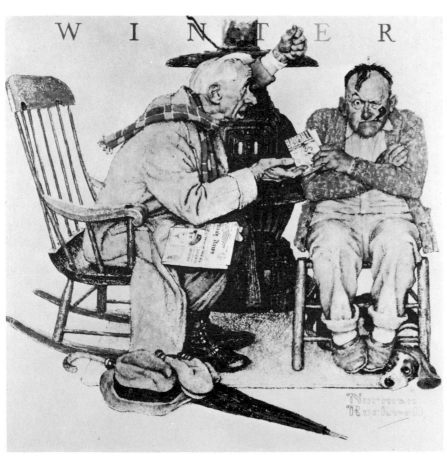

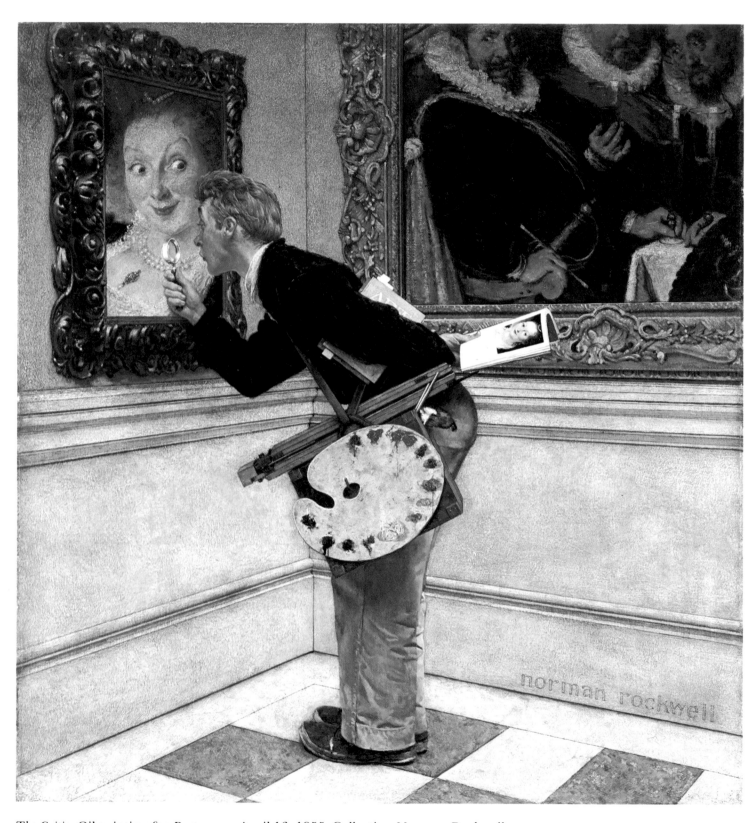

The Critic. Oil painting for *Post* cover, April 16, 1955. Collection Norman Rockwell

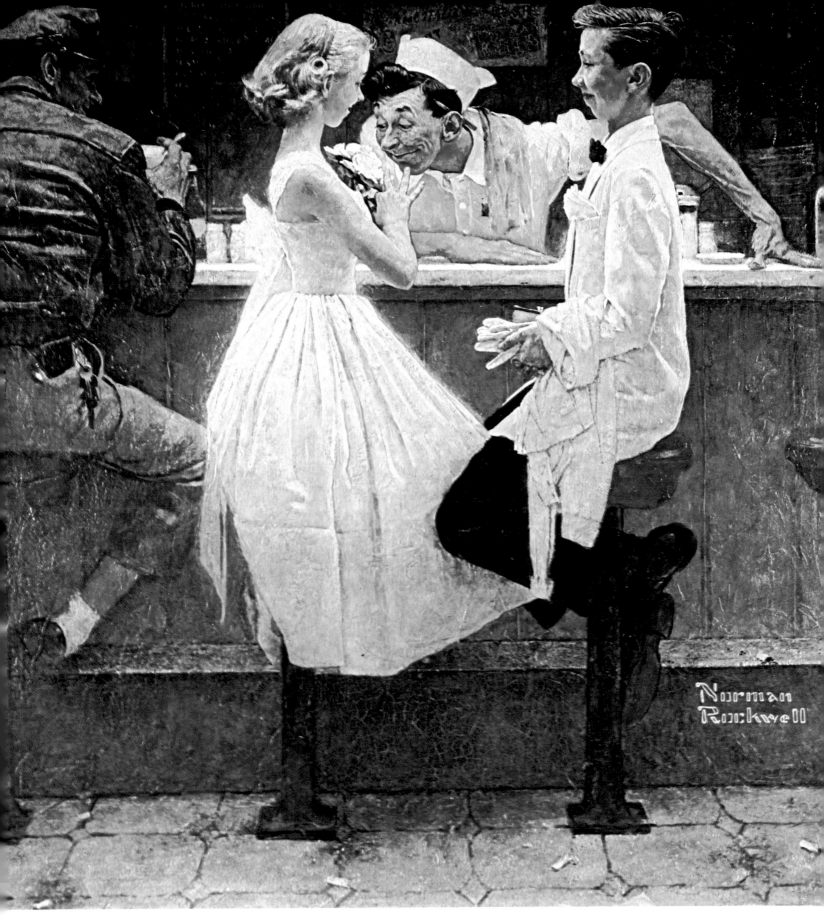

After the Prom. Oil painting for *Post* cover, May 27, 1957. Collection Mr. and Mrs. Thomas Rockwell

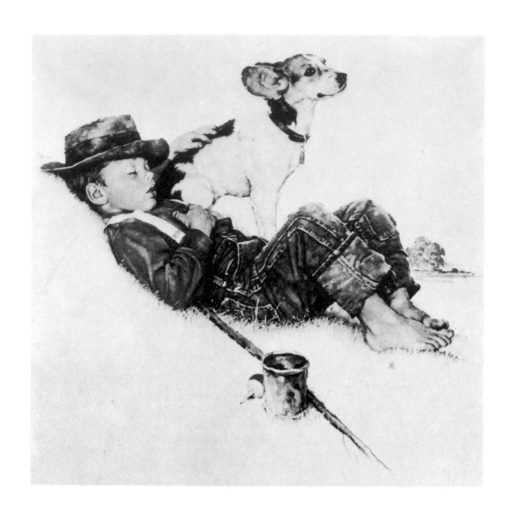

Four Seasons calendar: Boy and Dog, 1958. © Brown & Bigelow, St. Paul, Minn.

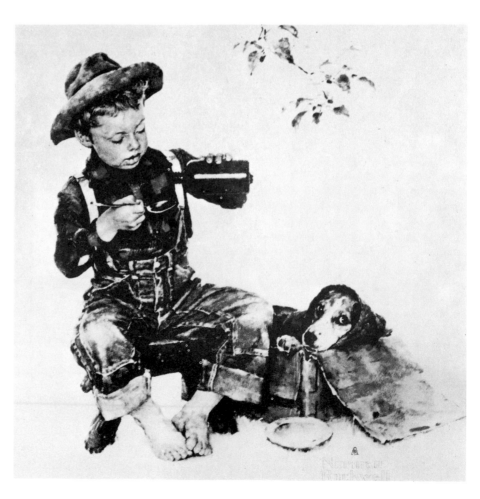

160

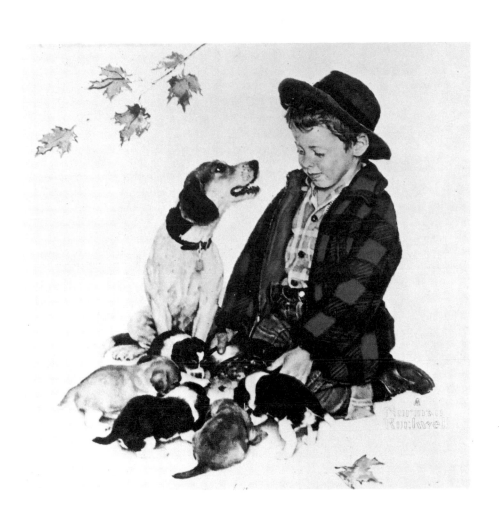

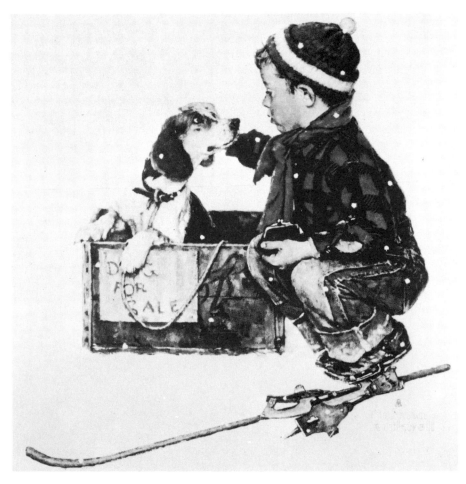

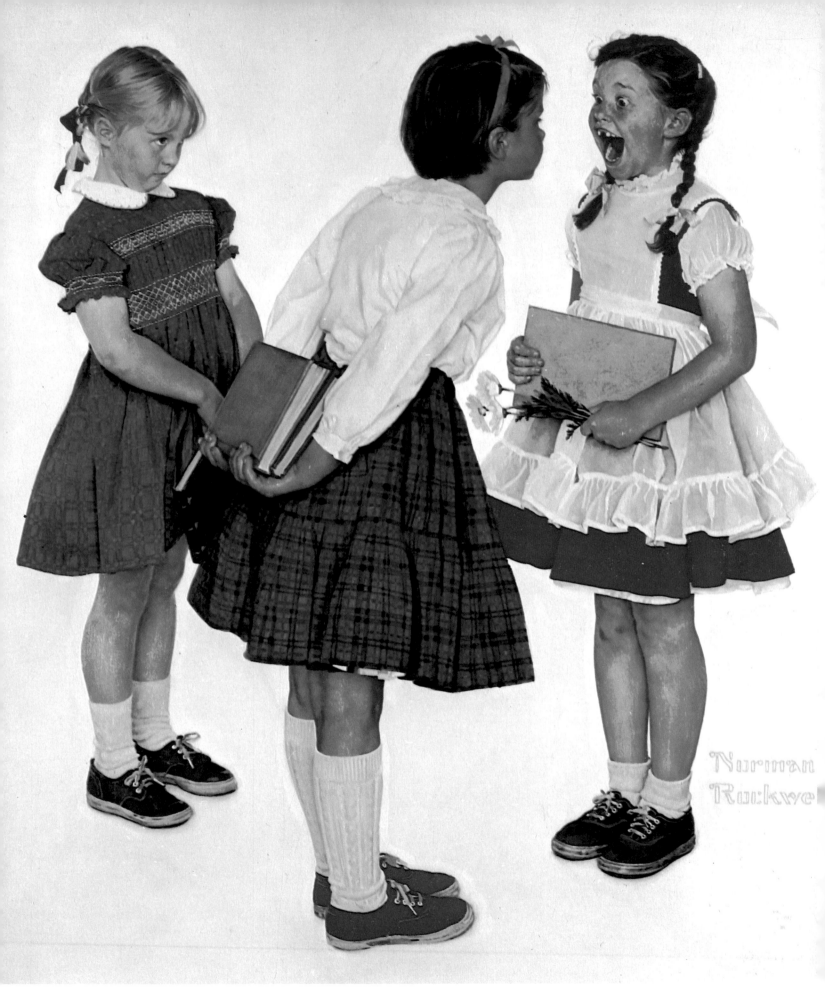

Checkup. Oil painting for *Post* cover,
September 7, 1957

Jockey Weighing In. Oil painting for *Post*
cover, June 28, 1958. Private collection

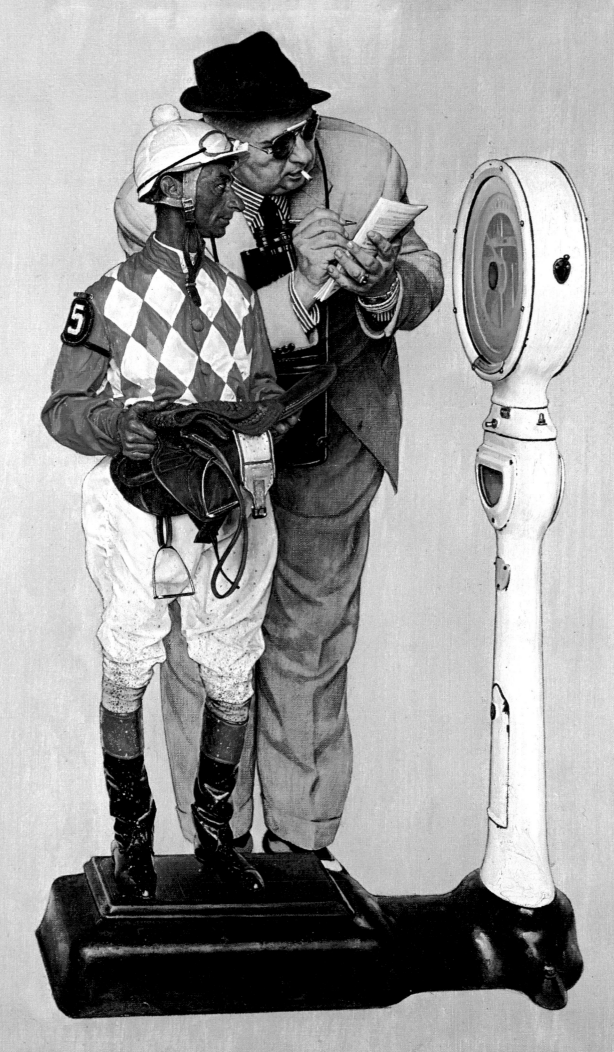

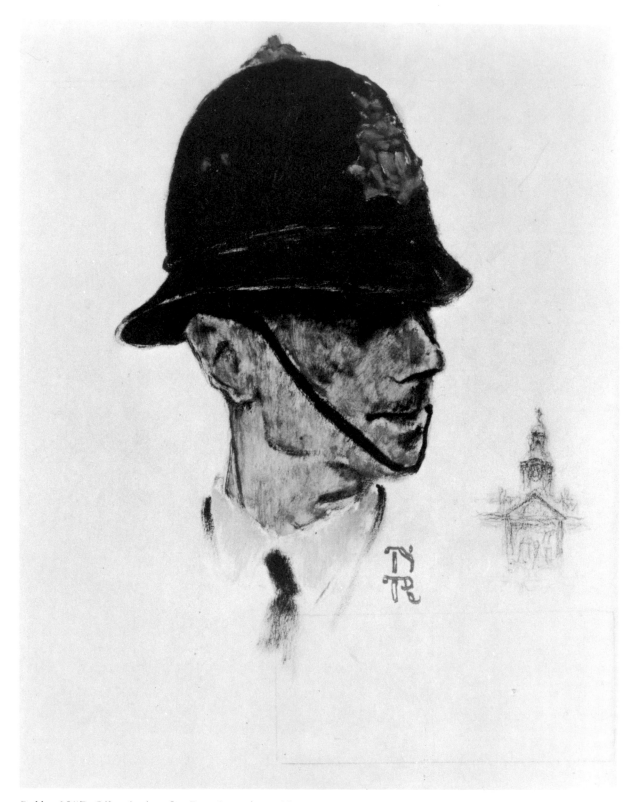

Bobby. 1957. Oil painting for Pan American Airways

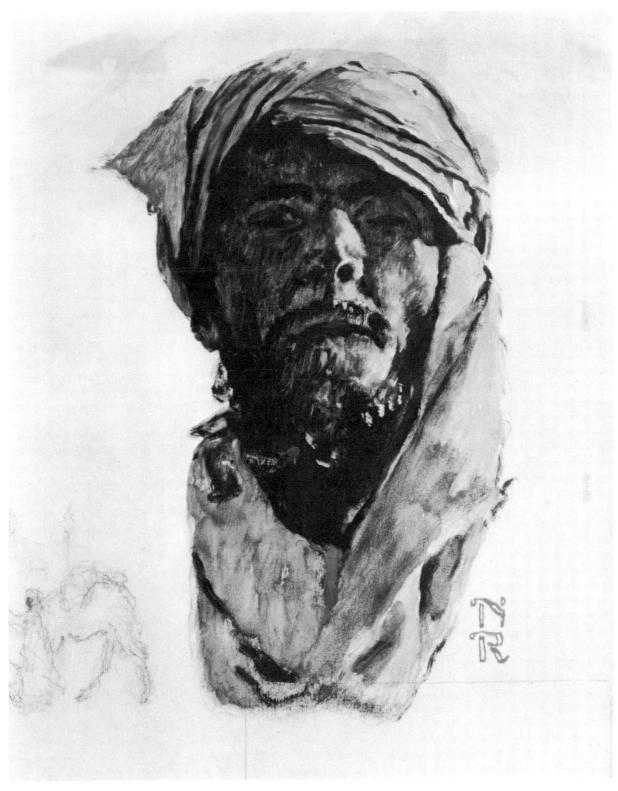

Arab. 1957. Oil painting for Pan American Airways

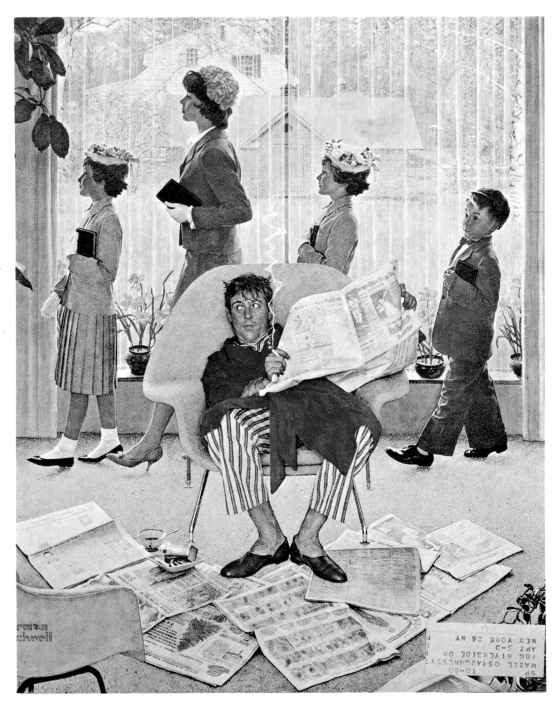

Easter Morning. Oil painting for *Post* cover, May 16, 1959. Private collection

166

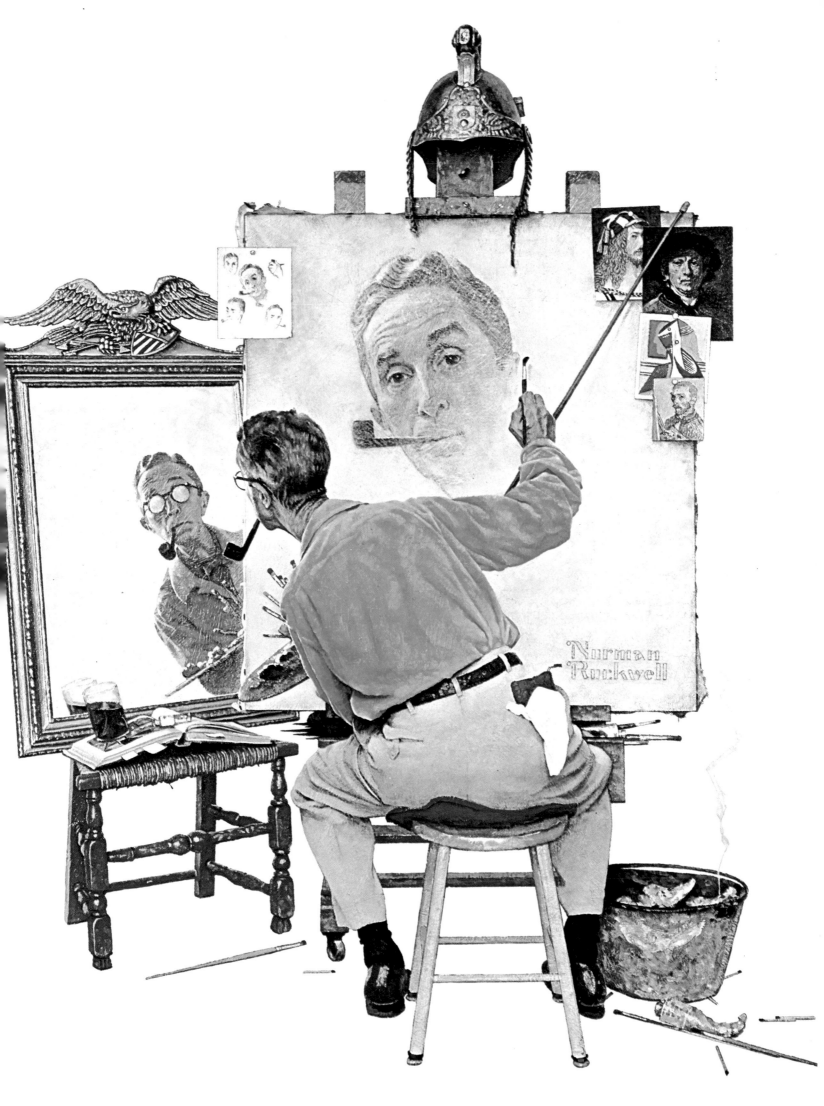

Norman Rockwell

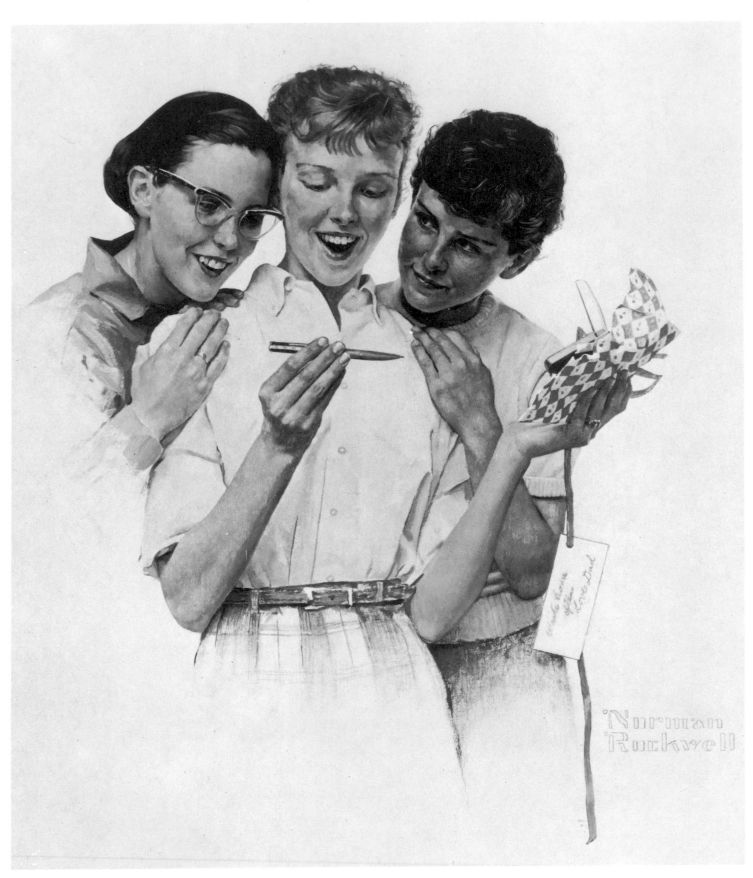

Advertisements for Parker pens, 1959

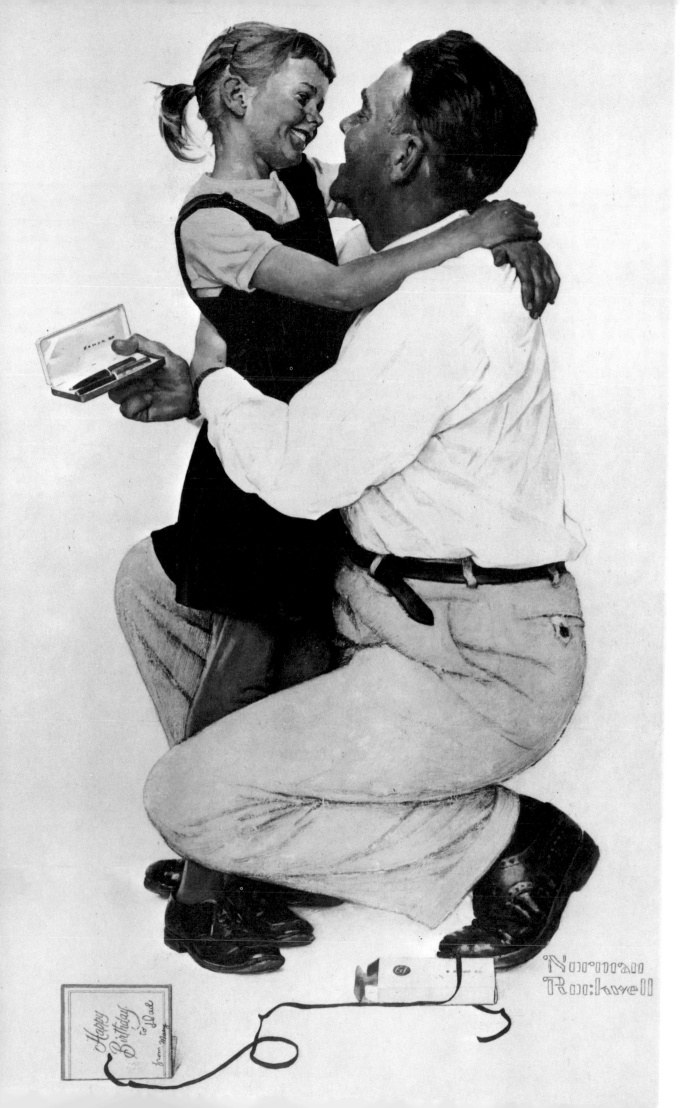

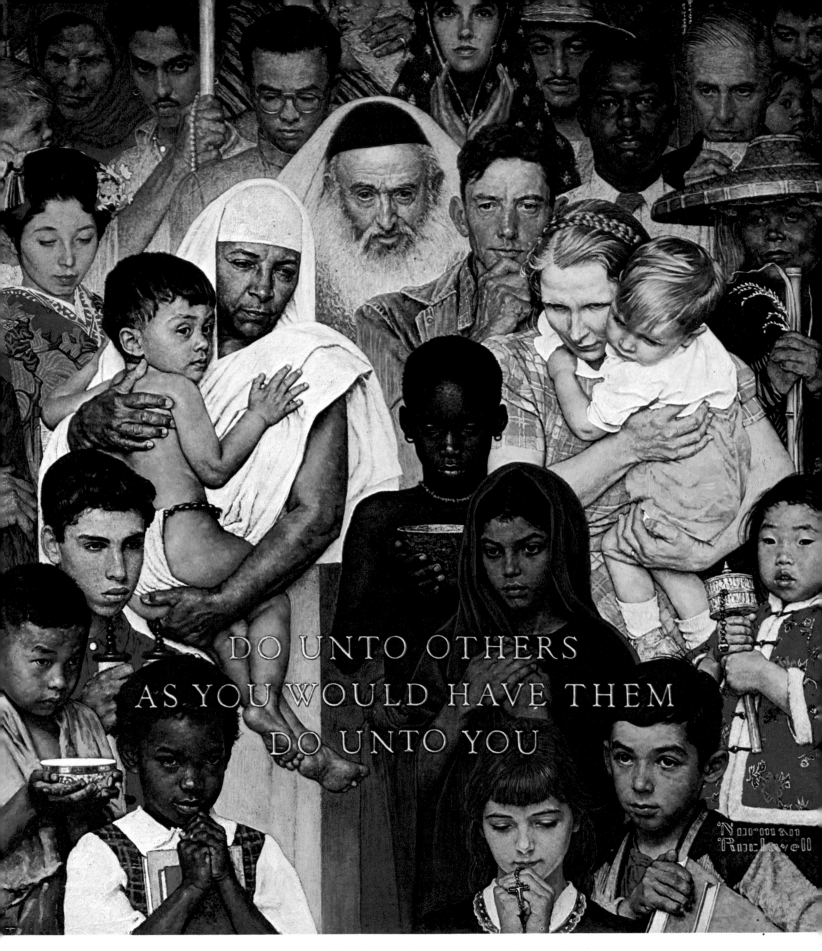

The Golden Rule. Oil painting for *Post* cover, April 1, 1961. Collection Norman Rockwell

1961-1978

orman Rockwell's world was changing. The old swimming hole was polluted, carefree youth came in two colors, and typical, average, ideal Americans were going to fly to the moon. In 1963, he left the *Saturday Evening Post* after an uninterrupted association of forty-seven years and went to work for *Look.* There was a big difference. Instead of painting cheerleaders he painted integration; instead of peace and prosperity, he painted poverty, protest, and the Peace Corps. In 1954, he had painted Bob Hope for the *Post;* in 1967, he painted Bertrand Russell for *Ramparts.*

What happened? How did a chronicler of nostalgic America turn into a crusader? How could a man spend half a century finding humor and pathos in the daily trivia of American life and suddenly start painting about Russian education, Ethiopian agriculture, and the space program? And how did a man who had prospered by avoiding controversy find himself in Little Rock?

Rockwell was a professional. He accepted assignments, did the work, and got paid. He and the *Post* worshiped each other; they welcomed his cover ideas almost until the very end — but always subject to editorial approval. The point of view was the magazine's, not the artist's. Fortunately, Rockwell shared their point of view most of the time. But no job was done, no painting completed regardless of how strongly he wanted to do it, without their approval, including the Four Freedoms.

The *Look* jobs were almost completely special assignments. Rockwell accepted them, did the work, and got paid. The surprising and wonderful elements here are that the jobs were offered and that he did accept them. Imagine approaching the best-known artist in the country, a wealthy, venerable figure sixty-nine years old, and suggesting he change his line! And think of the artist who had just written in his autobiography: "I do ordinary people in everyday

Rockwell and his wife Molly.
1967. Charcoal sketch.
Collection Norman Rockwell

situations and that's about all I can do." But even the tenderest moment in the family albums is meager fare compared with a single footprint on the moon. No artist—even Pyle—had such history to record.

Rockwell painted *The Golden Rule* in 1960 and married Molly Punderson in 1961. All of the styles and subject themes—even period settings—that developed over the years turned up again: unfinished and partly finished sketches in pencil and paint, silhouetted groups, full interiors, caricatures and portraits, masses of people, exteriors—and, through it all, Boy Scouts.

The Golden Rule is a pastiche, a reassembly of parts from another picture, never finished, dealing with the conscience of the United Nations. Rockwell's reuse of his own creations occurs surprisingly seldom considering the frequency with which he repeated themes and the length of his working life.

The massing of people—usually head-on or in profile—began with the *Freedom of Worship* in 1942, was used in several Boy Scout calendars, and became a major device in the sixties; *The Golden Rule, The Peace Corps in Ethiopia, How Goes the War on Poverty?, The Right to Know,* and *Astronauts on the Moon* all received this treatment. Based on a studio-arranged composition made from photographs of each individual, the series is characterized by painstaking rendering with emphasis on the unifying effect of common, usually strong, light sources. In sharp contrast is a series of portrait sketches done from life in Russia, Tibet, Mongolia, and Ethiopia—continuing the free brushy style that produced the heads for Pan American Airways in 1957.

In his final year at the *Post,* 1963, all of the covers were portraits. The art editor had approved a group of storytelling ideas, but as the editor did not use them they went with Rockwell when he left. *McCall's* printed some of them and so did *Look.* These may be the last of their kind.

To the end, which came peacefully on November 8, 1978, the assigned subjects Rockwell now accepted were big and important and challenging. Rockwell met them with enthusiasm and imagination. But he did not change. He still painted Christmas and funny-sad stories and springtime. He still liked his edges well defined and, in spite of outer space, he liked his backgrounds close in and parallel to the picture plane. Horizontals and verticals made him happier than diagonals, and the object in the foreground still invites us into the picture. Facial expressions are more serious, and the people who wear them are more important, but they still bring things to life as only Rockwell can. He did not abandon average America, but he became increasingly specific. His portrait of the nation remained, as always, more benevolent than deserved.

Hope for the Poor. Oil painting for *Look Magazine* cover, June 14, 1966

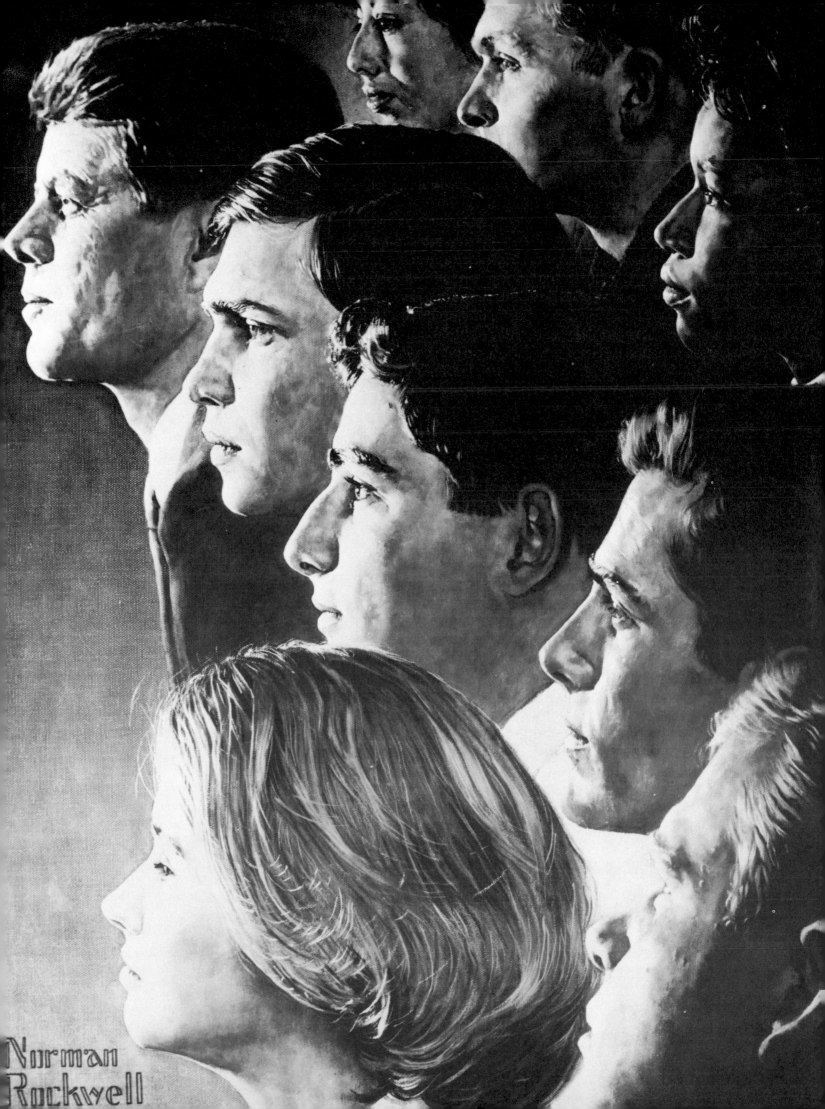

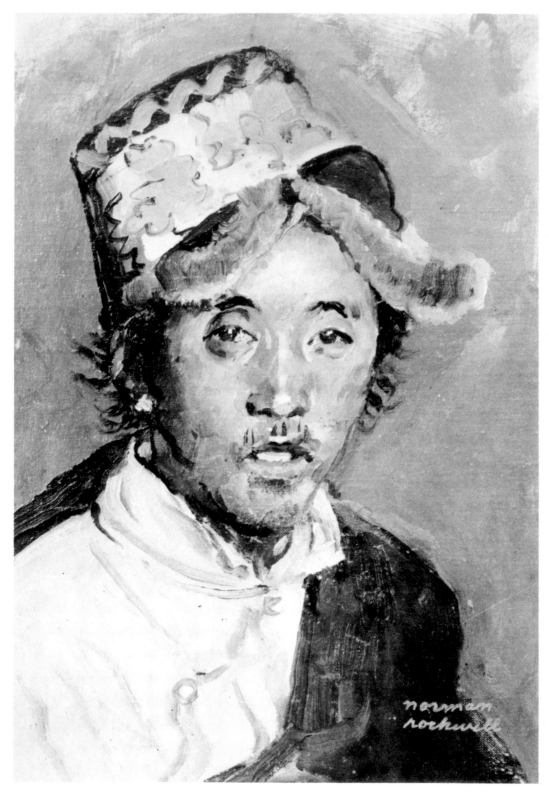

Tibetan. Early 1960s. Oil painting. Collection Norman Rockwell

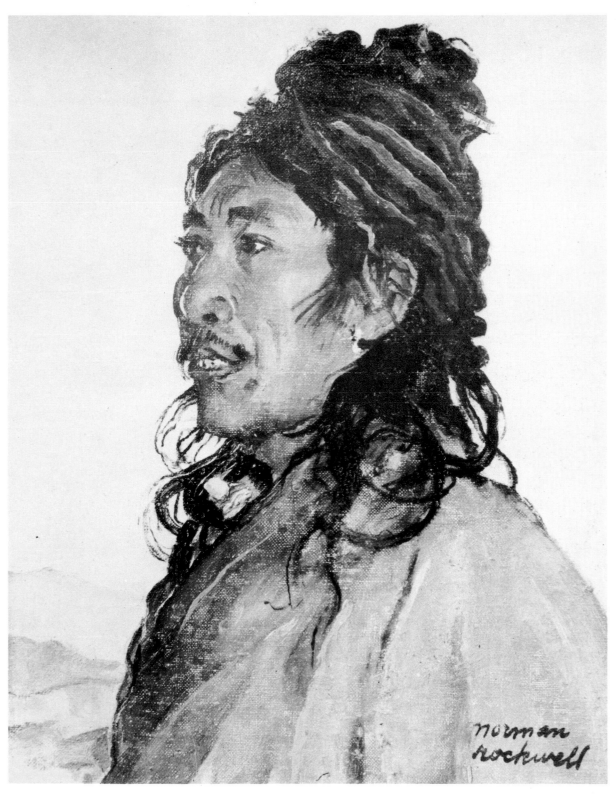

Mongolian. Early 1960s. Oil painting. Collection Norman Rockwell

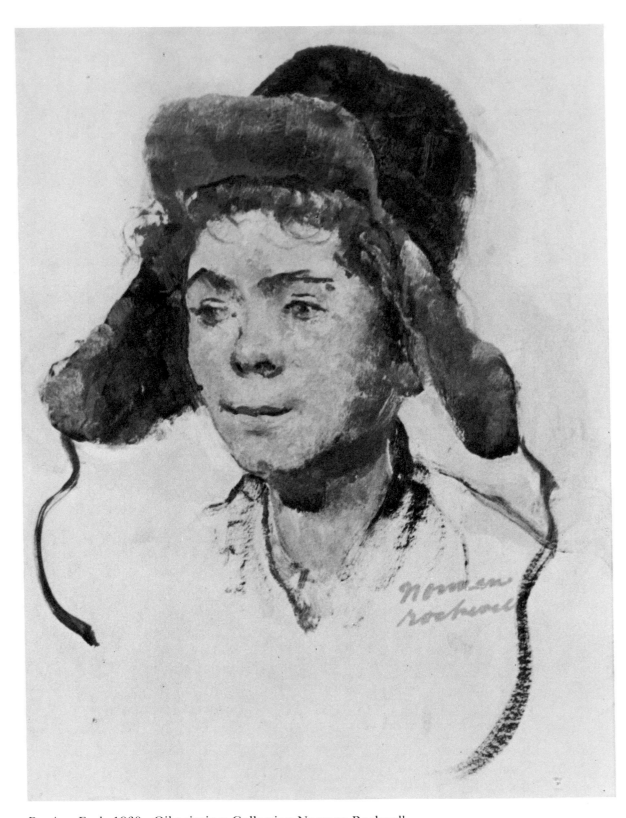

Russian. Early 1960s. Oil painting. Collection Norman Rockwell

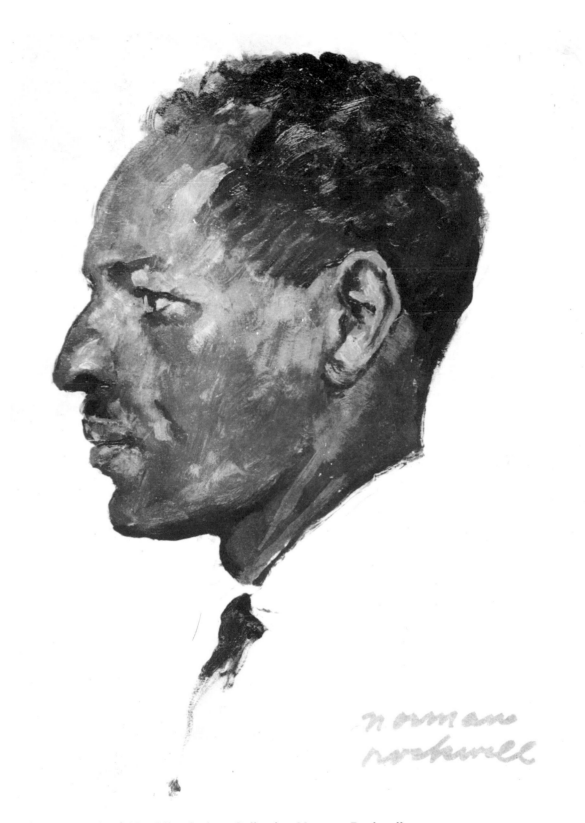

Ethiopian. Early 1960s. Oil painting. Collection Norman Rockwell

Part of a promotional series for the 1966 movie, "Stagecoach." Twentieth Century-Fox Film Corporation

Bing Crosby. Illustration based on the film "Stagecoach," 1966.
Twentieth Century-Fox Film Corporation

Ann-Margret. Illustration based on the film "Stagecoach," 1966.
Twentieth Century-Fox Film Corporation

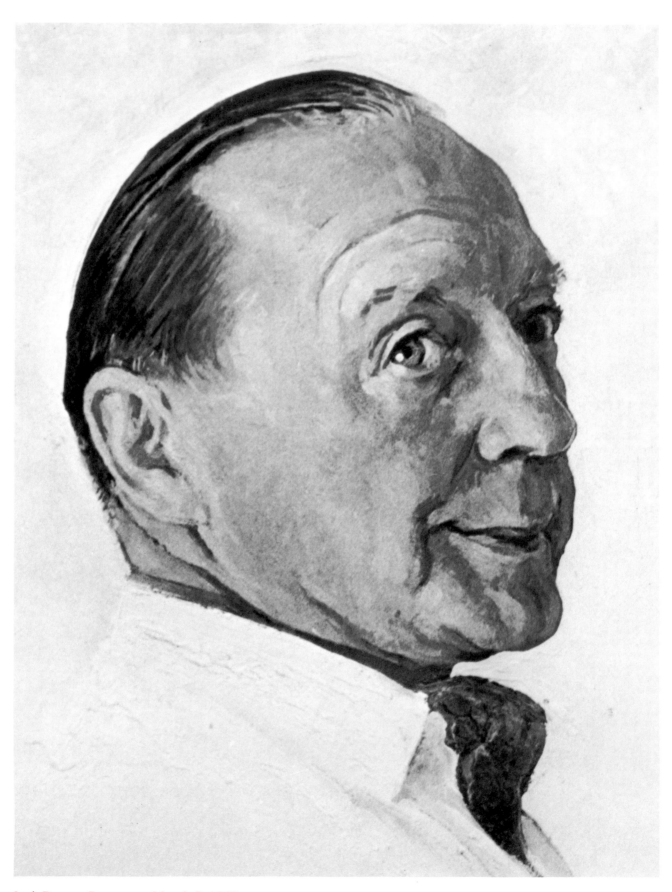

Jack Benny. *Post* cover, March 2, 1963

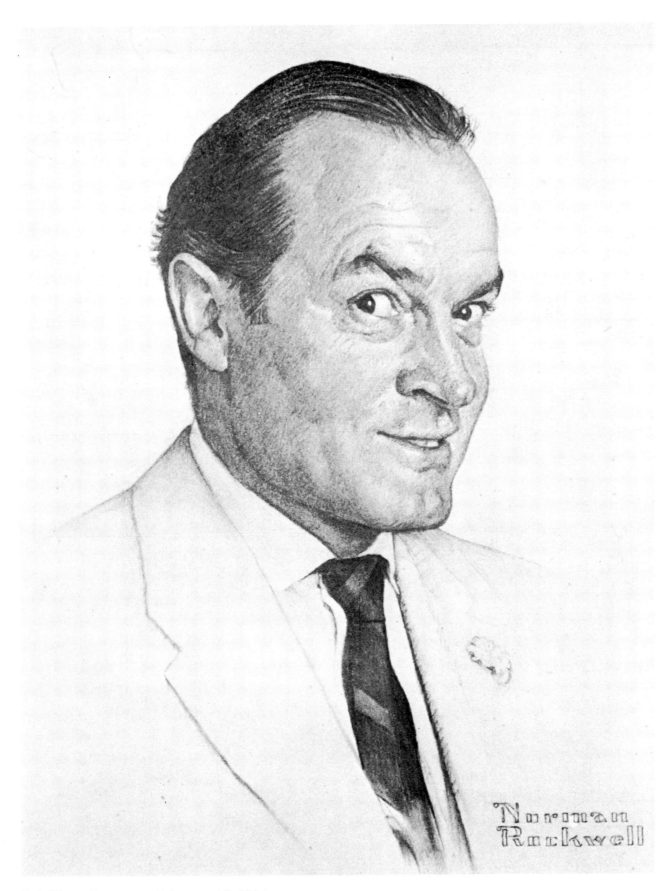

Bob Hope. *Post* cover, February 13, 1954

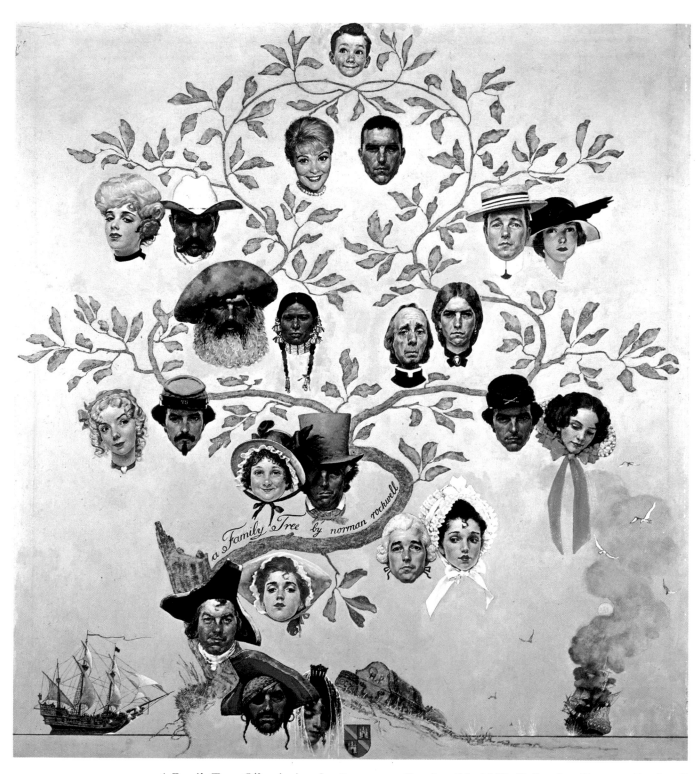

A Family Tree. Oil painting for *Post* cover, October 24, 1959. Collection Norman Rockwell

Abstract & Concrete. Oil painting for *Post* cover,
January 13, 1962. Private collection

Russian Classroom. Oil painting for *Look Magazine* illustration, October 3, 1967. Collection Jack Solomon

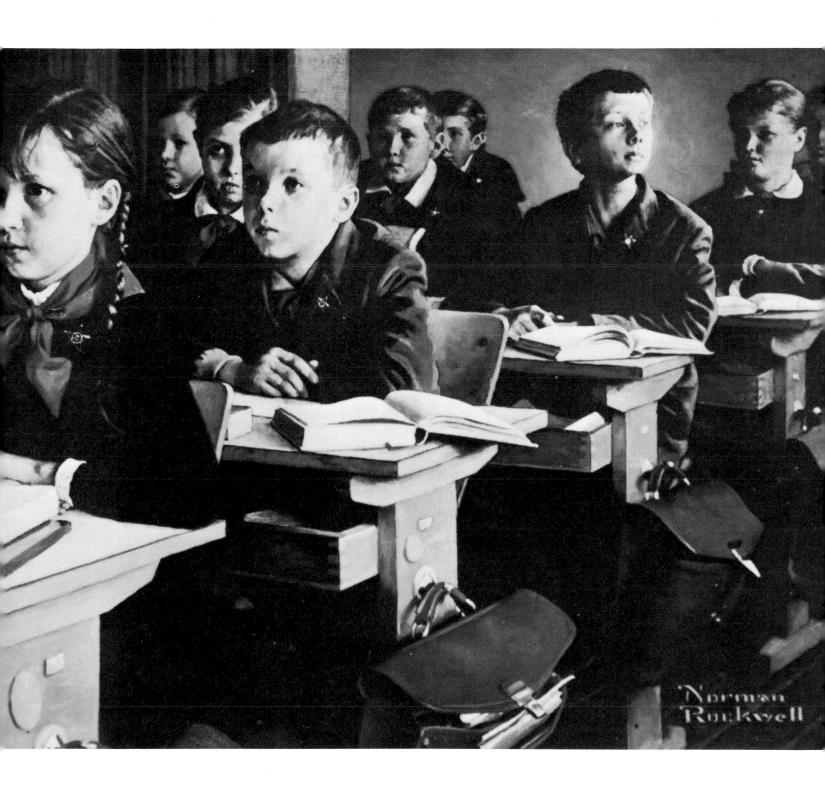

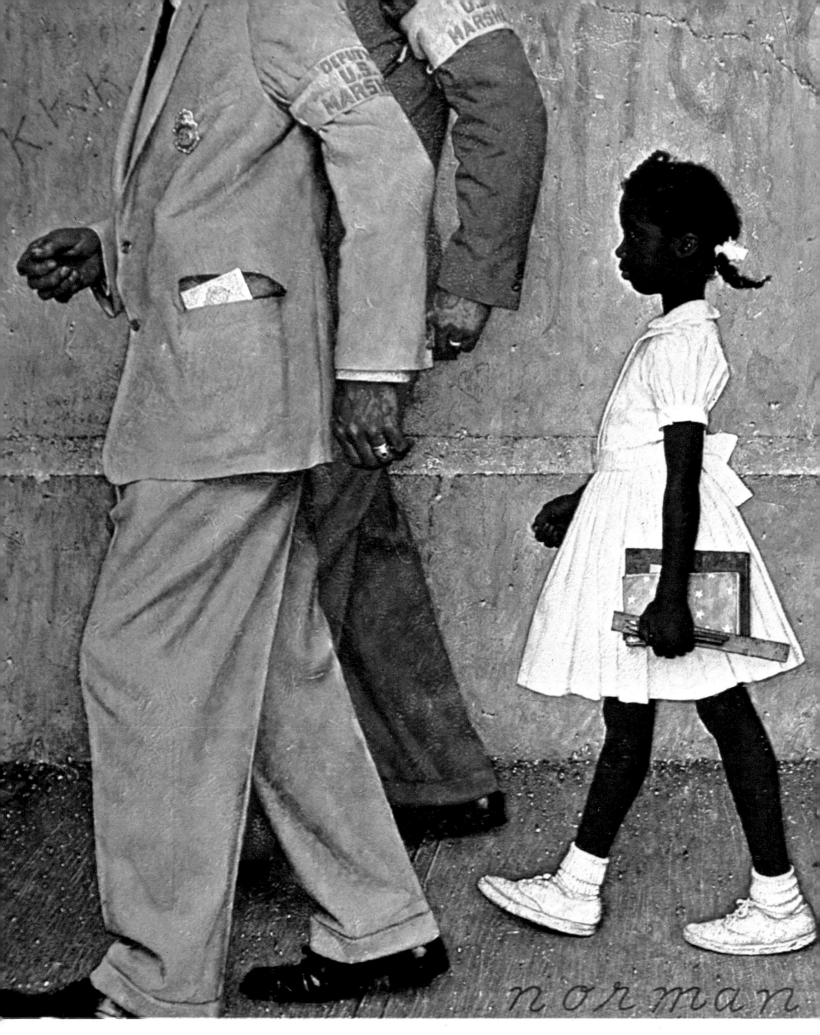

The Problem We All Live With. Oil painting for *Look Magazine* illustration, January 14, 1964. Collection Jack Solomon

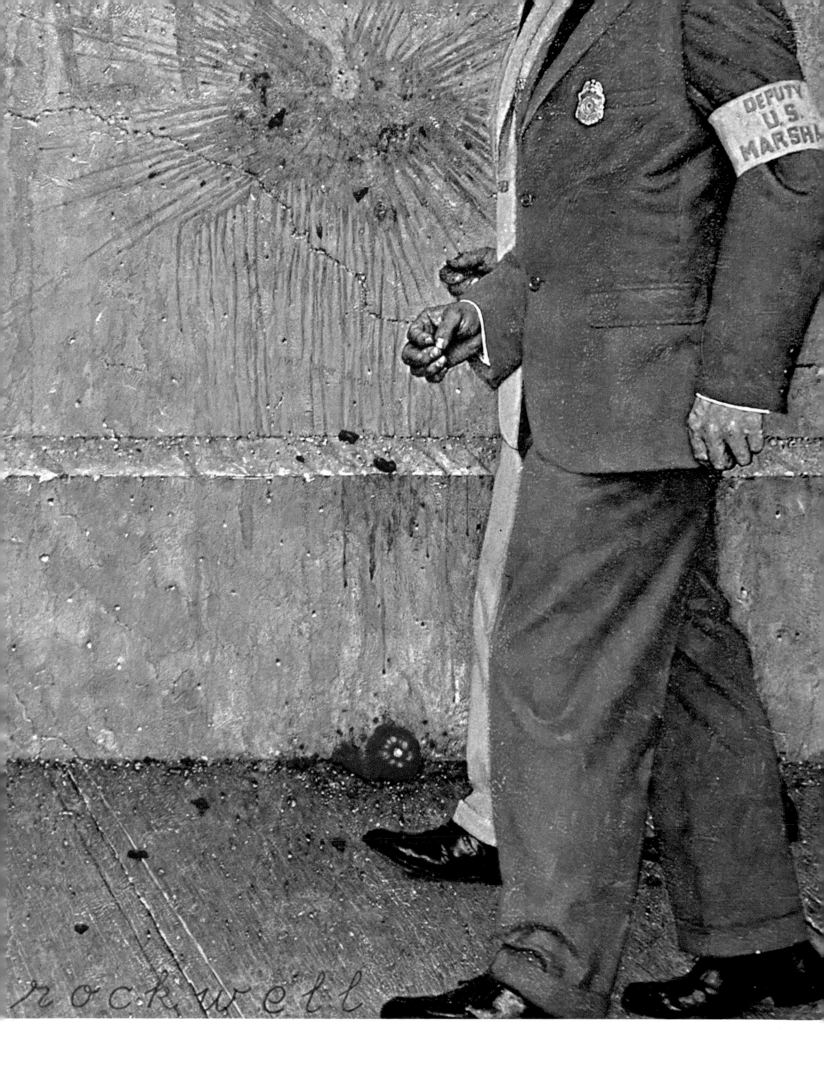

rockwell

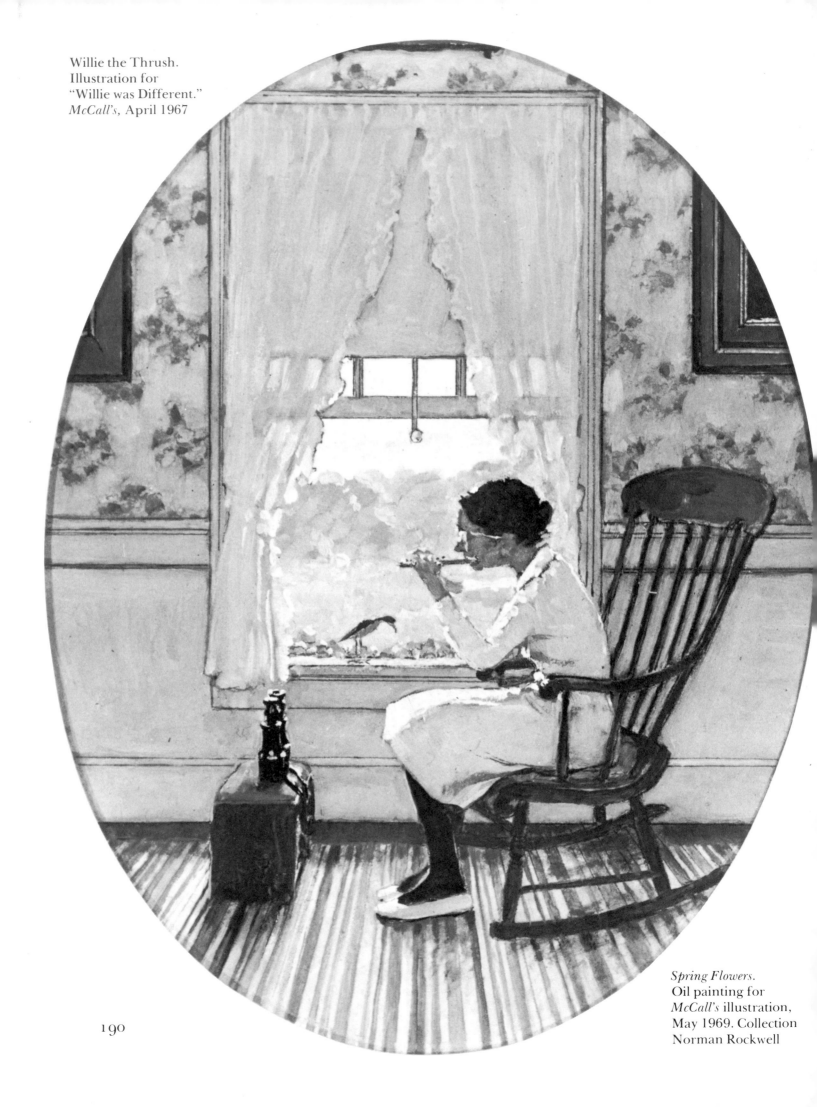

Willie the Thrush.
Illustration for
"Willie was Different."
McCall's, April 1967

190

Spring Flowers.
Oil painting for
McCall's illustration,
May 1969. Collection
Norman Rockwell

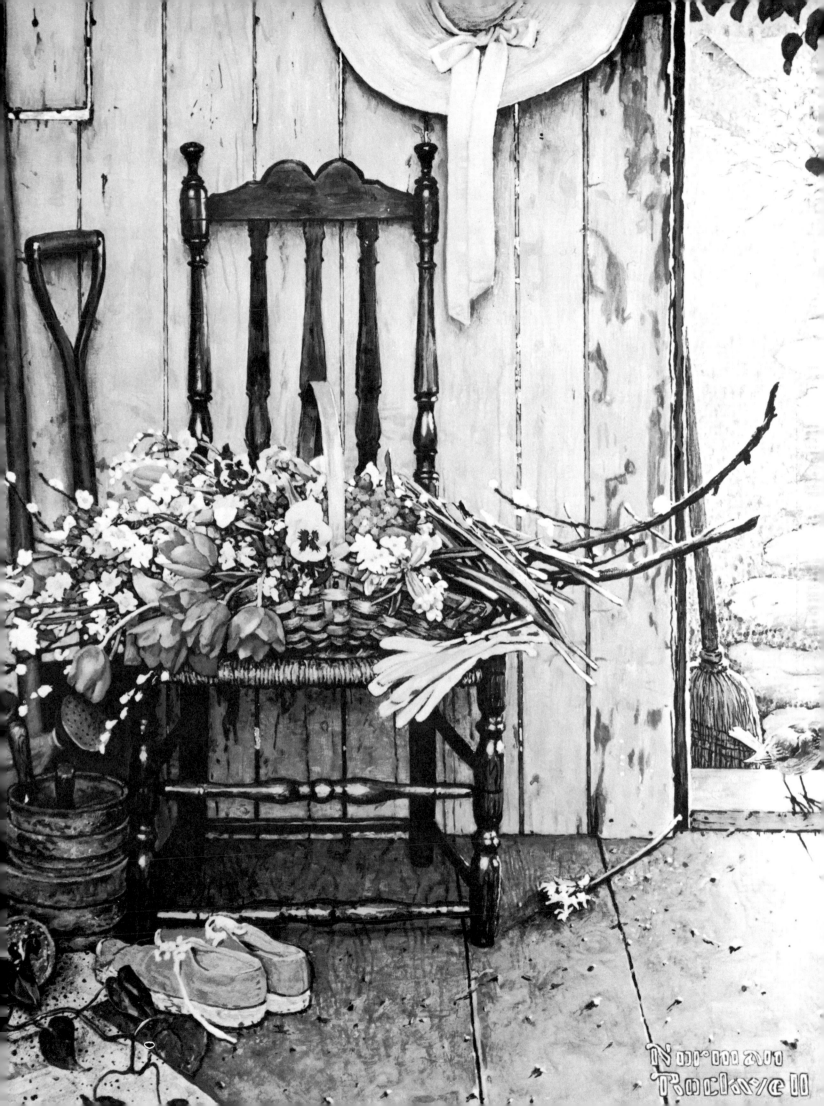

Moving In. Oil painting for *Look Magazine* illustration, May 16, 1967. Old Corner House, Stockbridge, Mass.

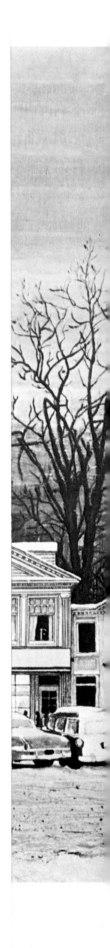

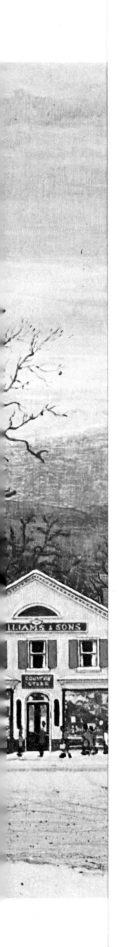

Stockbridge at Christmas.
Oil painting for *McCall's* illustration,
December 1967. Collection Norman Rockwell

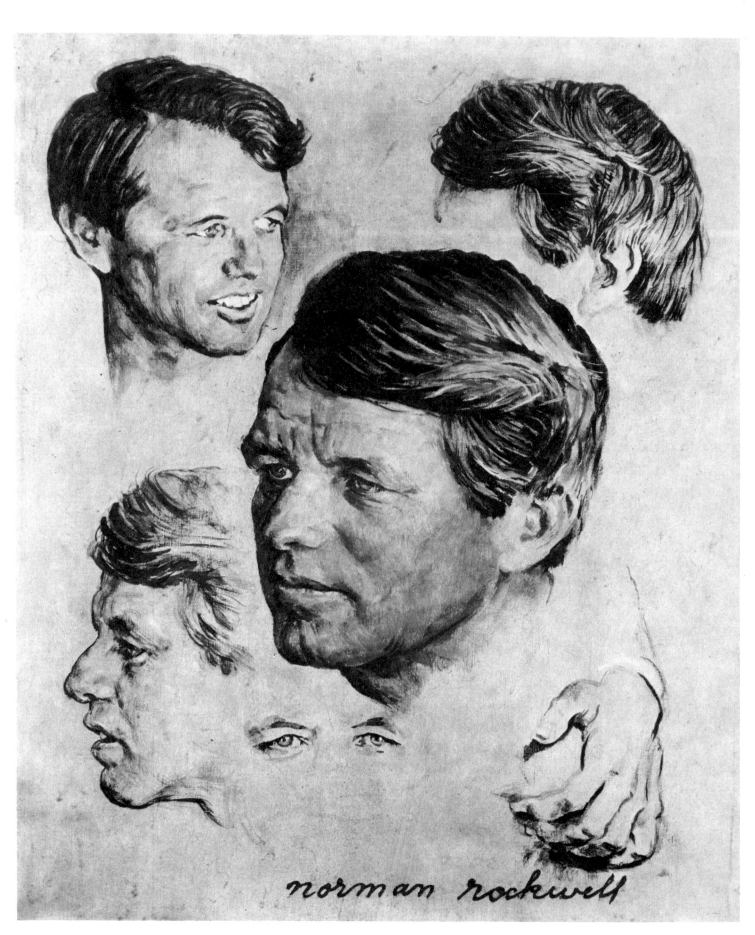

Robert F. Kennedy. Oil painting

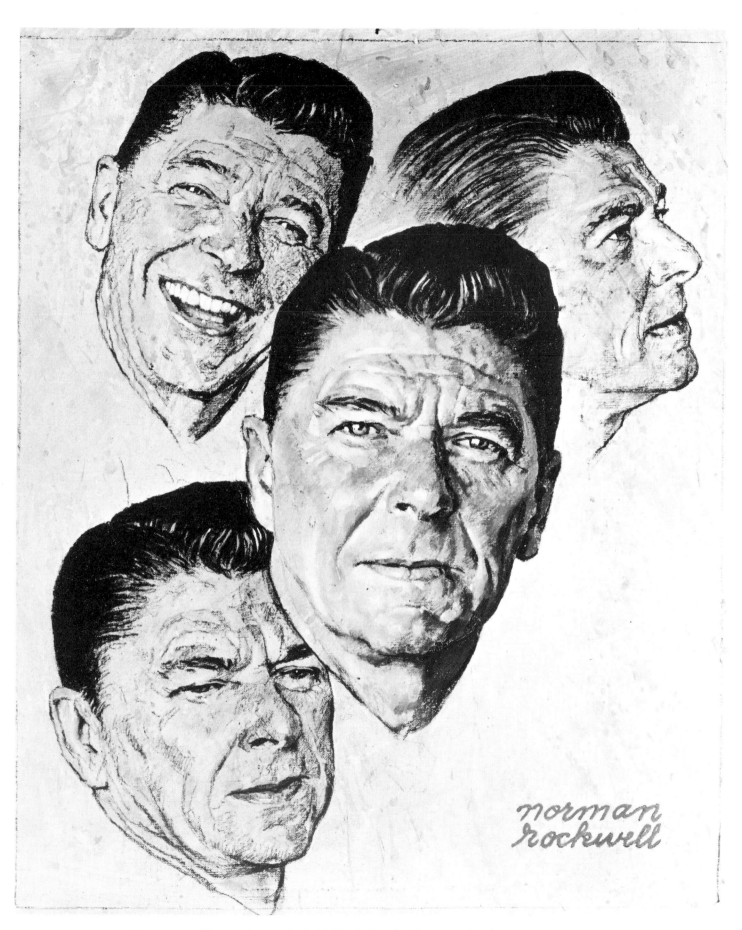

Ronald Reagan. *Look Magazine* illustration, July 9, 1968. © Cowles Communications, Inc.

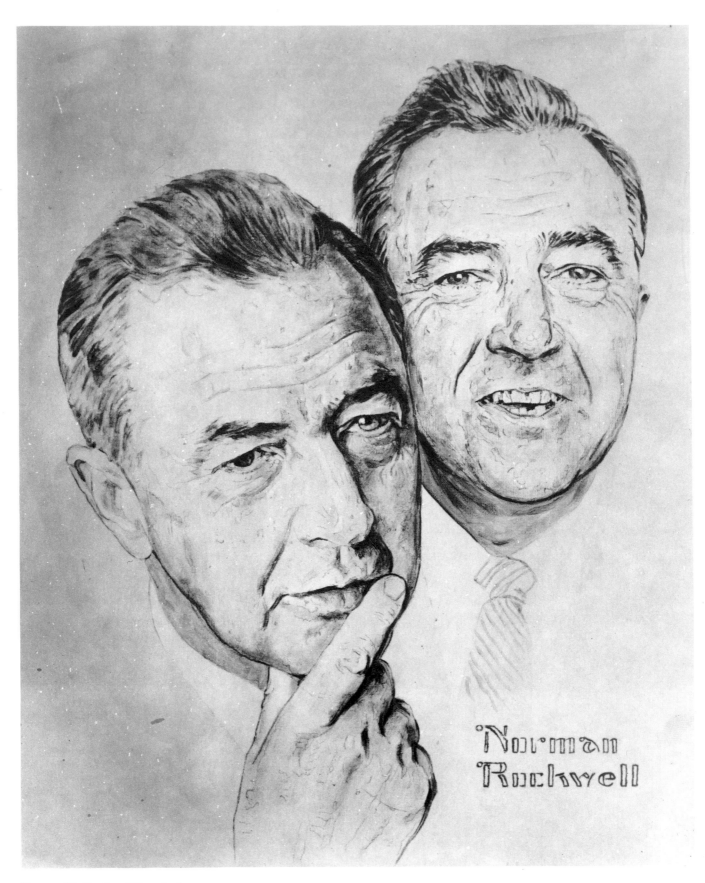

Eugene McCarthy. Oil painting

202

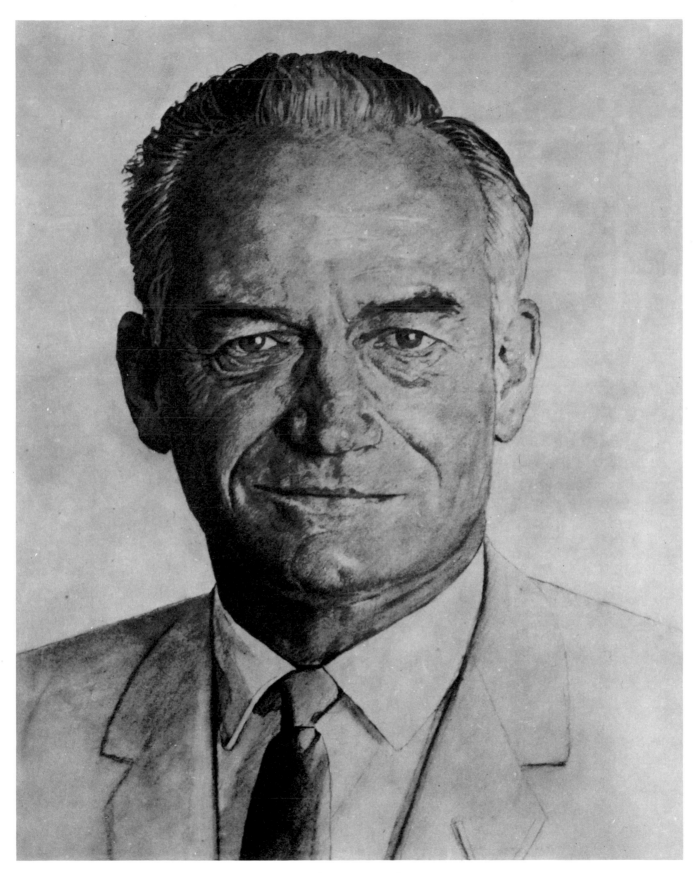

Barry Goldwater. *Look Magazine* illustration, October 20, 1964. © Cowles Communications, Inc.

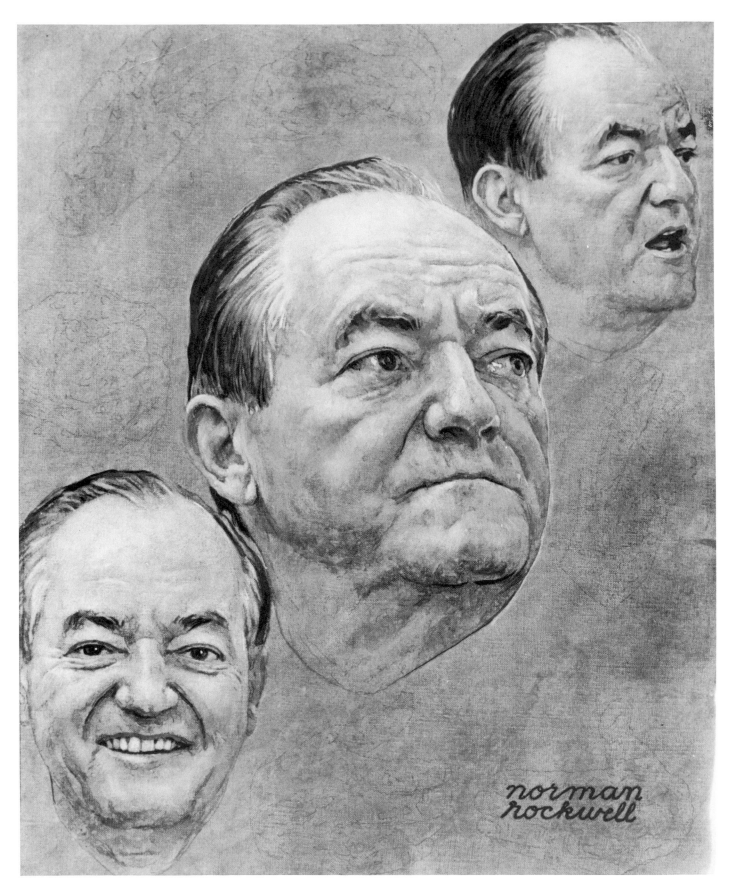

Hubert Humphrey. *Look Magazine* illustration, July 9, 1968. © Cowles Communications, Inc.

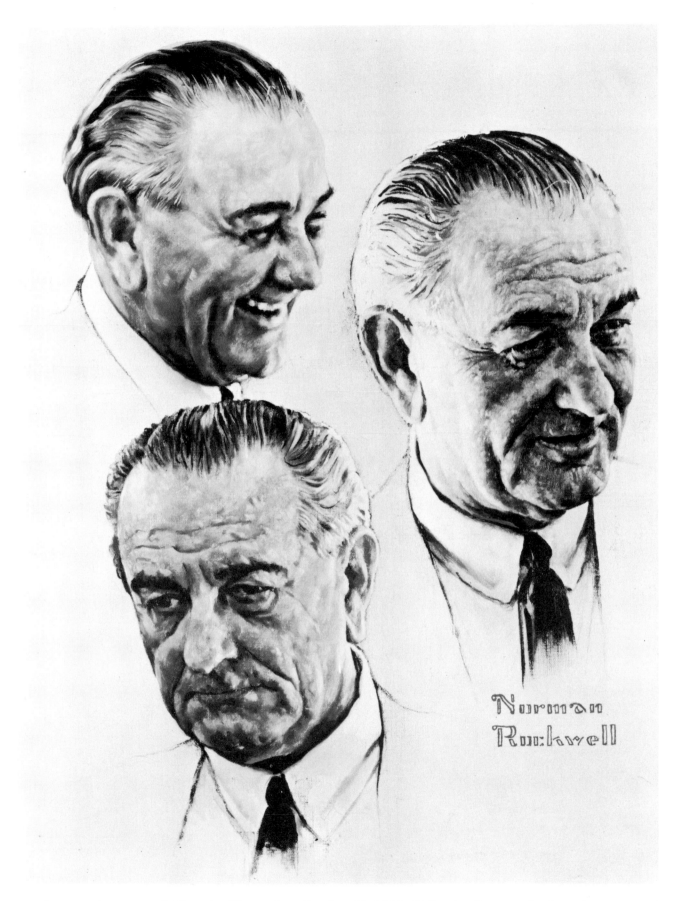

Lyndon B. Johnson. *Look Magazine* illustration, October 20, 1964. © Cowles Communications, Inc.

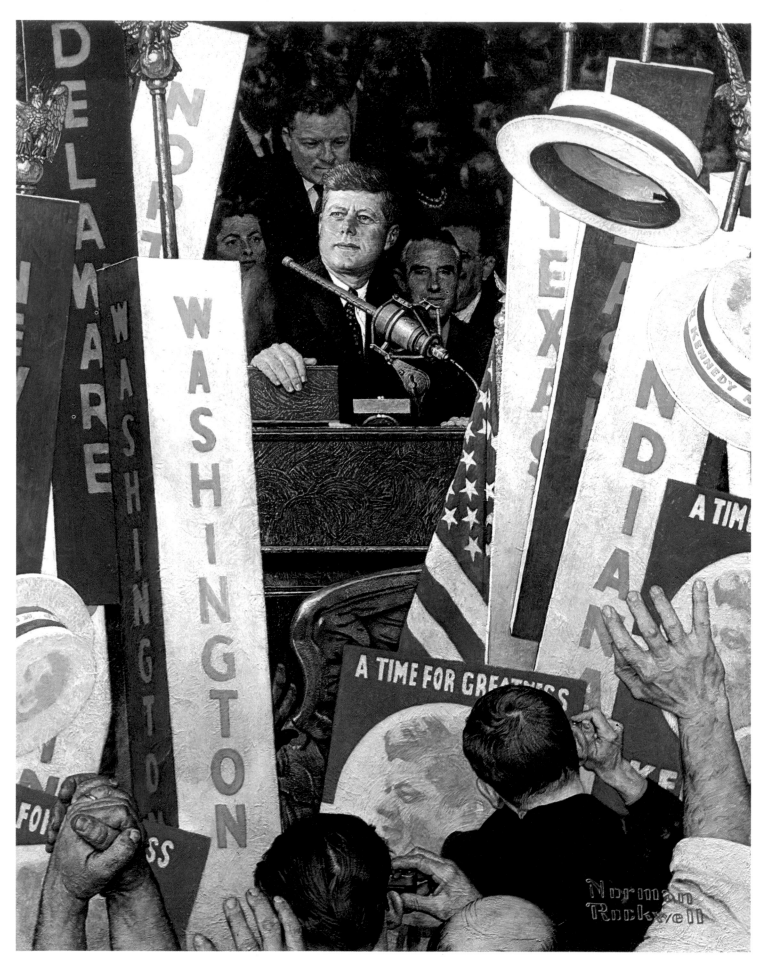

A Time for Greatness. Oil painting for *Look Magazine* cover, July 14, 1964. Private collection

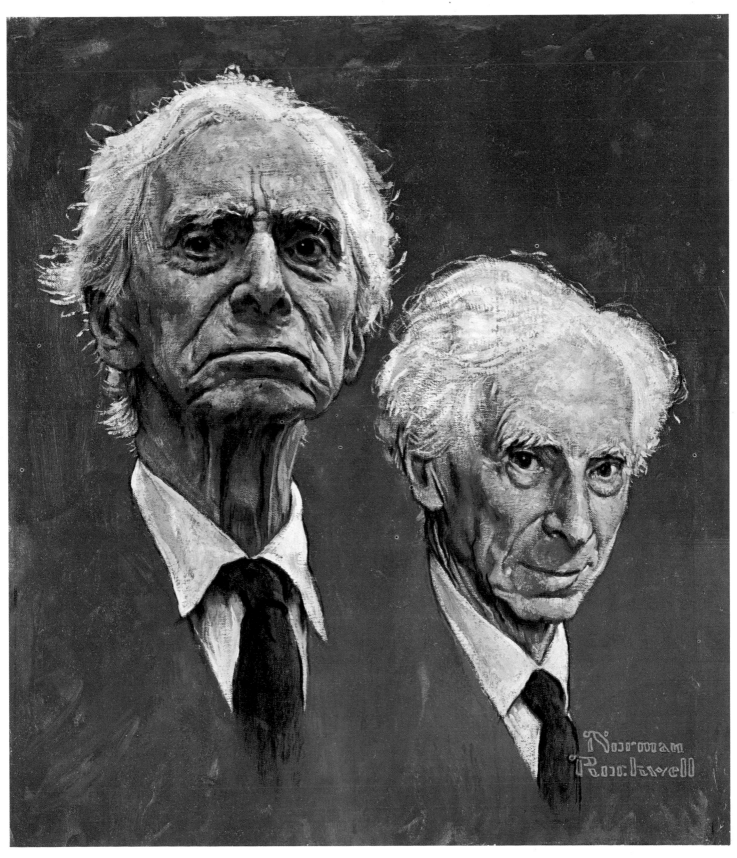

Bertrand Russell. Oil painting for *Ramparts* illustration, May 1967. Collection Norman Rockwell

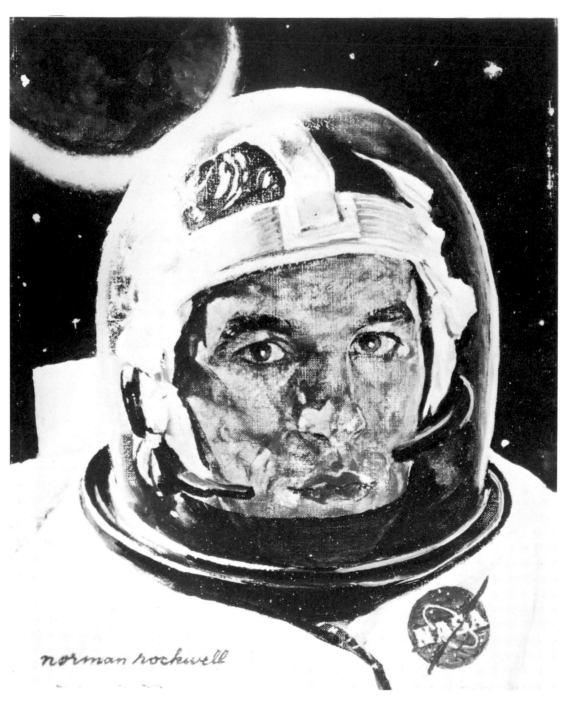

Portrait of an Astronaut. Oil painting for *Look Magazine* illustration, January 10, 1967. The National Air and Space Museum, Smithsonian Institution, Washington, D.C.

Man's First Step on the Moon. Oil painting for *Look Magazine* illustration, January 10, 1967. The National Air and Space Museum, Smithsonian Institution, Washington, D.C.

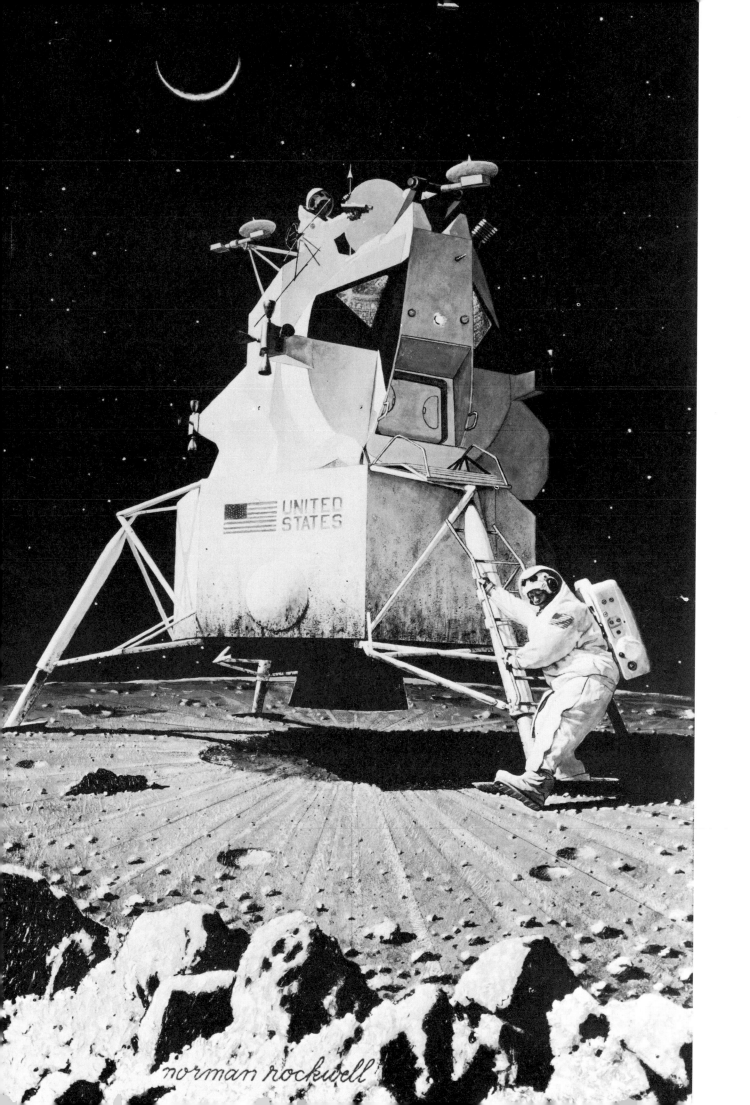
norman rockwell

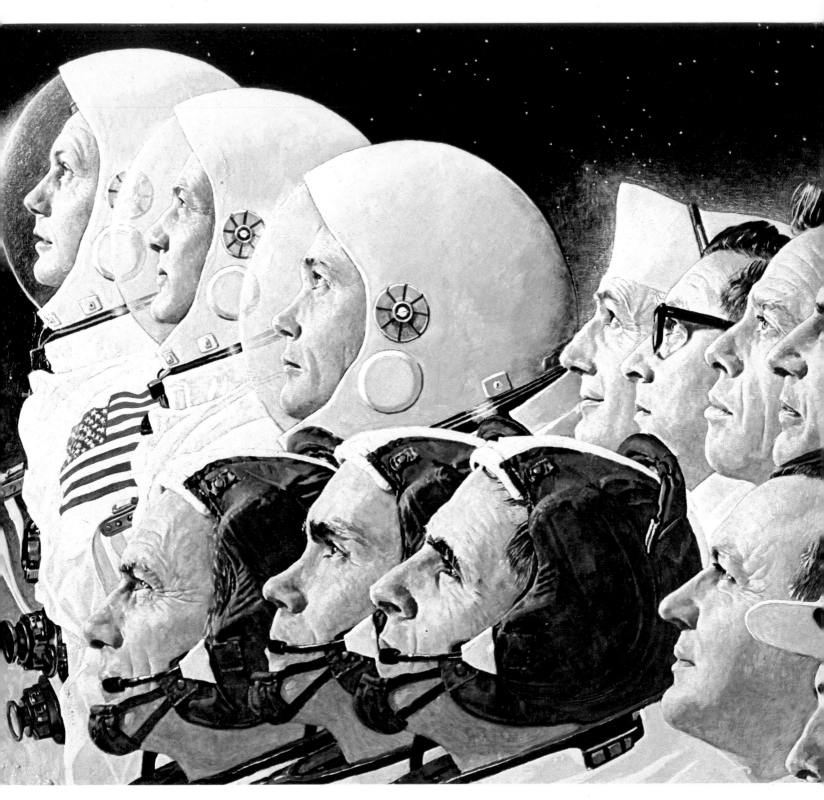

Apollo 11 Space Team. Oil painting for *Look Magazine* illustration, July 15, 1969.
The National Air and Space Museum, Smithsonian Institution, Washington, D.C.

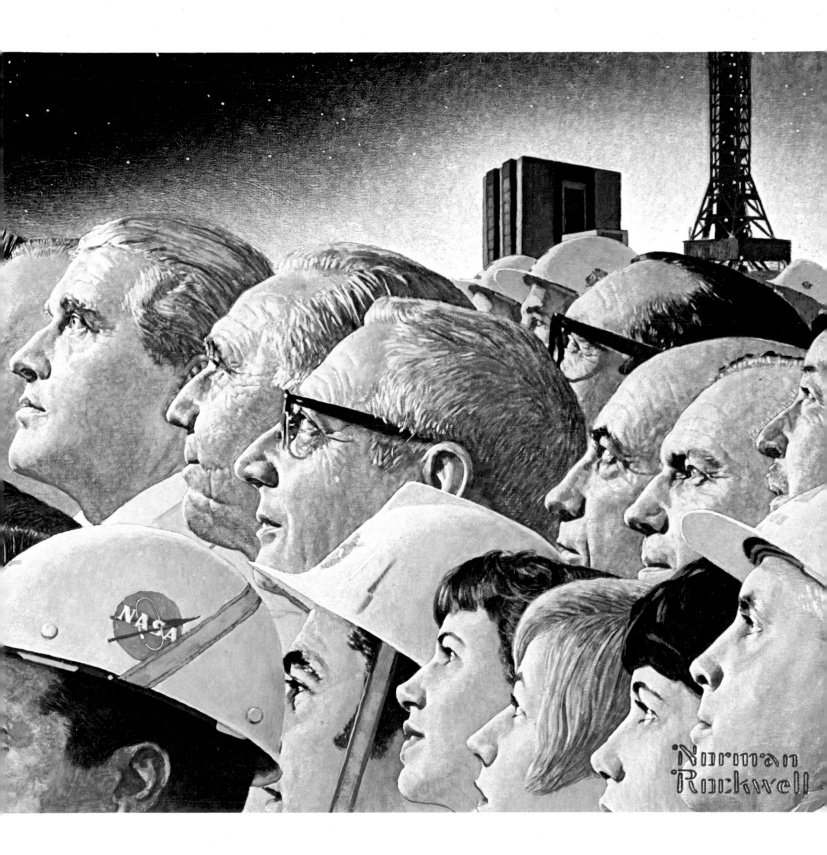

INDEX TO ILLUSTRATIONS

Illustrations have been indexed by category. Asterisks * indicate colorplates.

MCCALL'S

191. "Spring Flowers," oil painting, May 1969

195–98.* "Stockbridge at Christmas," oil painting, December 1967

190. "Willie the Thrush," April 1967

RAMPARTS

207.* "Bertrand Russell," oil painting, May 1967

ST. NICHOLAS

26. "End of the Road," November 1915

16. "The Magic Football," December 1914

34. "The Ungrateful Man," January 1917

26–27. May 1915

34–35. January 1917

SATURDAY EVENING POST

90. "The Blacksmith Shop," November 2, 1940

88–89.* "Blacksmith's Boy—Heel and Toe," oil painting, November 2, 1940

134–35.* "County Agricultural Agent," oil painting, July 24, 1948

90–91. "Daniel Webster and The Ides of March," October 28, 1939

109.* "The Handkerchiefs," May 11, 1940

80–81.* "The Land of Enchantment," oil painting, December 22, 1934

112–13.* "The New Tavern Sign," February 22, 1936

140. "Norman Rockwell Visits a Country Editor," oil painting, May 25, 1946

136–37. "Norman Rockwell Visits a Ration Board," July 15, 1944

138–39. "Norman Rockwell Visits His Country Doctor," April 12, 1947

138–39. "Red Oaks, Georgia Schoolroom," oil painting, November 2, 1946

105. "The Virtuoso," oil painting, May 27, 1939

102. "You Can Look It Up in the Record," April 5, 1941

WOMAN'S HOME COMPANION

94–97. "Louisa May Alcott: Most Beloved American Writer," December 1937–March 1938

MAGAZINE COVERS

Country Gentleman

47. "Bully Before," June 4, 1921

47. "Bully After," June 11, 1921

55. "Christmas," December 18, 1920

30. December 1, 1917

30. December 22, 1917

Judge

31. "Two A.M.—Watch Your Step," January 13, 1917

Life

71. "A Pilgrim's Progress," November 17, 1921

49.* "Thanksgiving (The Glutton)," oil painting, November 22, 1923

35. May 10, 1917

Literary Digest

32.* "Boy and Girl on a Horse," oil painting, September 4, 1920

18. "Dolly's Shoe," 1921

56.* "Grandpa and the Children," December 24, 1921

19. "The Hopeless Case," 1923

18. "Mending the Coat," 1921

60.* "Old Sea Captain," oil painting, December 2, 1922

41.* "Paying the Bills," oil painting, February 26, 1921

19. "Playing the Banjo," 1922

19. "Reading Hour," 1923

Look

173. "Hope for the Poor," oil painting, June 14, 1966

206.* "A Time for Greatness," oil painting, July 14, 1964

St. Nicholas

27. "Winter," January 1916

Saturday Evening Post

184.* "Abstract & Concrete," oil painting, January 13, 1962

150. "Adlai E. Stevenson," October 6, 1956

159.* "After the Prom," oil painting, May 27, 1957

108. "April Fools," oil painting, April 3, 1943

83. "Barbershop Quartet," sketch and oil painting, September 26, 1936

64.* "Ben Franklin's Sesqui-

PAINTINGS AND MURALS

overleaf:
Rockwell in his studio, 1970.
Photo by Louis Lamone,
Lenox, Mass.

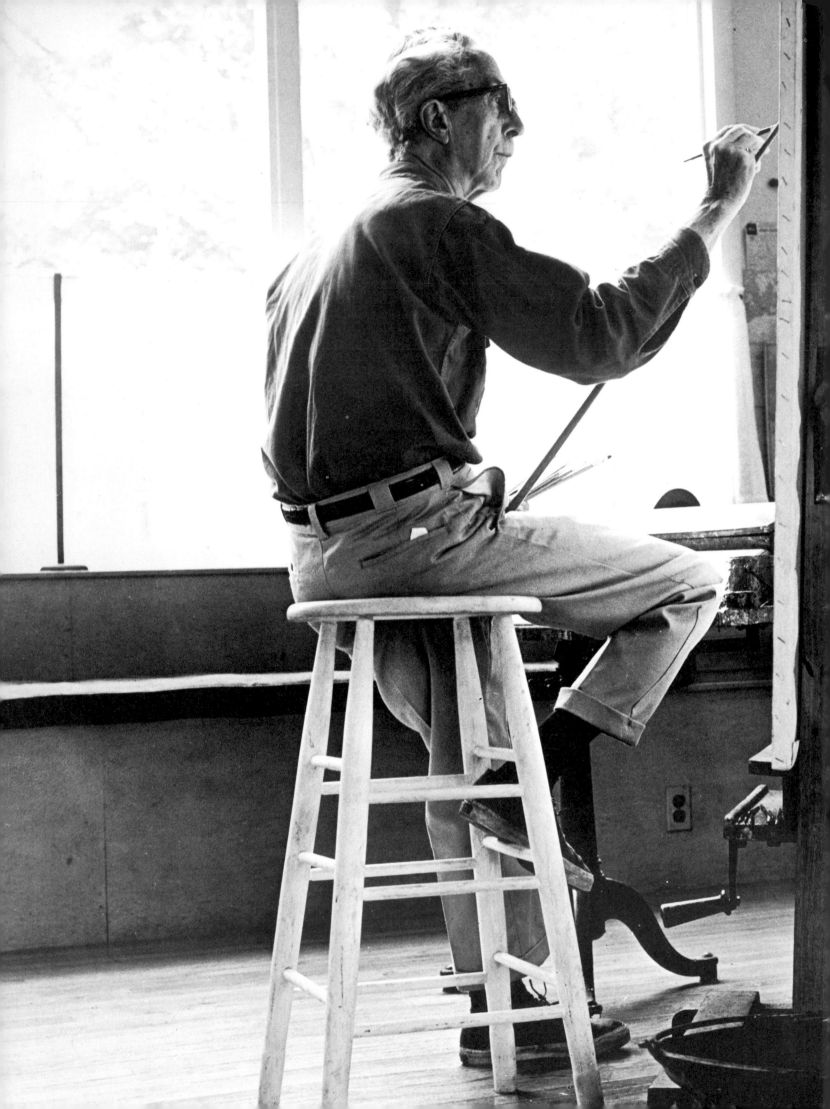